THE DEATH OF PHOTOGRAPHY

PETER GRAVELLE

A life un-examined is a life not worth living.

Dedicated to the two women in my life who have made this book possible.
My mother, Joan Elise and Angela.
I love you both.

A catalogue record for this book is available from the
British Library.

First Edition 2016

First published in Great Britain in 2016 by
Carpet Bombing Culture.

An imprint of Pro-actif Communications

www.carpetbombingculture.co.uk

Email: books@carpetbombingculture.co.uk

© Carpet Bombing Culture. Pro-actif Communications

ISBN: 978-1-908211-41-5

CARPET
BOMBING
CULTURE

WE ALL NEED
AN
N. M. E.

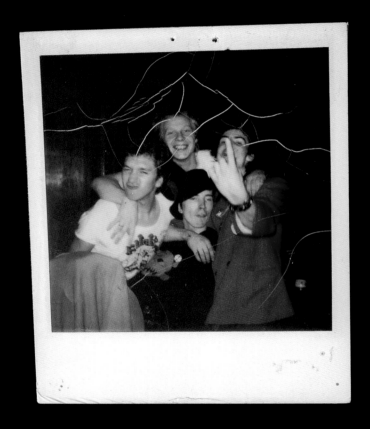

THE EARLY YEARS

I had finished school passing all my exams - much to my master's surprise and annoyance - and had continued on to University. I had thought only good times and learning lay ahead. Instead I found only apathy, drunkenness and a few friends all in their final year. I wore a fur coat in summer and by my second term I was travelling most of the time to London where an American girl I had met on a gap year lived.

The low spark of high-heeled boys was among us and London was cool, exciting and generally welcoming. University wasn't for me so I applied for a job as a photo assistant at Carlton Studios in Marble Arch. It was the largest group of photo studios in Europe at the time. I was interviewed by Tommy, a man who didn't mince his words. He looked at what photo samples I had and then asked me, "How tall are you?" "Six foot," I replied. "OK, start here Monday morning, eight sharp. As an assistant you will be paid £10 a week, luncheon vouchers and the use of studios at night as long as they are not being used."

Thus my apprenticeship at Carlton began. It was the past home of the great John French who Bailey had worked under. Most of the photographers were ex military men, most of whom had learnt their trade in the forces. Inside Carlton there were thirteen studios. Work ranged from still-life, to food, to room sets, hardware, fashion of every description, to portraiture. I rented a room with a bed in Kilburn and started work with a carpet photographer whose studio was on the third floor with no elevator. Within six months I ended up working for the best Carlton had to offer, Ted Ward-Hart, a.k.a Fuzzy Ted. I worked hard, even using the studios after work for myself, something that no other assistants bothered to do. I was beginning to know my f-stops from my bus stops.

I carried on with all that Carlton had to offer, the cameras, the lights, the prop rooms, plus the in-house film processing. By chance the owners, waiting one day for an important job to come through, noticed some of my test shots. They liked what they saw, and subsequently asked me to do some further tests for them, where-upon I was offered a studio of my own. For the next year I photographed everything and anything that was put in front of me, mostly mail-order catalogues until a disagreement over wages led me to leave Carlton and set up on my own. I thought I was ready anyway.

Work in the mid-seventies was pretty hard to come by but I soldiered on and within a year or so I opened a studio in Vauxhall. Equipment, or lack thereof, was always a problem, but in some ways that forced me to be more creative with what I had. My main influences were Avedon and Penn. Newton was re-inventing himself with the help of Nova magazine and I would buy a magazine if it had a shoe advert by Bourdin. I did not believe photography was a rich man's profession and poor man's hobby. Then came some vicious rock and roll into my life and my studio.

LAS VEGAS

We were sitting at the traffic light when a car pulled up next to us.
My two sisters jumped up and down yelling, "It's Elvis."
My mother threw me a camera as she jumped out to get an autograph.
My father turned his 8mm camera on the scene. Snap. Whirl.
As a family we always had cameras.

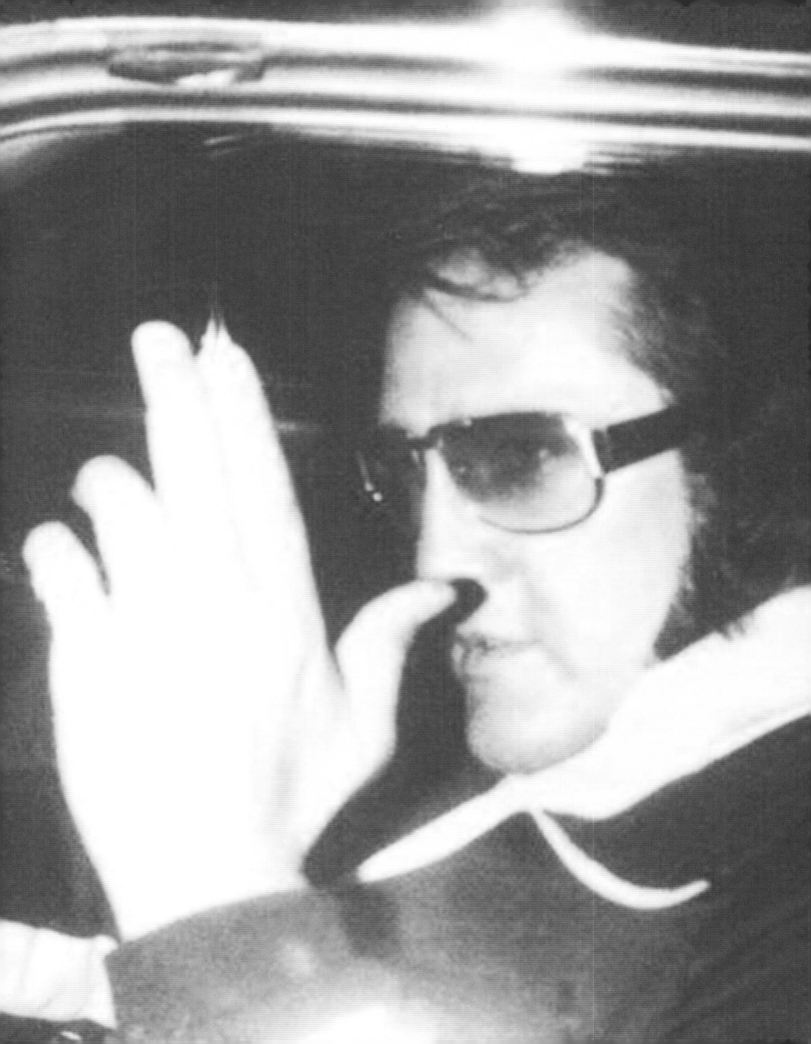

School Daze

What is a Canadian born Protestant aged 11, who has been expelled from a sequence of English State Schools, doing waking up one morning in a Roman Catholic English Public School with the London borough paying the school fees? And I, the only Protestant in a school of over 250 borders, only boys, on the way to becoming men. Well, I submit to you, dear reader, because my school years' testimony does reflect my adult life and I am not alone in answering to this truth.

The violent tragedy of my early school days was set amidst exquisite architectural surroundings set on a beautiful natural vista which at every turn drew attention to a strangely impenetrable aesthetic. A grand vision was born in the mind of John Wood the elder and indulged by Ralph Allen, an early paradise appeared in the form of Prior Park. Samuel Taylor Coleridge's complete mental breakdown whilst in Bath and in the presence of Thomas De Quincey, author of The Confessions of an Opium Eater has led to speculation that the poem 'Kubla Khan' was actually written after an opium-fuelled visit to Prior Park.

'In Xanadu did Kubla Khan, a stately pleasure dome decree.'

'Xanadu', that is how it seemed and looked, but human nature settles for less as the dark of night encapsulated the soul and broken hearts and minds turn from the glory that is God to the more accessible demigods of lower worlds and young blood is enticed to savagery and perversion in the Public School tradition of savagery, bullying, sexual perversion, psychosis and pathology.

'In the philosophy of Heraclitus it (enantiodromia) is used to designate the play of opposites in the course of events the view that everything that exists turns into its opposite.'

C.G. Jung (1949)

Boys in the senior school got wind of my and others mimetic Nazism and persecution of other pupils: they smelt our blood. Among any year group it would seem the same tragic comedy would play itself out, releasing latent devils to inflict untold emotional and psychological damage whilst parents, or local authorities, envisaged we were taking virtuous strides forward.

My acceptance into the school was on the understanding that I would become a Roman Catholic but an injudicious, insensitive attempt to nudge me in that direction by the Head Master seriously backfired. Although early stages of mysticism were developing me, Roman Catholicism was not a comfortable fit at all.

As someone who in later days would be included in the reason for the death of Sid Vicious by way of providing him with what may have been has last heroin fix, this is ever important through complex theology. From the mental dungeons of Prior Park it was not more than a skip and a jump to embrace punk and to revel in recording its cultural influence and effect through the lens of my camera. My inner lens focuses on the acuity too, and as William Blake, approaching death held out his open hand and heart to the Church, so do I wait in silence to hear another unseen voice from afar to liberate and protect me from error, climbing upwards towards infinite grace and whilst doing so shed the weight of my earthly travails.

THEN CAME
VICIOUS
R&R.

—

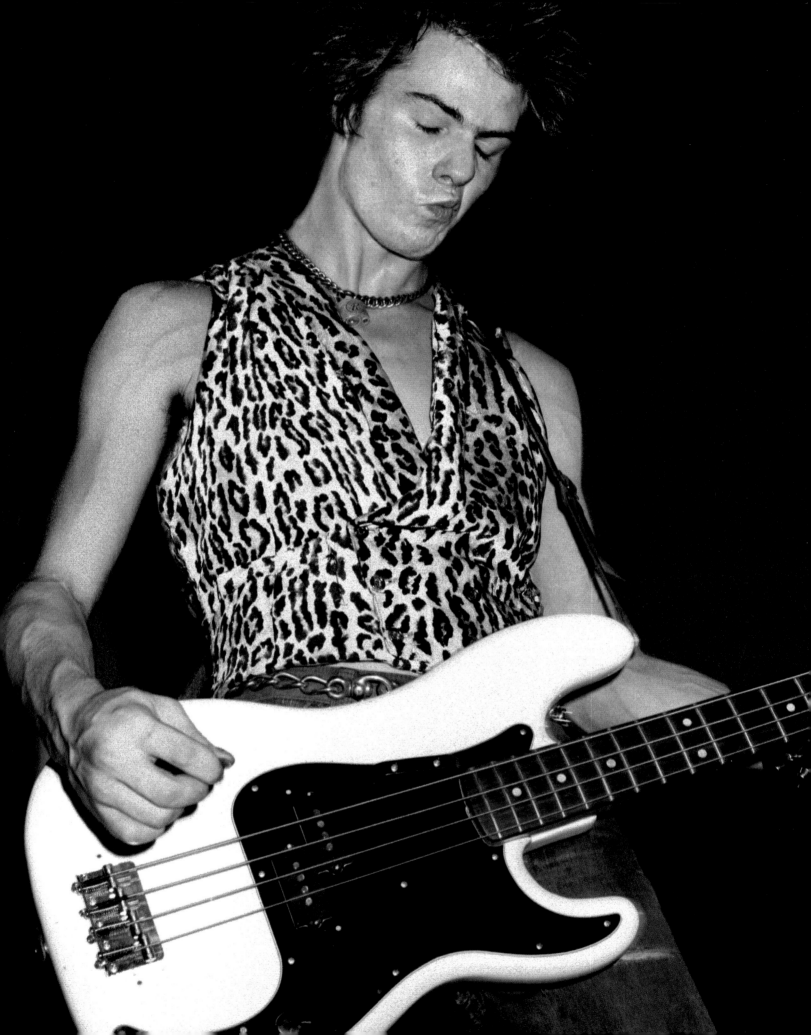

DAMNED IF I DO
DAMNED IF I DON'T

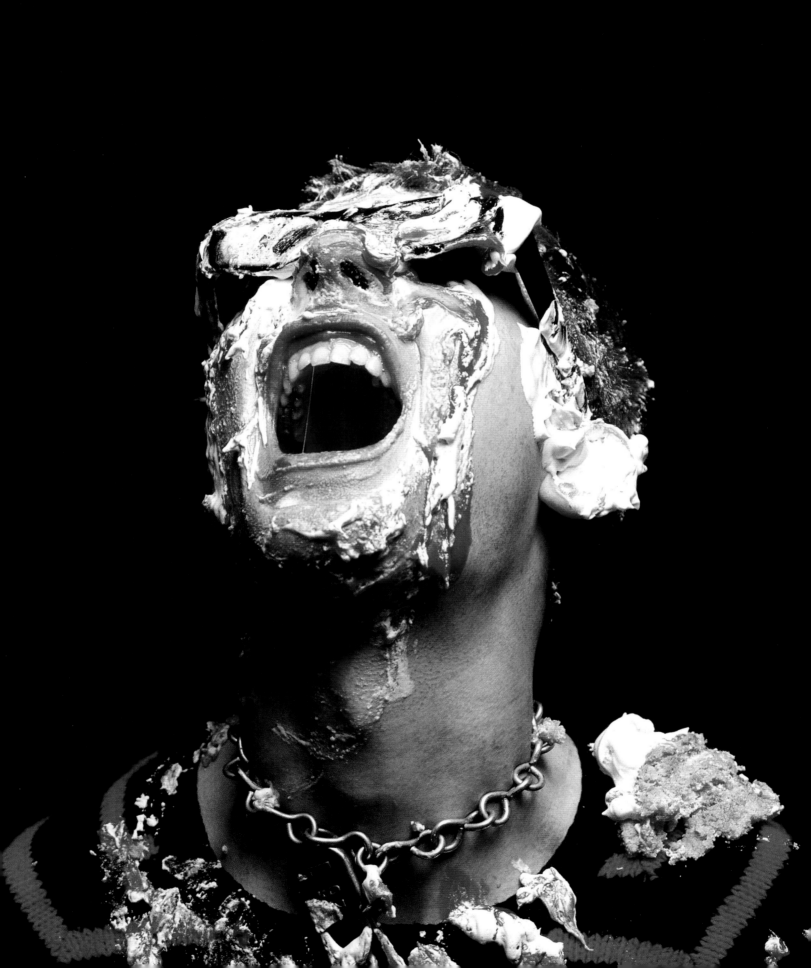

KODICK

'Change your name, change your fate.' Cree Capone

It's 1980 and I can't remember my name. Well, to be precise, I can't remember who the person that I'm about to talk to on the phone knows me as. To quote the Stranglers, 'Something better Change.'

Let's go back a few years, and I will try to begin to explain how this 'state of confusion' began.

It's 1976 and I am in London.

"Can you take some photos of my boyfriend's band?"

Photographers are always being asked favours. Of course they had no money, weren't used to being in front of the camera and their appearance, without the aid of stylists, hair, or make-up, was more than likely quite dubious. The reason I agreed was probably more down to the person who asked me, a one Miss Judy Nylon. Judy was to become one half of the band Snatch, along with Patti Palladin, my first wife.

At the time I was an up-and-coming photographer in London already making a name for myself in fashion and advertising. To refer to Judy as just a model would be doing her an injustice. She had worked for me in a model capacity before, as well as doing styling and research. What I liked about the darker, more thoughtful Judy - as compared with other models I had worked with at the time - was her real love and understanding of photography and its short history. I agreed to take the band's photo on the premise that I would be given complete creative freedom. I wanted to make sure I was going to get something out of this myself as I would be footing the studio, film and processing bills.

But unbeknown to me, I had just opened Pandora's Box.

Music has always been a driving force in my life. One very close to my heart if not my very being. To say pop, or popular music was in a bad state was a bit of an understatement. Groups like Yes, Emerson Lake and Palmer continued to bore nearly one and all. Rod Stewart sang about whether we thought he was sexy, and of course there was the usual top 20 mix of disasters. Indeed, when I think back, I remember Leo Sayers' first album as being a breath of fresh air, and to regard that as a highlight is hardly indicative of a healthy music scene.

Soon after, I found myself at The Nashville on North End Road being subjected to a 45-minute speed fest. Nearly over before it had begun. I guess I had just been at my first Punk Rock show. The Damned.

The premise of my shoot was to be 'pie in the face'. Why I chose that I'm not entirely sure. Perhaps I was looking for a dynamic collision, or just good colour combinations in my 'arty' photos. Start talking art and you might end up bankrupt. So let's talk commercial. These photos would be used for something. I needed to get my money back. Solution? Make them too good.

The day of the shoot problems were few, except for not being able to find any pies despite the help of two very clever and industrious stylists. Change of plan: buy me flans, some ketchup, mustard, and shaving cream. Unfortunately the shaving cream was mentholated, and that stings. An amusing photo session.

Jake Rivera, or Andrew Jackman, (same person) signed The Damned and opened Stiff Records with Nick Lowe. A record cover is needed and I get together with old Glastonbury and Pink Fairy ultra-hippie Barney Bubbles (who, unfortunately, is no longer with us. He produced all of the Stiff Records graphics, concentrating on Elvis Costello, (for whom he created many wonderful record sleeves.) Barney and Jake loved the photos I had. Barney said he wanted the front cover to look like it came out of a mechanic's garage. I, somewhat shocked, agreed. We formed a company together 'Exquisite Covers' where we would push out the commercial work.

I started work for Ted Carroll and his producer Roger Armstrong of Chiswick Records. I was starting to learn the Music Biz from the bottom up. You could have a mediocre record but package it in a first-rate picture-sleeve and put in the right record stores, you could still guarantee fairly good sales. Once in a while you might just get lucky.

I used other names. Hugh Heffer comes to mind. ('Dirty Pictures' by The Radio Stars, Chiswick Records) I shot Johnny Moped, The Count Bishops, Gene October and Chelsea. Chelsea was for Miles Copeland and his new Step Forward label, the CIA family whose brother formed The Police, who I also shot a cover which features Stewart Copeland on a block of melting ice. A lateral thinking conundrum. I was more worried about the chance of him hanging himself. No health or safety problems in those days! Going back a couple of months, The Damned LP was released with the dubious honour of being the first Punk LP release in Britain.

"What name do you want to use Peter?" Looking back I fear Barney and Jake bullied me into using a Punk name. I came up with Kodick, an obvious play on Kodak. With that move I found myself regarded as a Punk Photographer. At least with the people who would know me for working under that name. For my more conservative fashion and ad clients I would remain Gravelle. Punk was beginning to break out and all those record companies would need a Punk Photographer to capture their new Punk signings. I was also helped by the press who would run stories of those filthy Punk bands spitting at photographers and even destroying their studios. Other photographers weren't keen to get their studios smashed up so I had free rein and could virtually ask for what I wanted to do.

The taxman must have loved us. We had Rat Scabies, Johnny Rotten, Billy Idol, Captain Sensible, Polystyrene, and so on. Thanks to Malcolm McLaren, punk had broken in a big way. His 'enfant des terribles' the Sex Pistols came with a surge that promised much, made sense, and was relevant. Everyone in the music biz watched on as the Sex Pistols took on the record business and practically the whole establishment. They were dropped by EMI after only one single release. They had Sid Vicious join the band and his first appearance as a Sex Pistol was signing a record contract with A&M.

Two days later they were £75,000 richer but still without a record label. It was an ex-hippy, Richard Branson, who, in expanding his record company with his second signing after Oldfield's Tubular Bells, came to the rescue. Virgin finally had a direction and the Sex Pistols had record distribution. An ideal situation for both. The Roxy Club opened and everybody had a place to go, to watch bands and chill.

You started to see the same people all the time. Everyone was thinking along the same lines. A communal right or wrong rested on everyone's shoulders. In reality we had about three months before it was ridiculed and ruined by a popular press who tried to reduce it to its lowest levels. Let's look at the safety pin through the cheek crowd, ha, ha, ha, ha. In the end, Punk would implode in on itself, fuelled by a growing drug problem, namely heroin. But for the moment it was the definite force in music under which many a talented band would walk through the door of.

Clients of mine where Virgin, Polydor, Phonogram, CBS, and virtually every other label that signed their token punk band. The Jam, Chelsea, Generation X, Johnny Thunders, Joe Jackson, The Police, Penetration, The Damned, Elvis Costello, John Cooper Clark, The Boys, and even The Nice and Humble Pie, plus many more used my imagery on their releases.

This set of photos celebrates not only the early days of punk but also other favourites of mine that might be regarded more as pub-rock. Despite dealing with virtually all the so-called punk bands of the time, it is not a complete catalogue, but a selection by me of the people that I thought were interesting. I have always hated categories. Especially putting musicians into categories.

Included are my travels with The Sex Pistols in the days of Sid Vicious. Looking back at these photos I feel it is quite remarkable how fresh faced the young Rotten in particular really looked. He would hardly be considered to look a public menace today.

My involvement with The Sex Pistols, and Sid in particular, features strongly in the film and DVD releases, 'Who Killed Nancy' by Alan Parker, and 'Sid Vicious by the People Who Knew Him', directed by Mark Slooper.

After Sid died, I returned to London and carried on with my photography, but I stopped doing a lot of music work. I had become pretty disgusted with the music business by then. I'd seen too many people so blatantly and obviously ripped off. There are people in the music business who don't give a shit about anyone, as long as they make their money. That's all they were interested in. Then it was on to the next band. Sid was a victim of this culture. Music can make you rich, but it's a filthy business sometimes. Maybe Punk had been reduced to the size of your trouser leg, a question of whether you wore flares or drainpipes. Malcolm, Punk's forerunner, had helped hammer the final nails into the punk coffin, in his dealings with Ronnie Biggs.

To get back to my telephone conversation, I think it was time that I knew, and others knew with whom they were talking. Like Punk, Kodick had run it's time, fashion was to become my king. I left London via Los Angeles to Milan, which became my base for the next 20 years, during which I travelled and worked extensively in North America and Japan.

What seemed to have happened during those four short years, was to prove more than a passing fad. This was to be highlighted to me endlessly during my journeys by the continual amount of people telling me of their love and interest in Punk. It wasn't until my return to London in 2000, that I was to reopen the files that contain the work shown in this book, mostly for the first time. I'm glad I did as it made me remember a time when, like or dislike it, change was allowed to come through. Now as we reach a time in the present when we will be forced to re-consider and re-invent our place and position in this world, maybe it's a good time to remember a time that did just that. Punk and its influence still carry on today. Virtually every musician of worth will cite a Punk band as a major influence.

I just hope we can take it a bit further next time around. Change a few more things for the better than we did last time. Most importantly make people think. Please enjoy the photographs. I hope that they will bring back some fond memories.

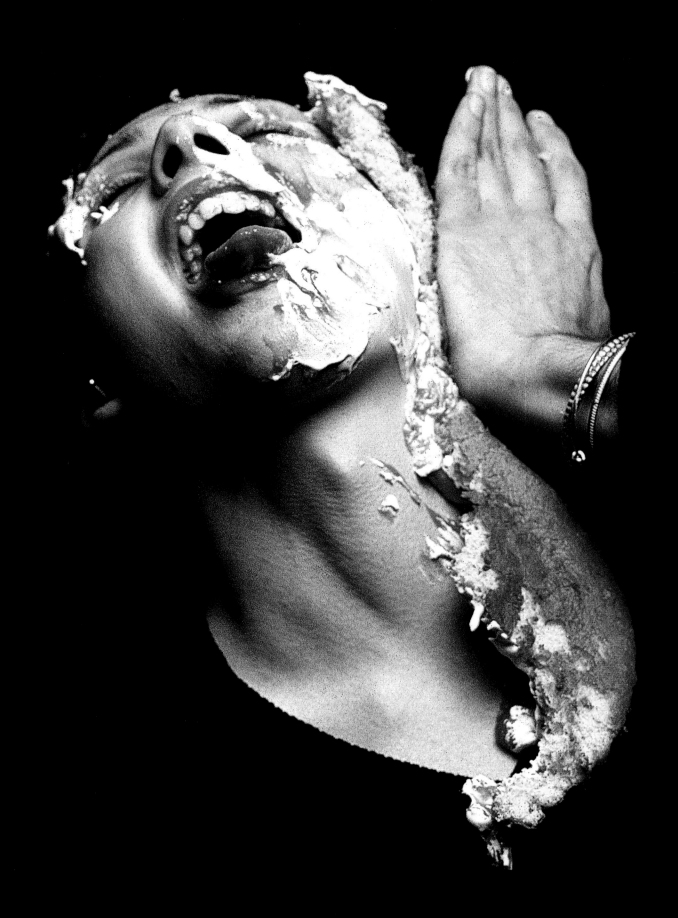

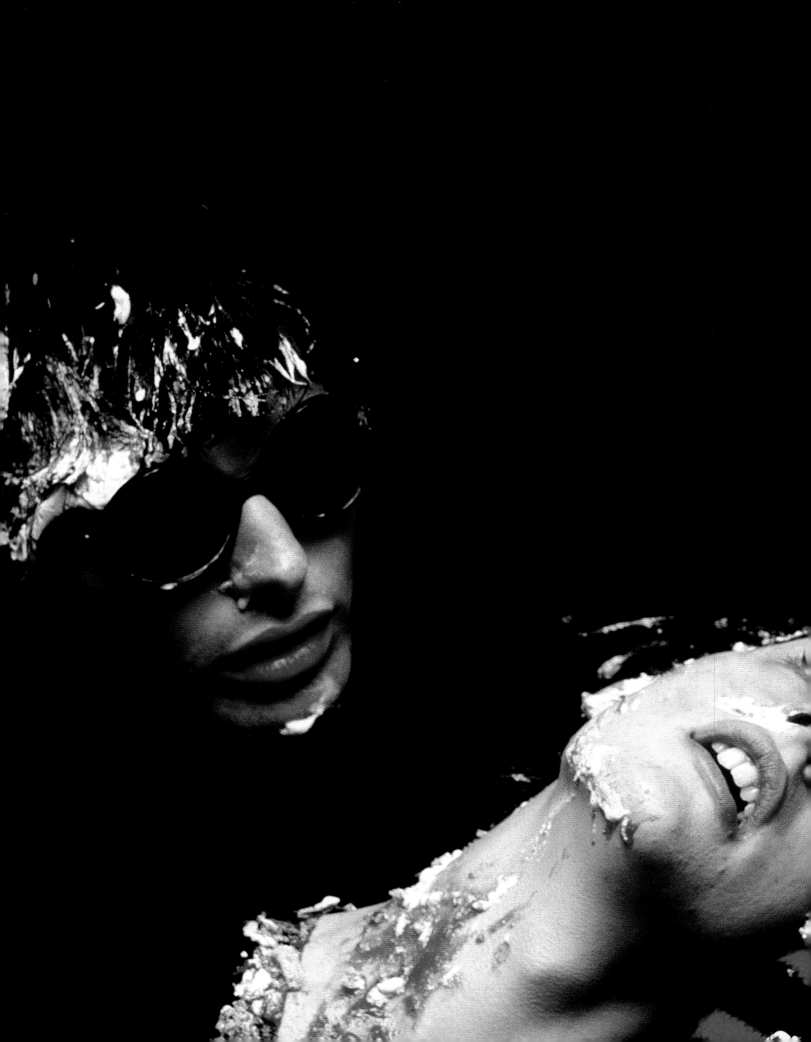

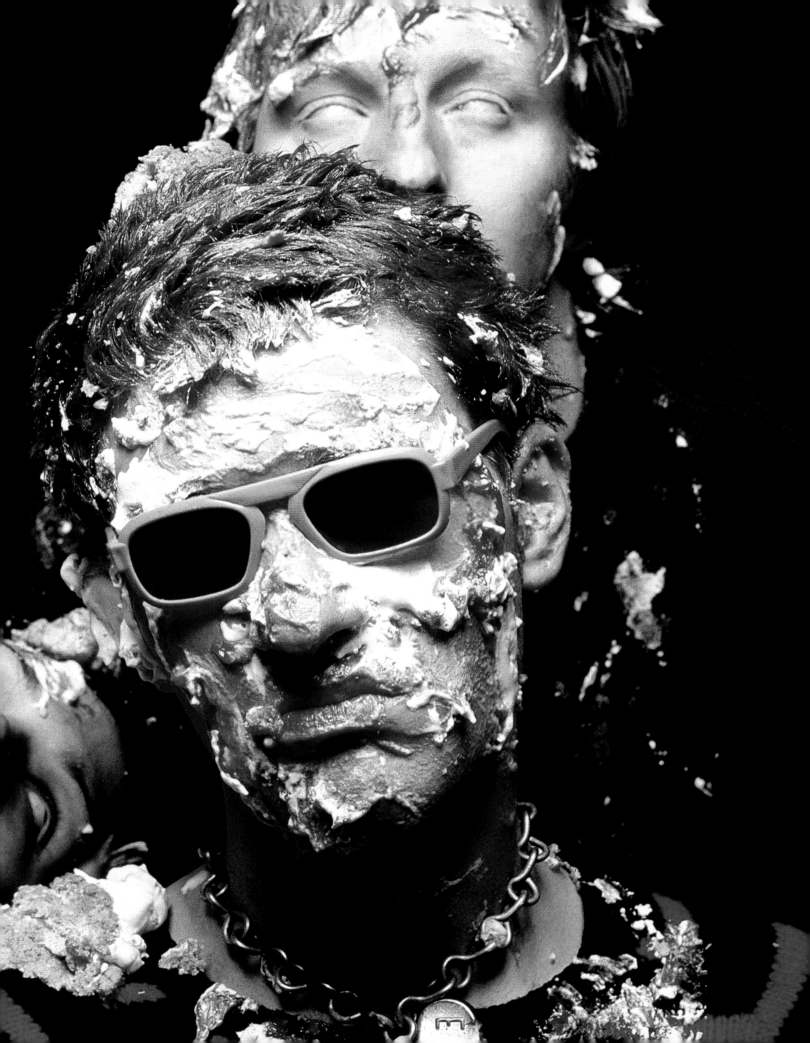

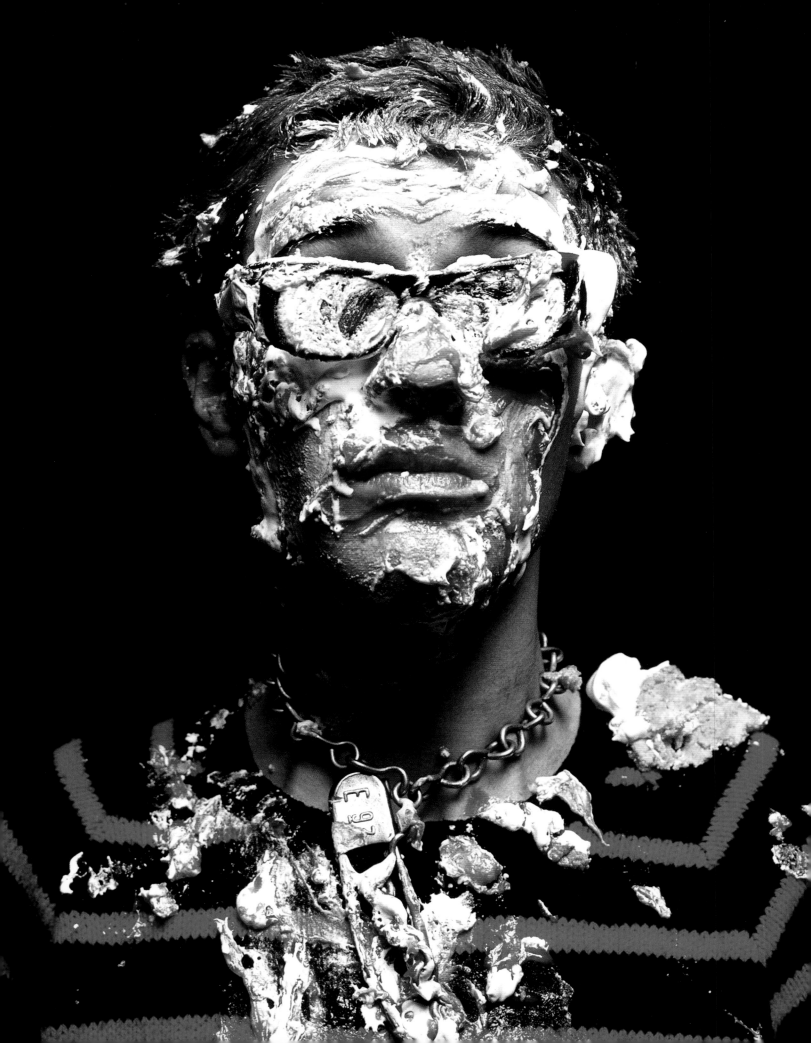

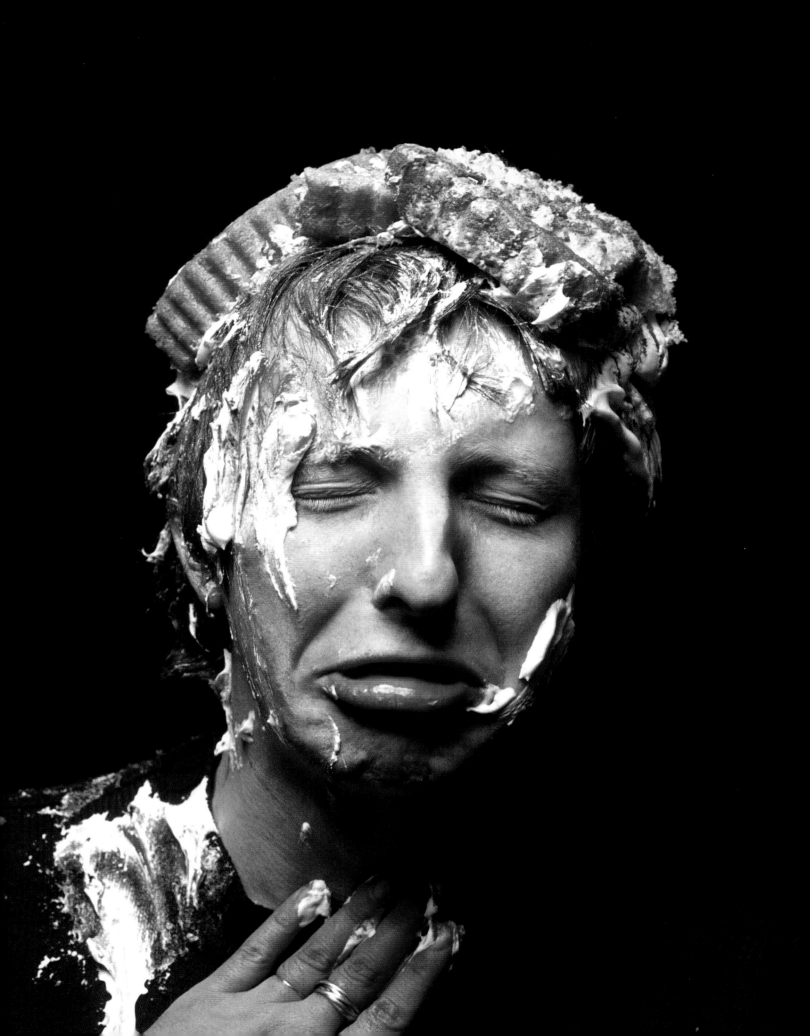

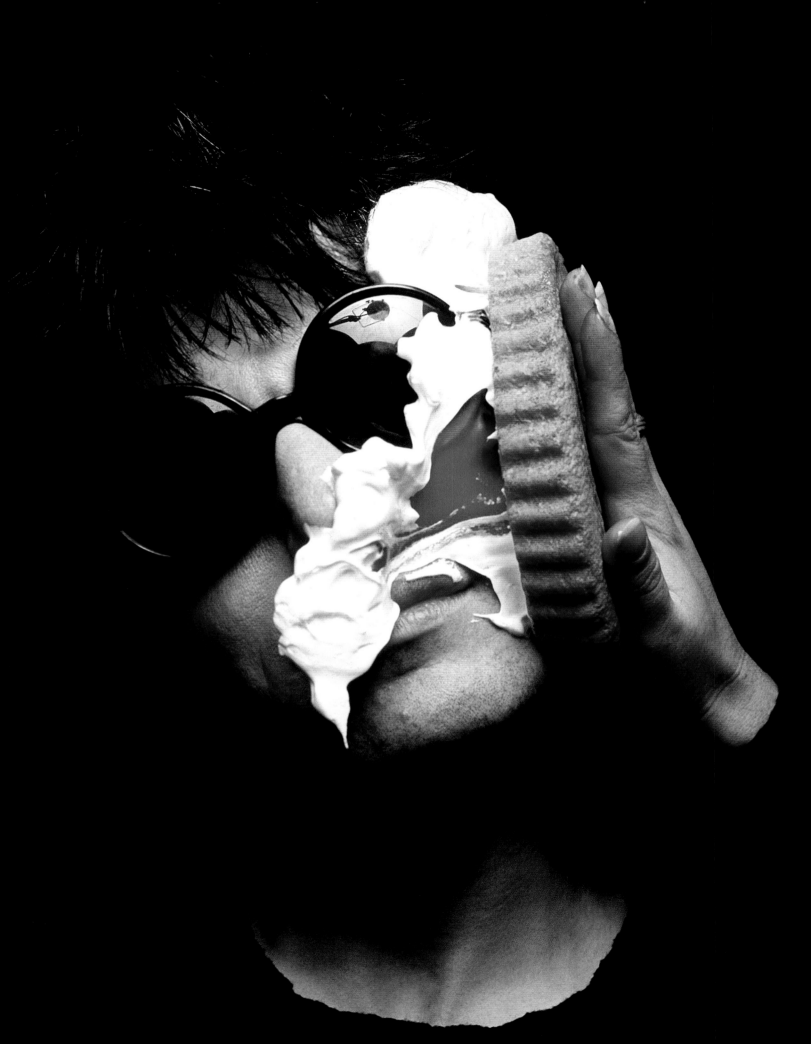

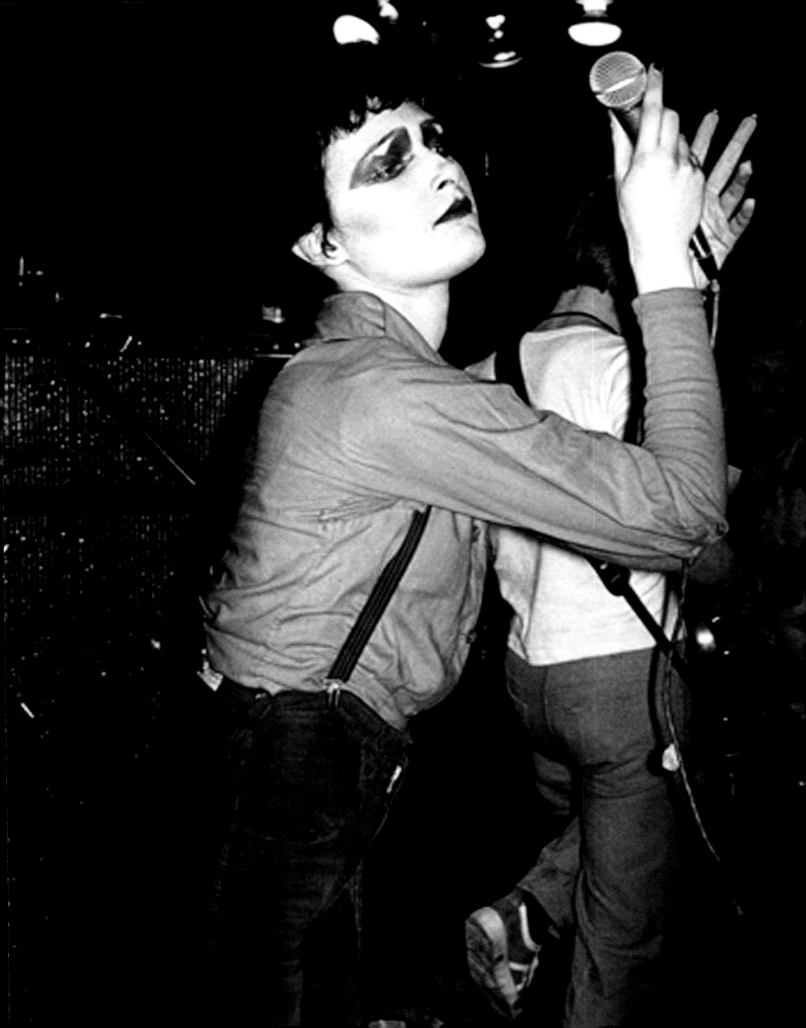

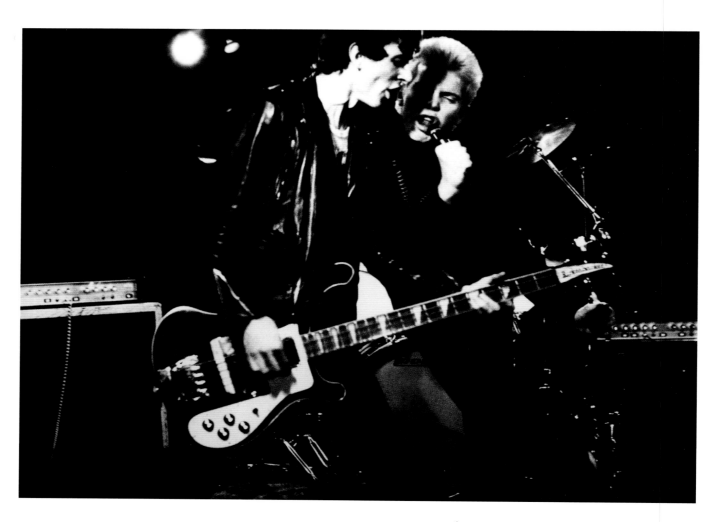

GENERATION

NEXt

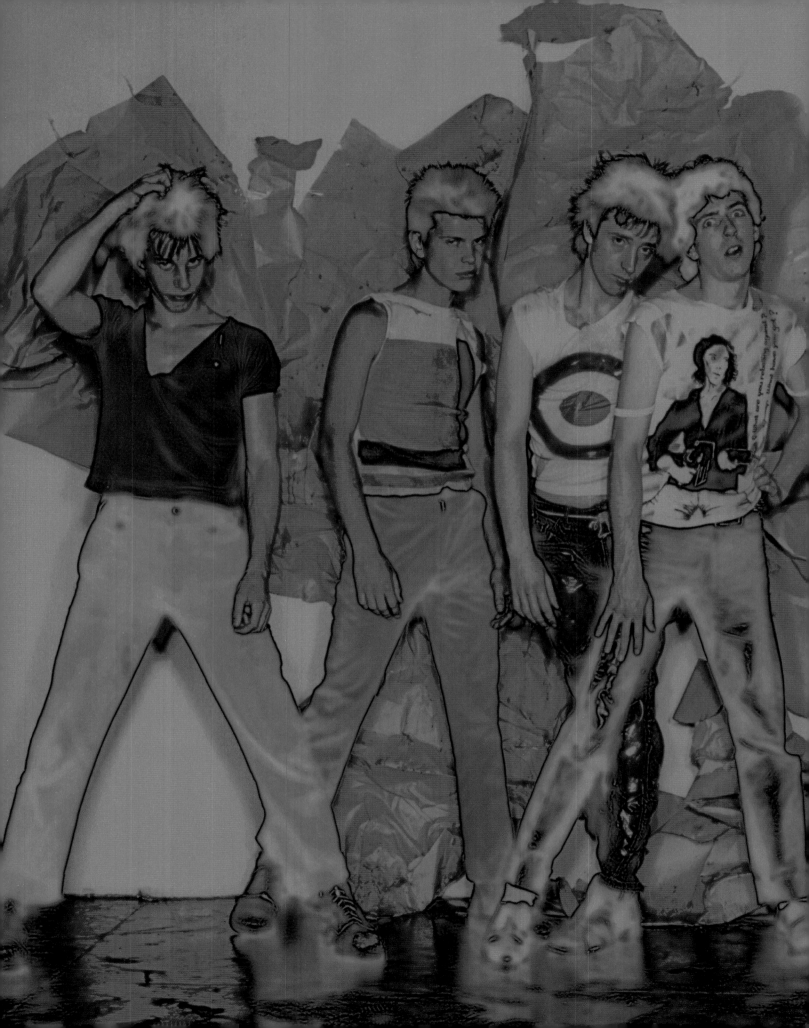

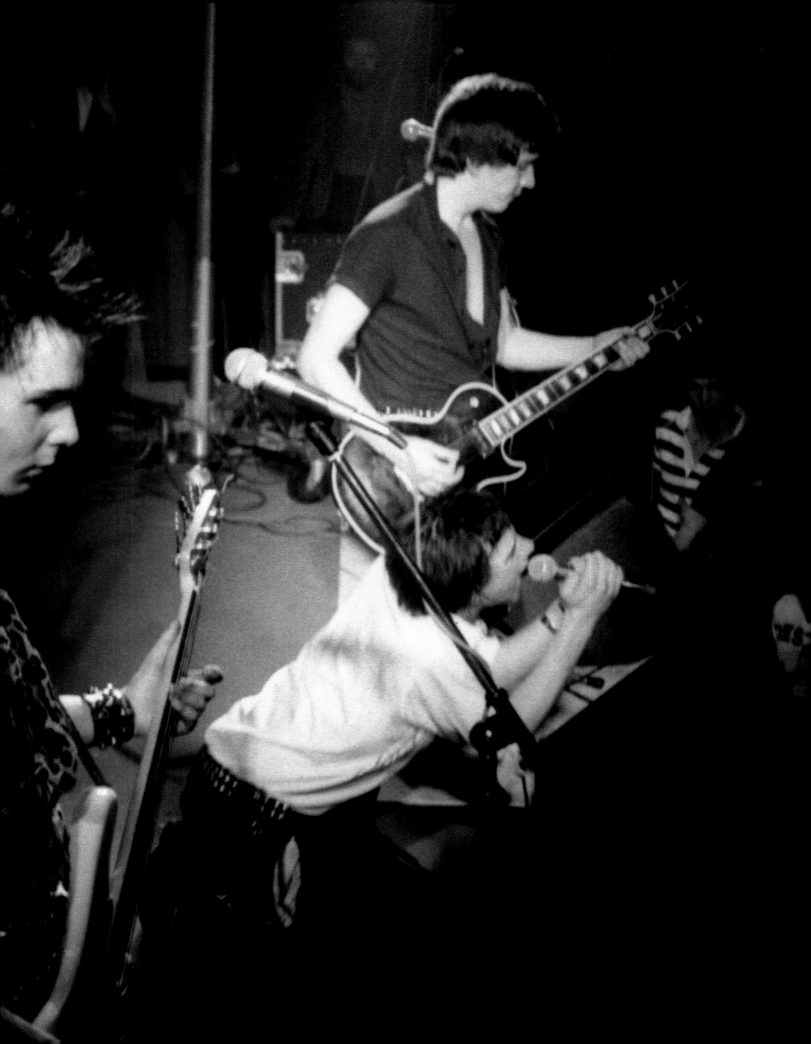

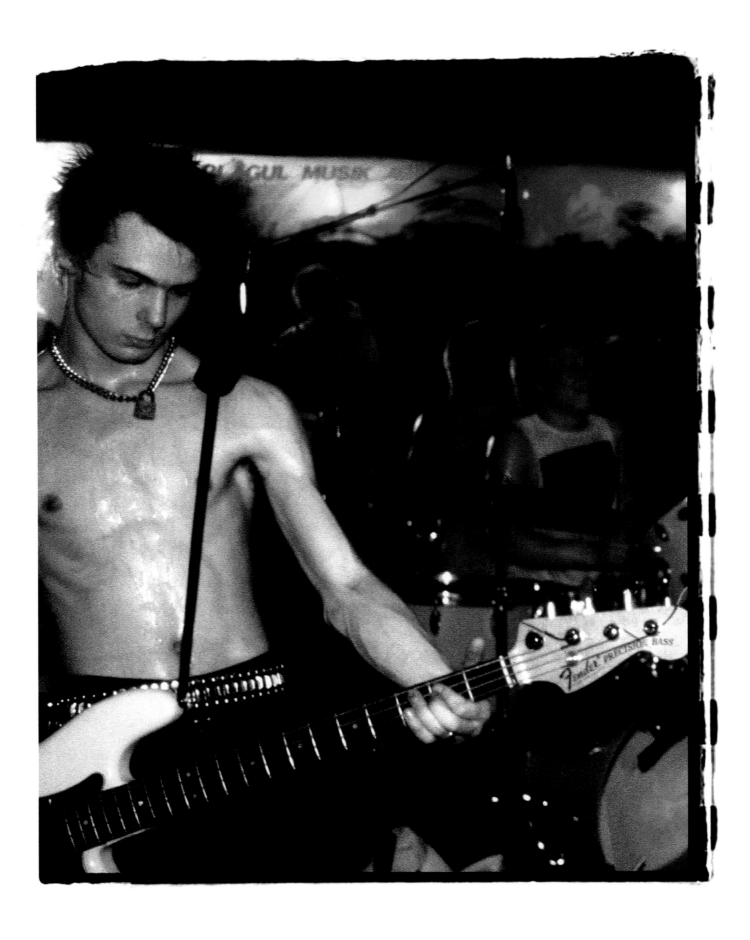

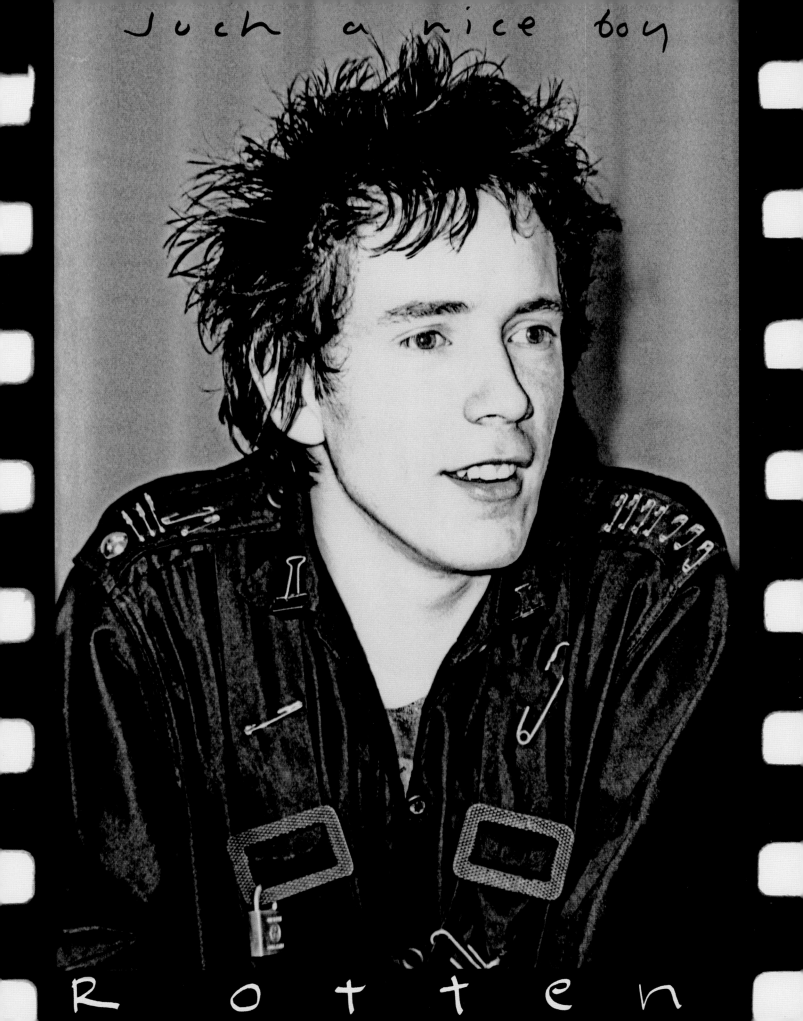

Such a nice boy

Rotten

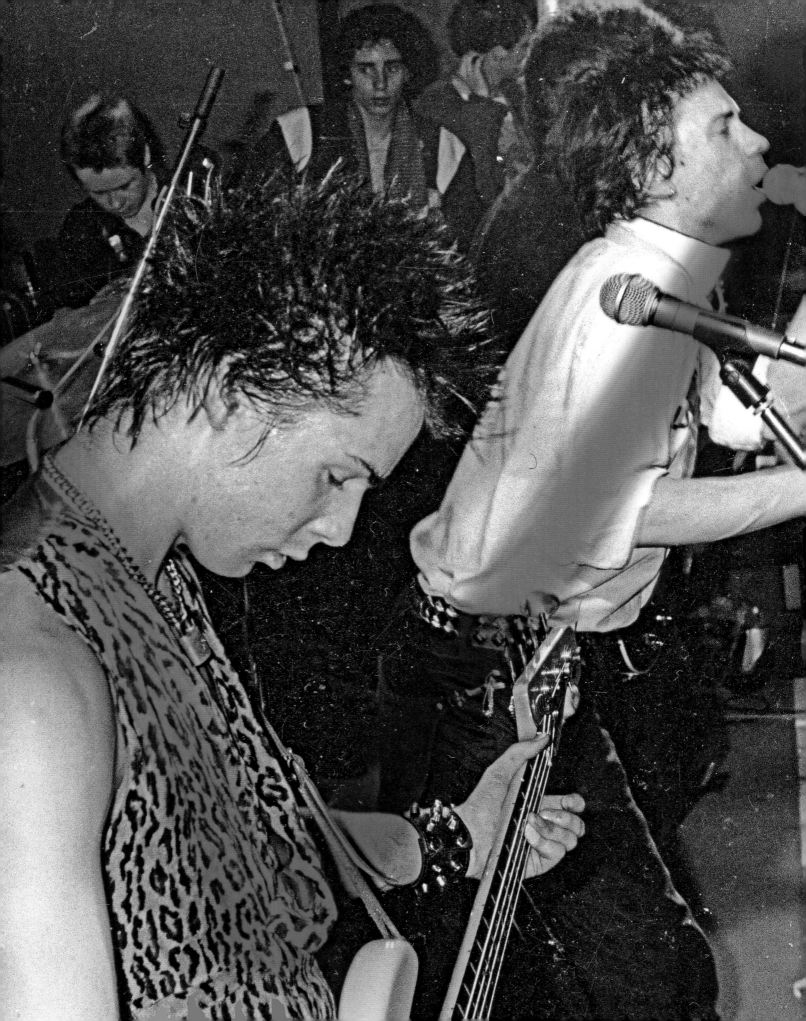

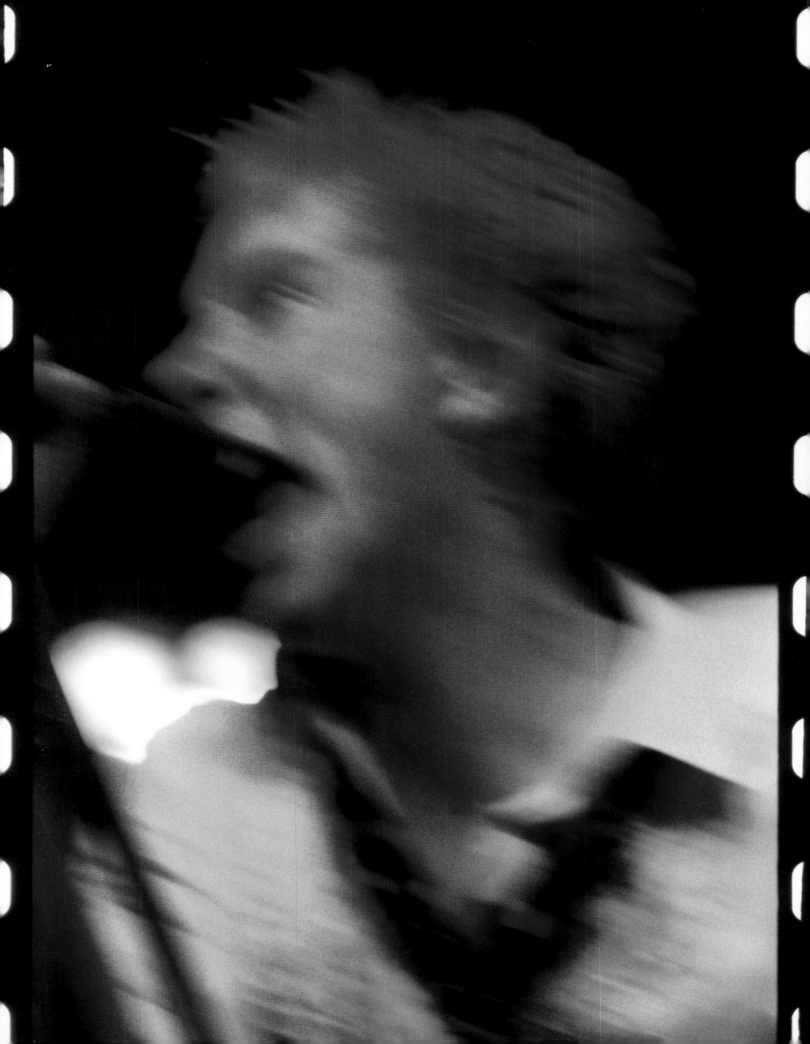

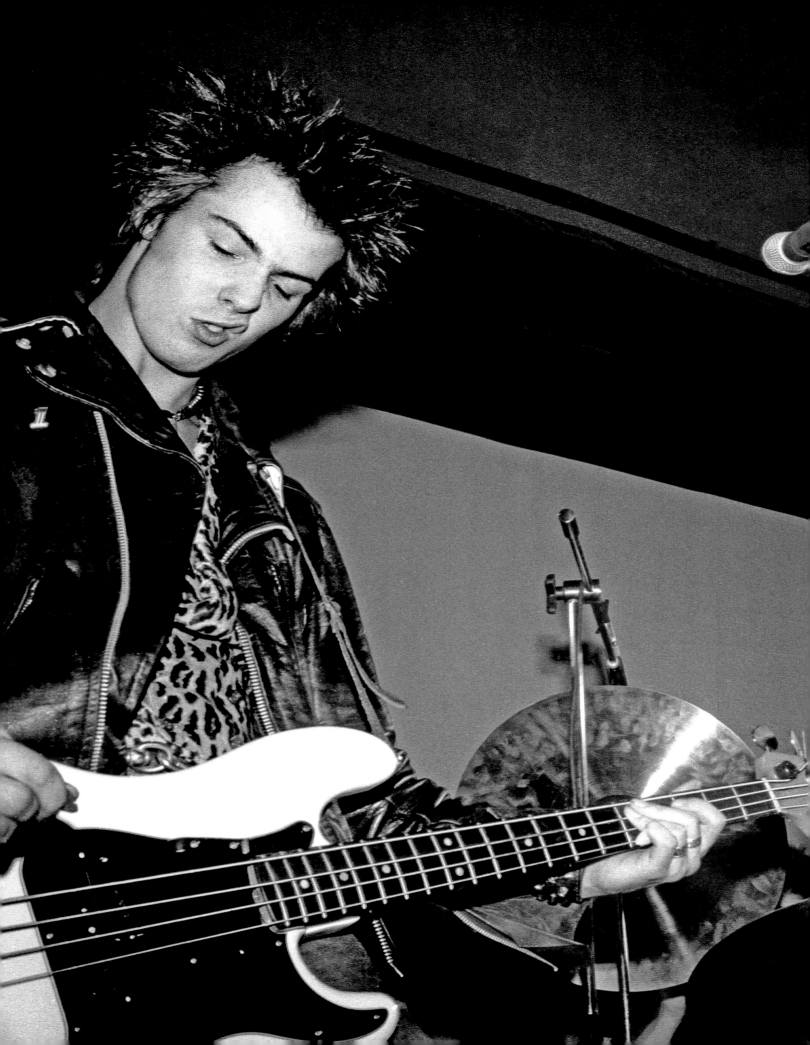

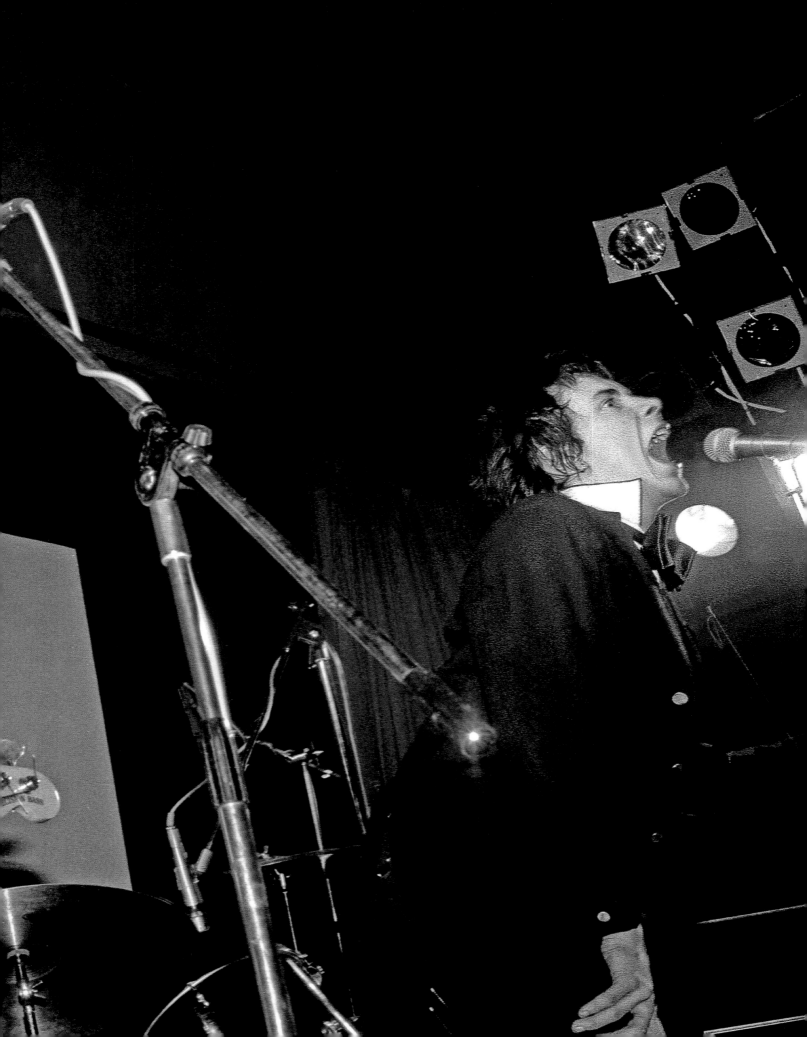

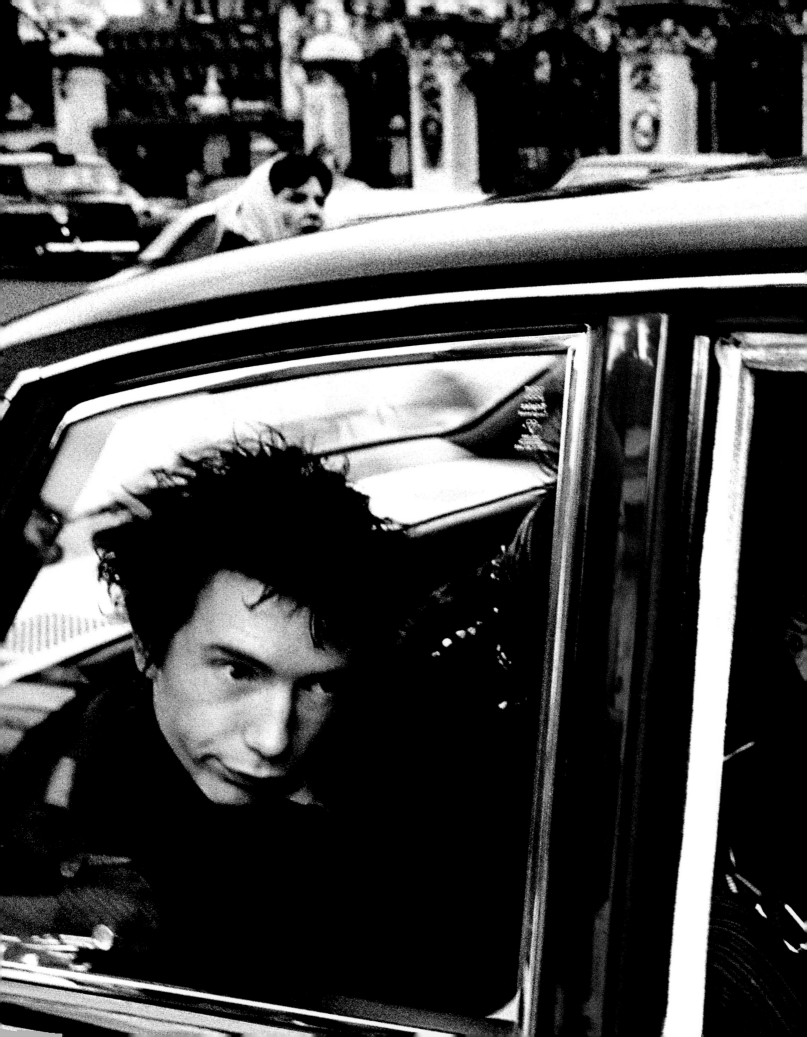

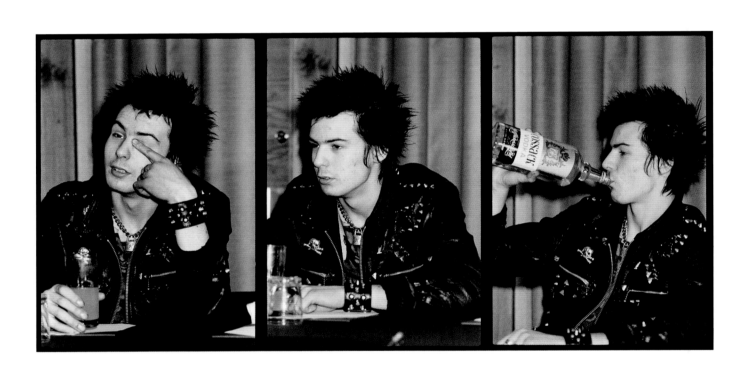

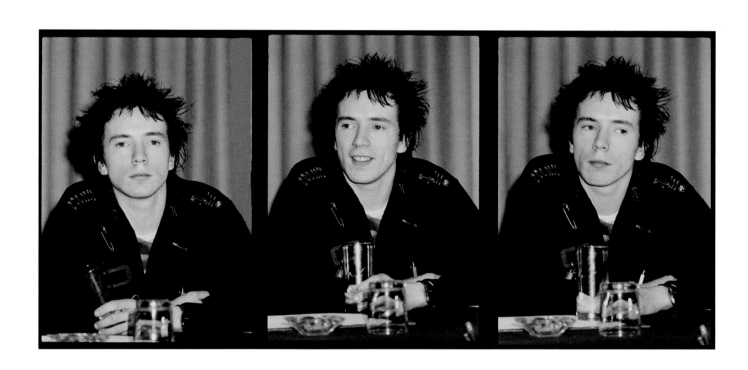

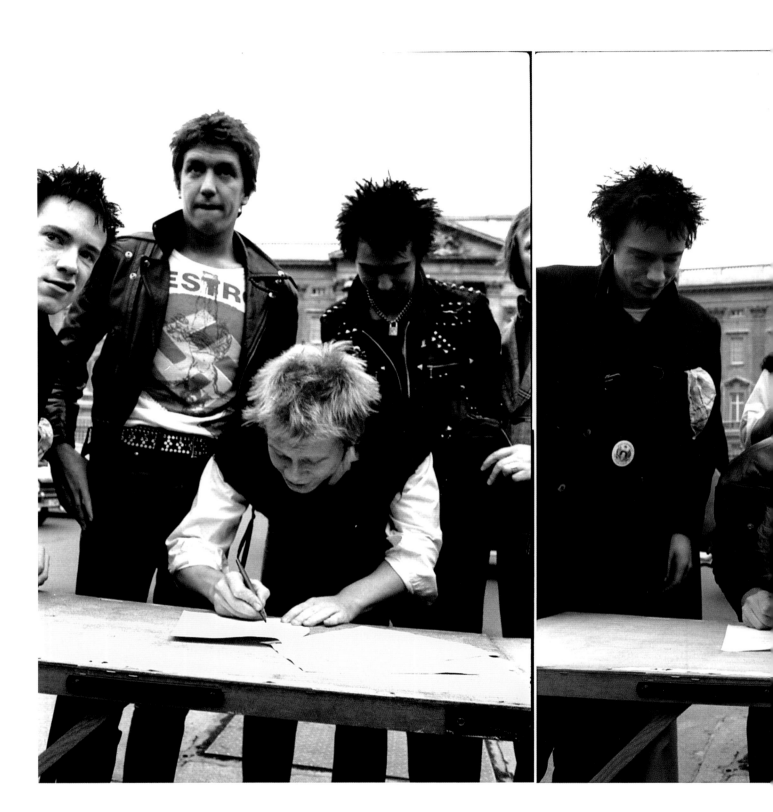

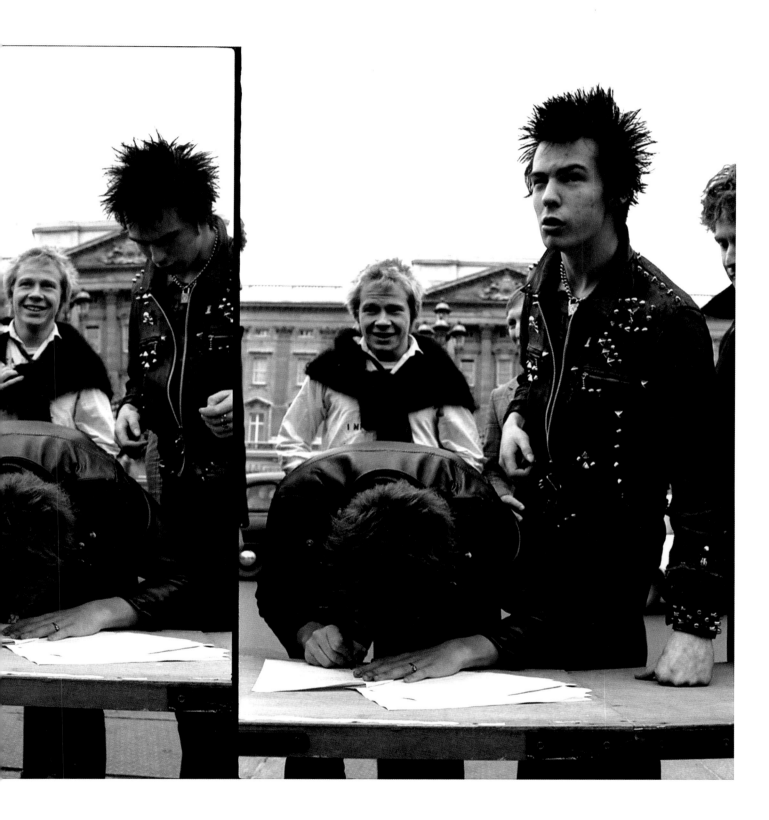

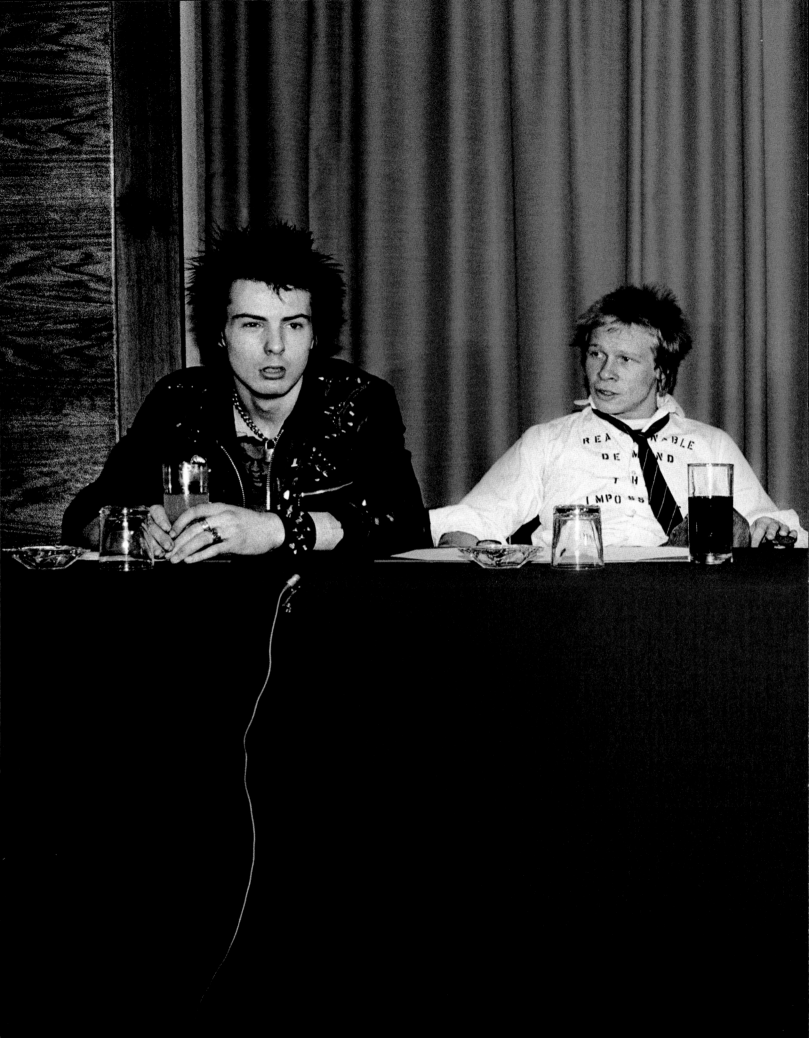

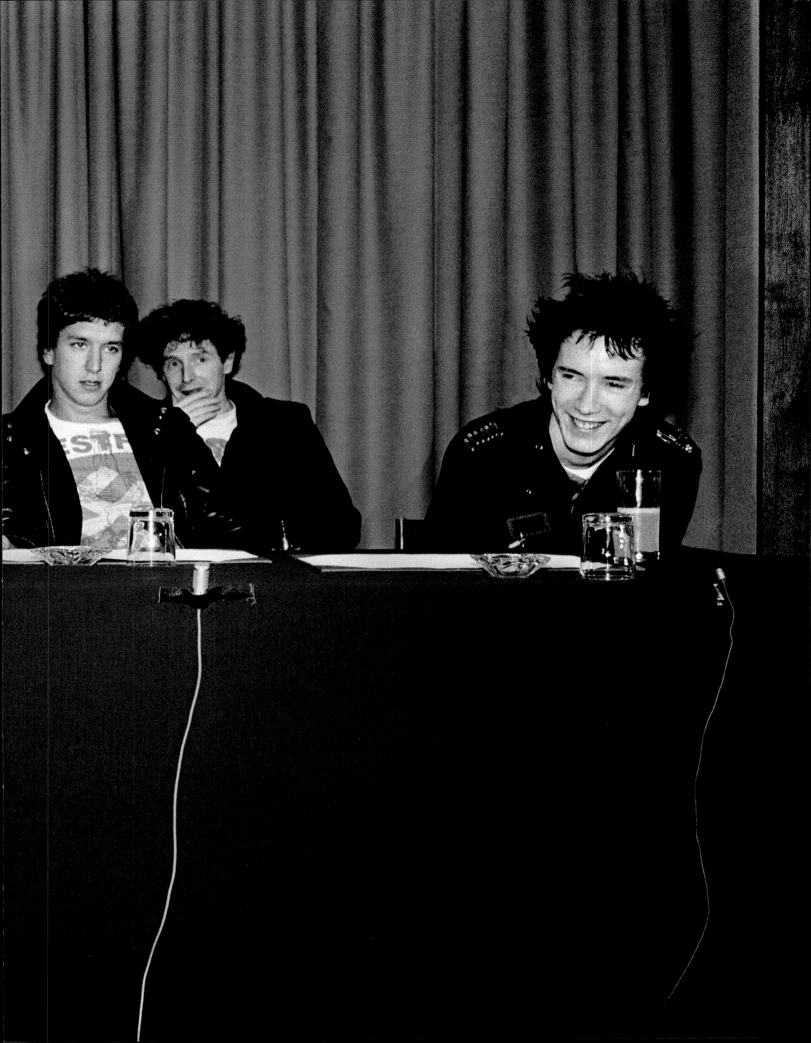

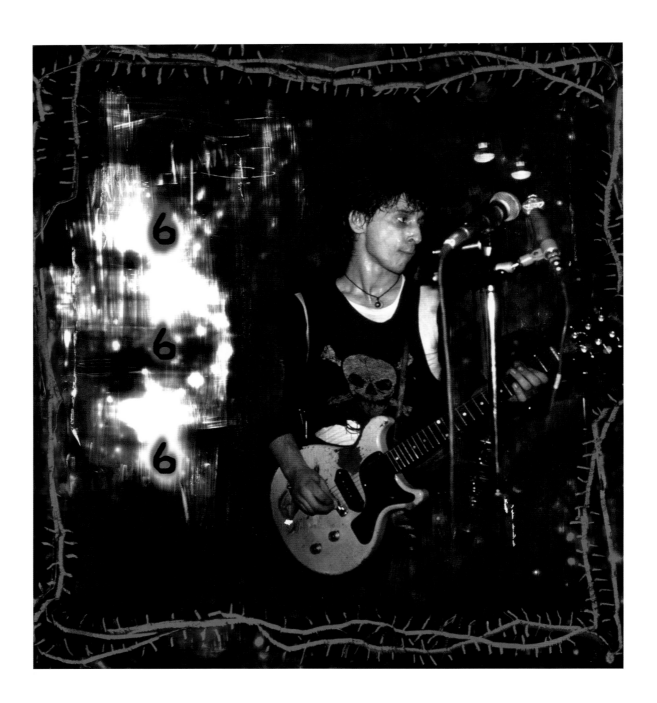

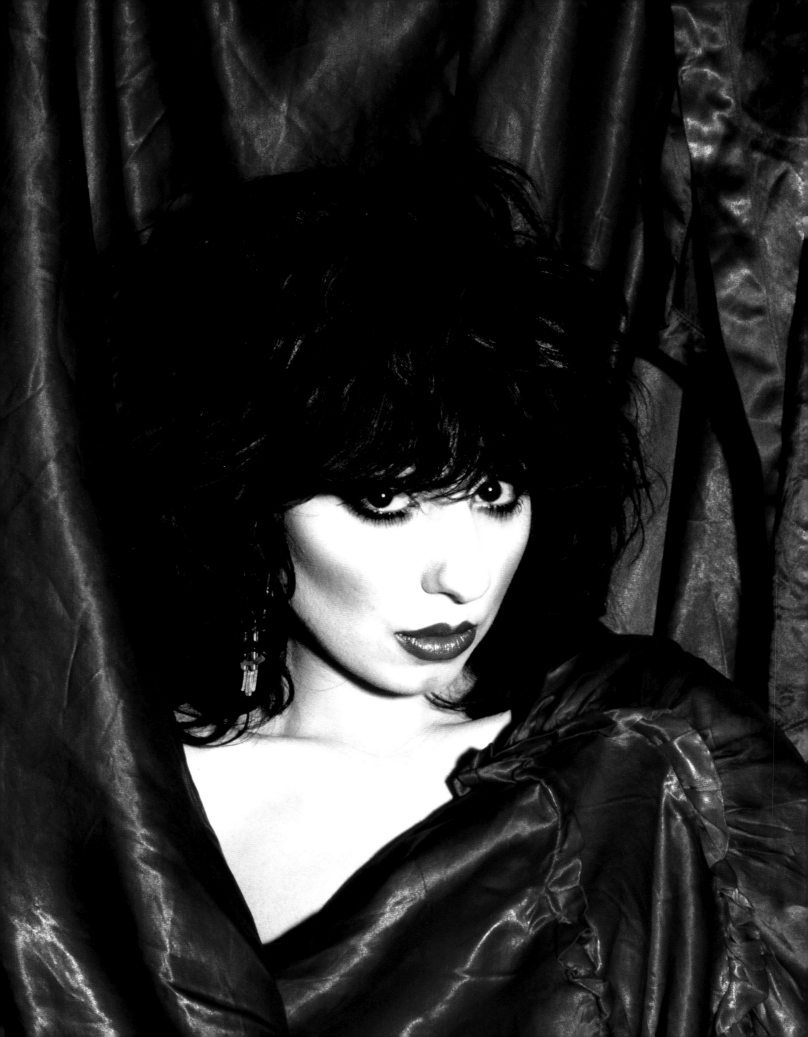

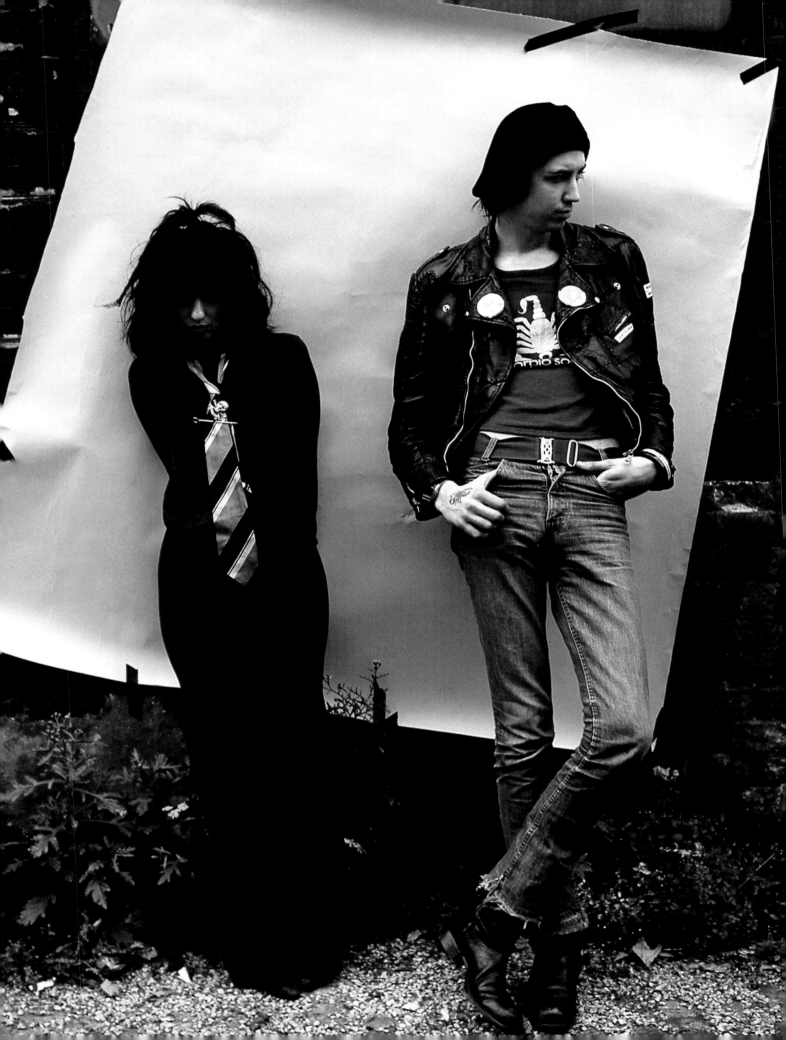

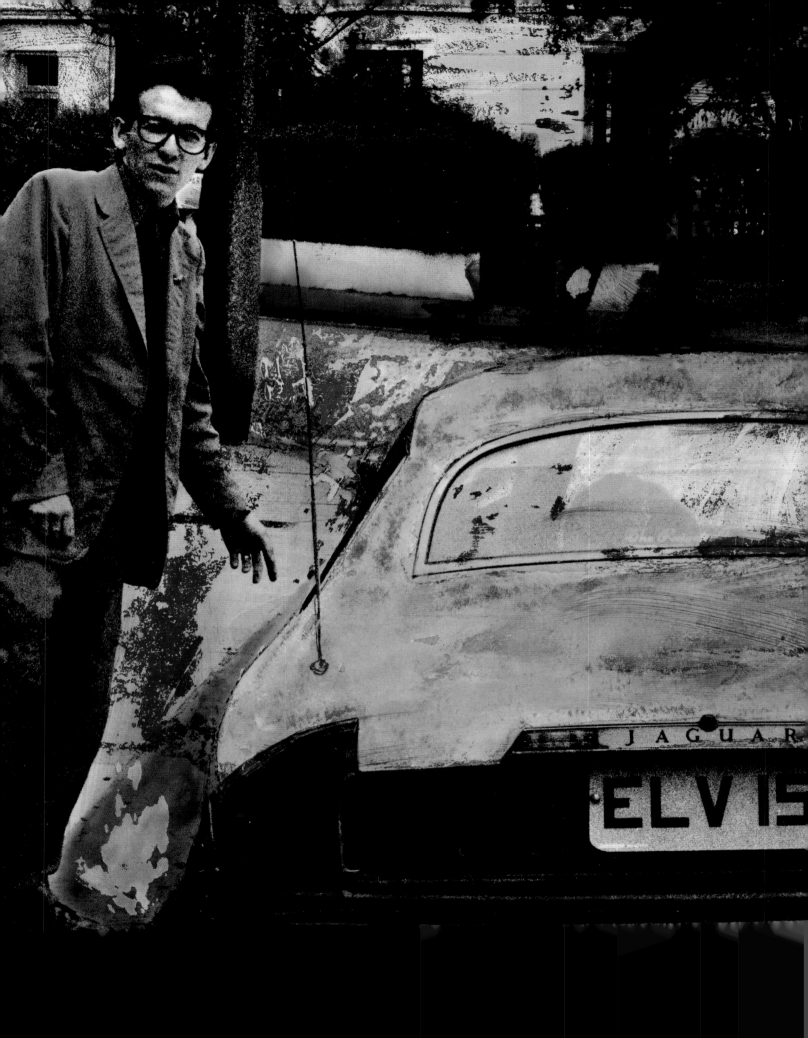

Lust Not Life

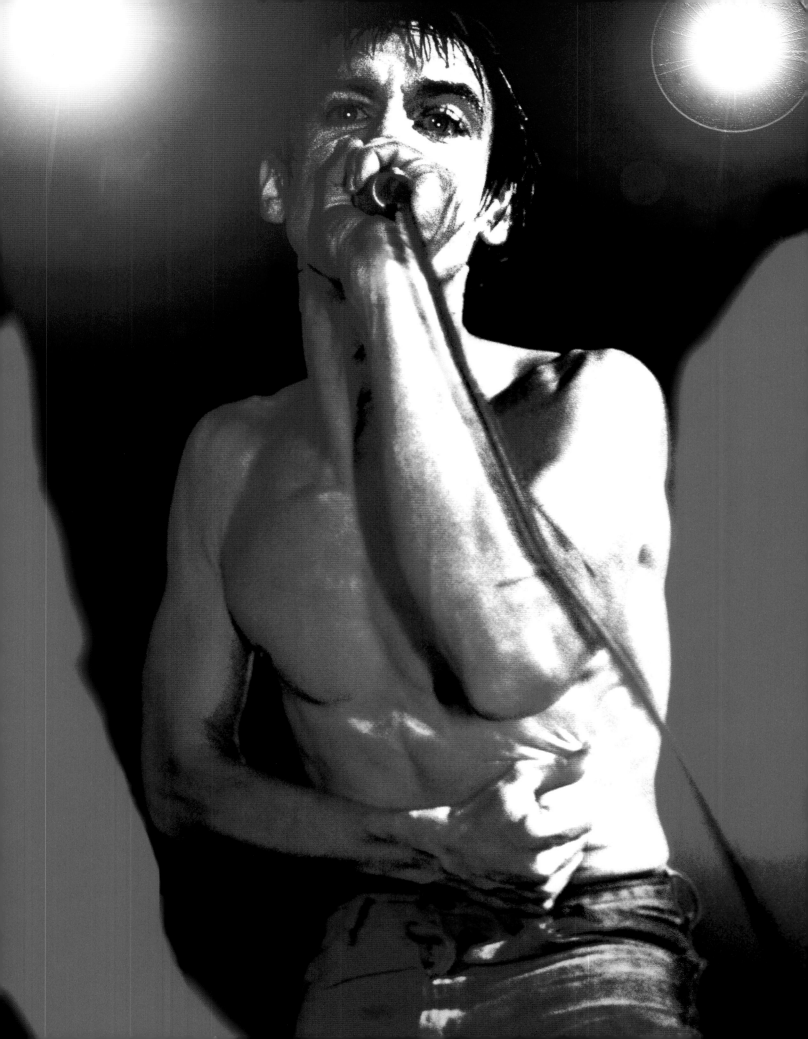

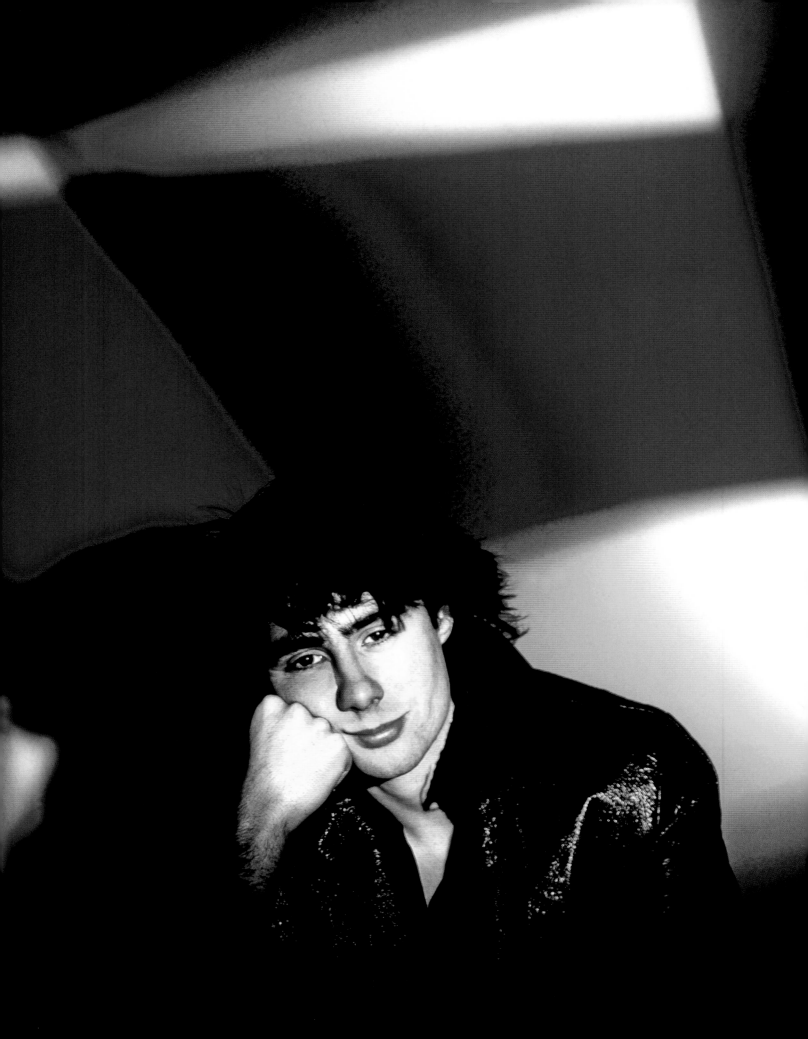

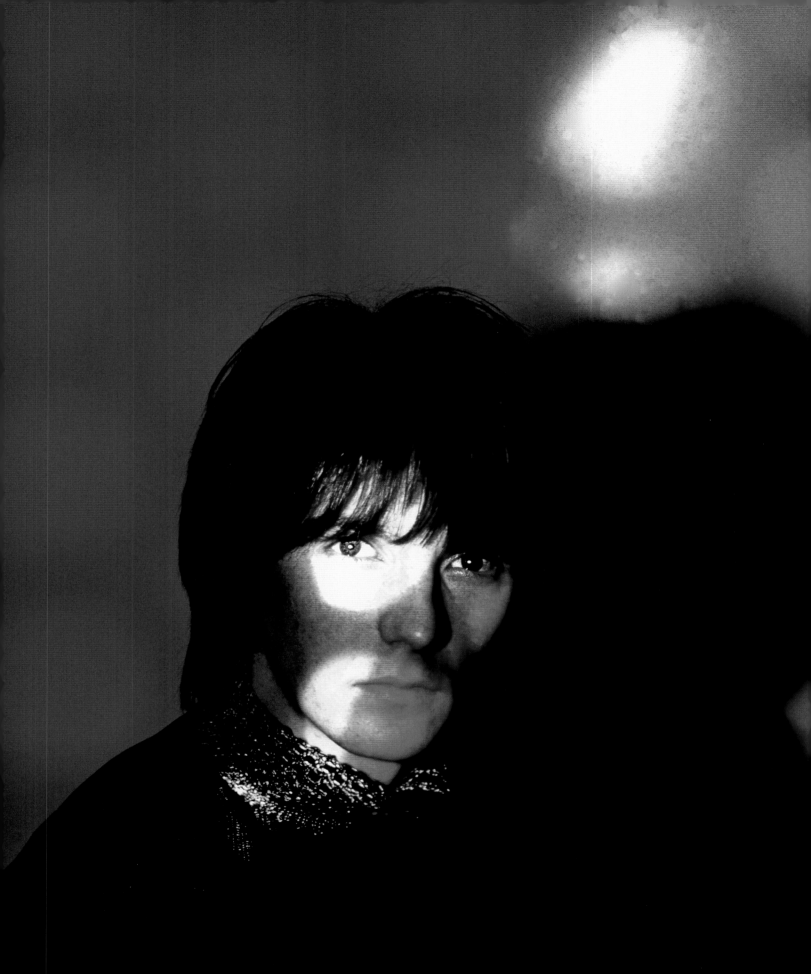

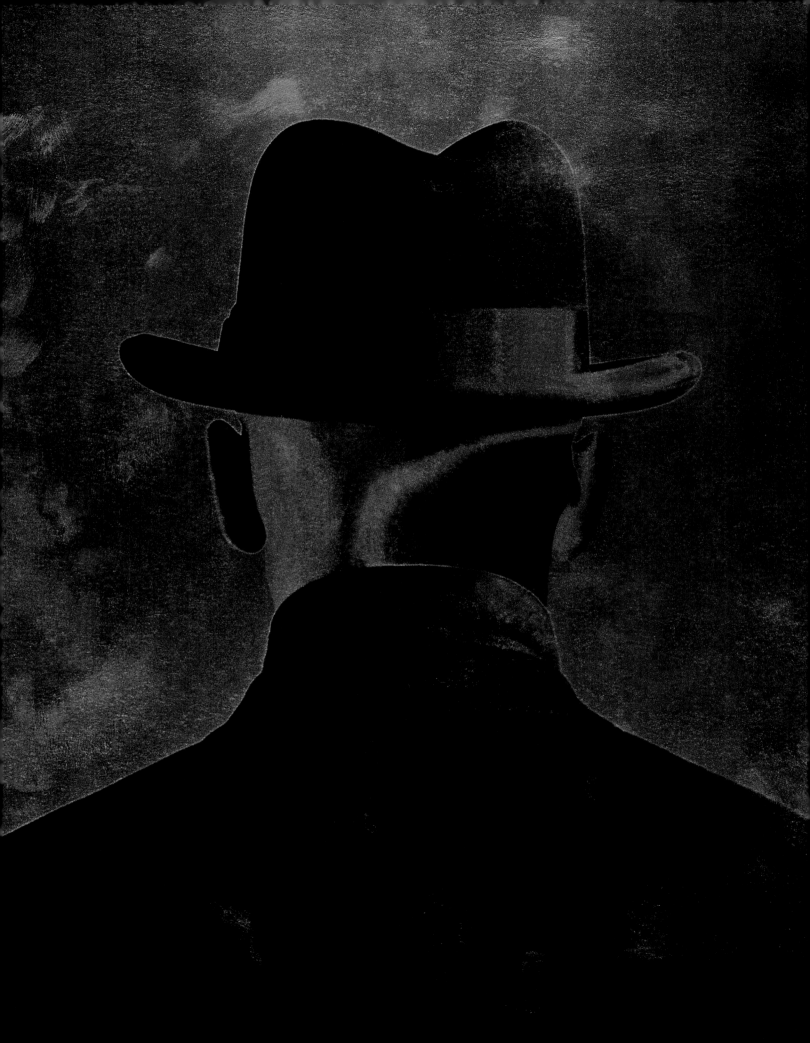

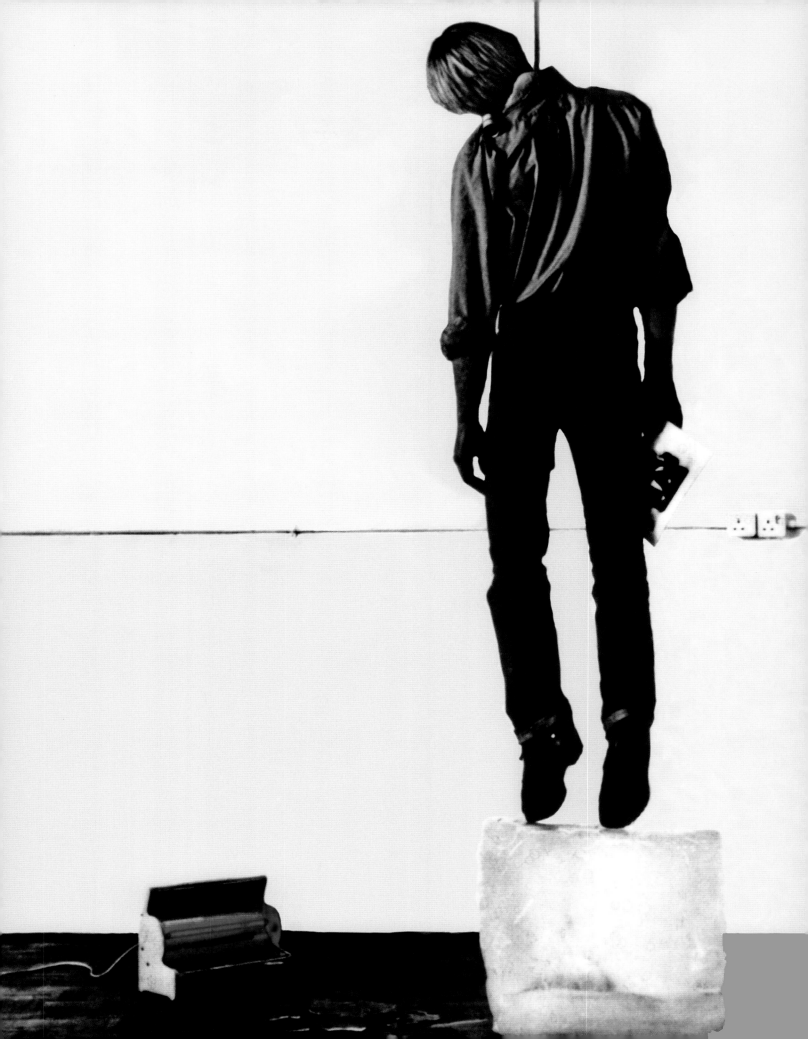

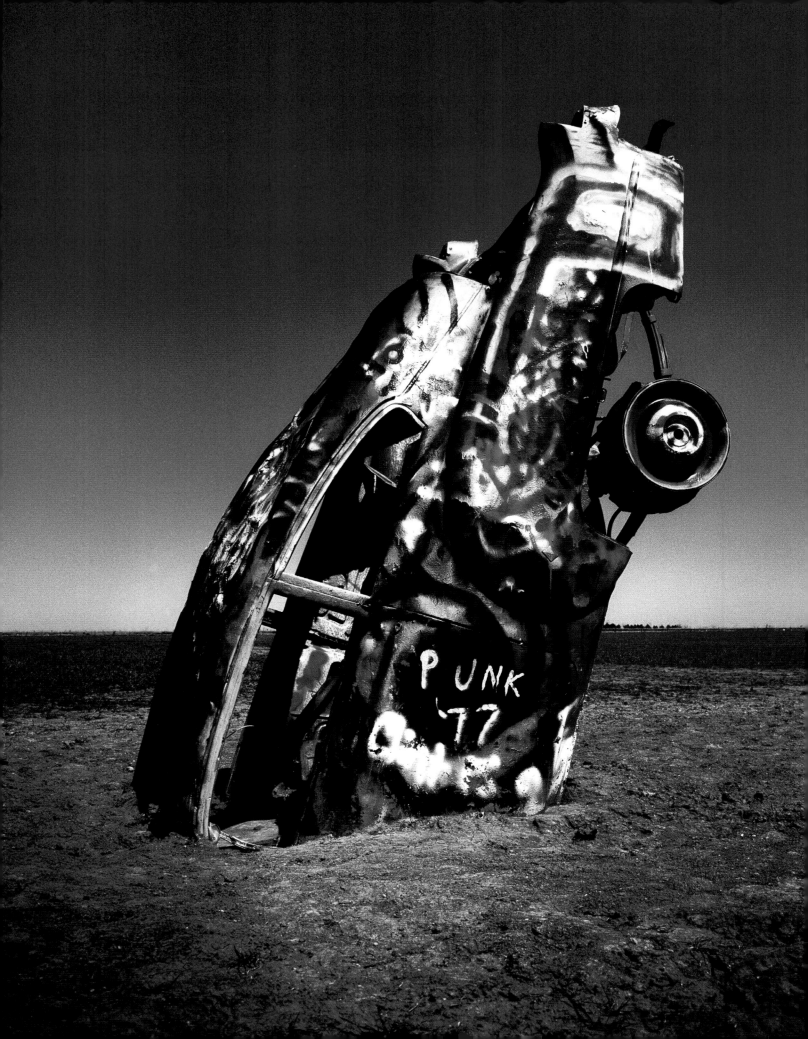

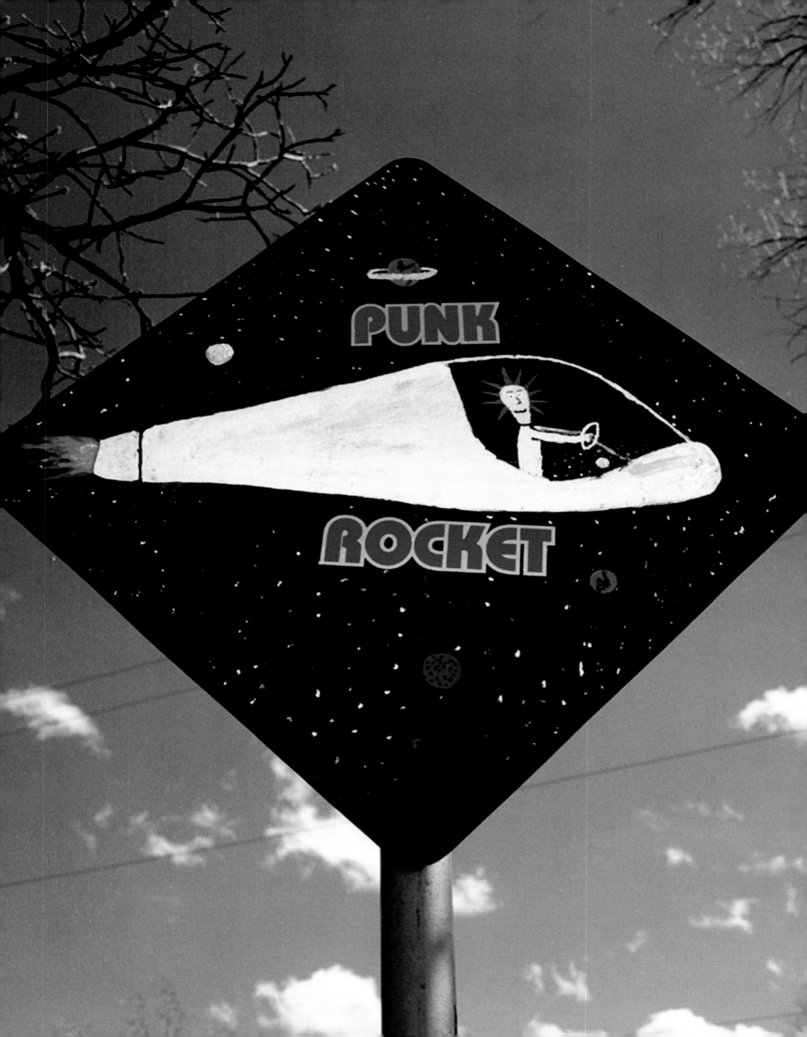

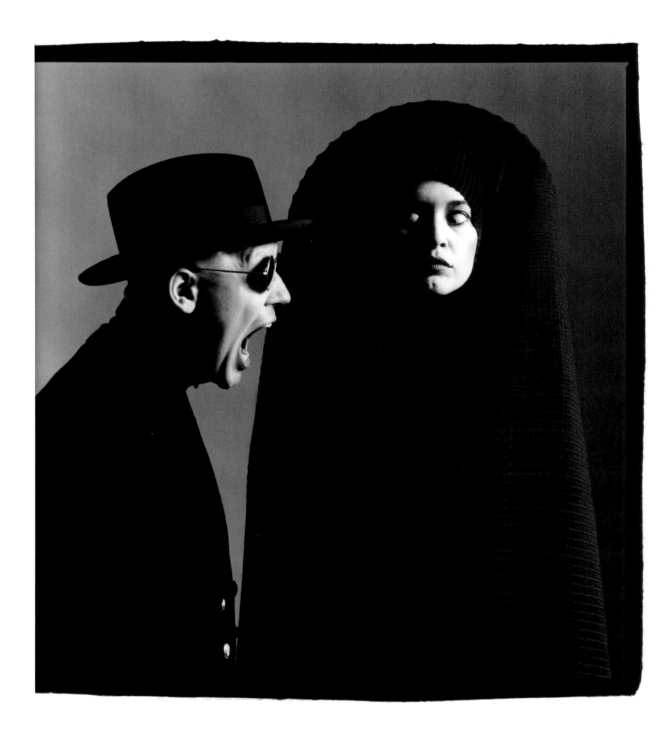

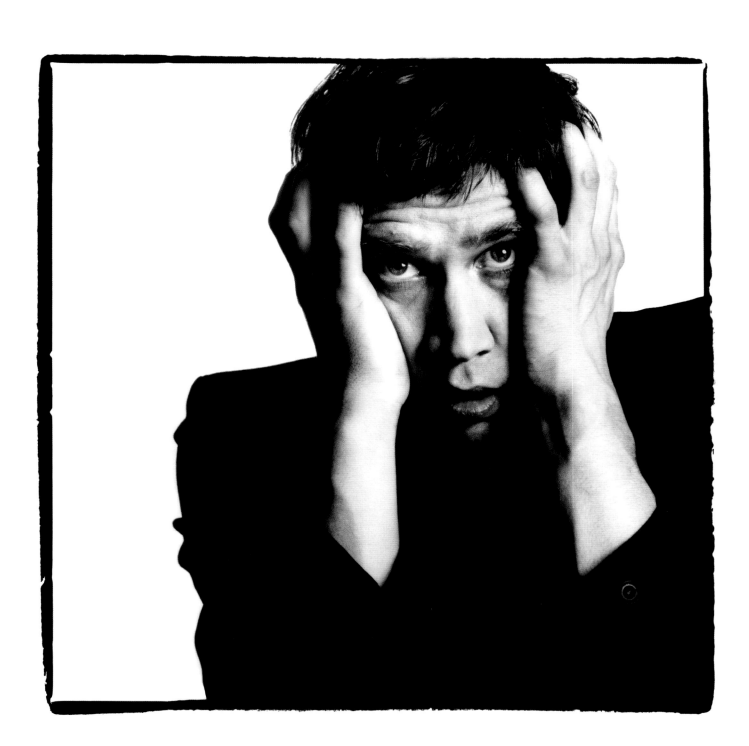

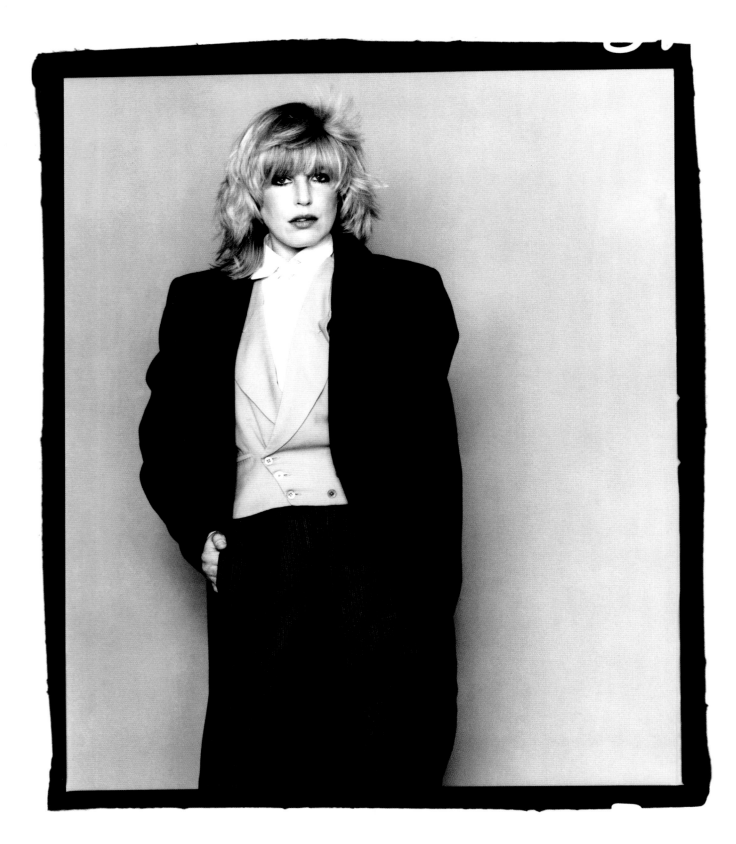

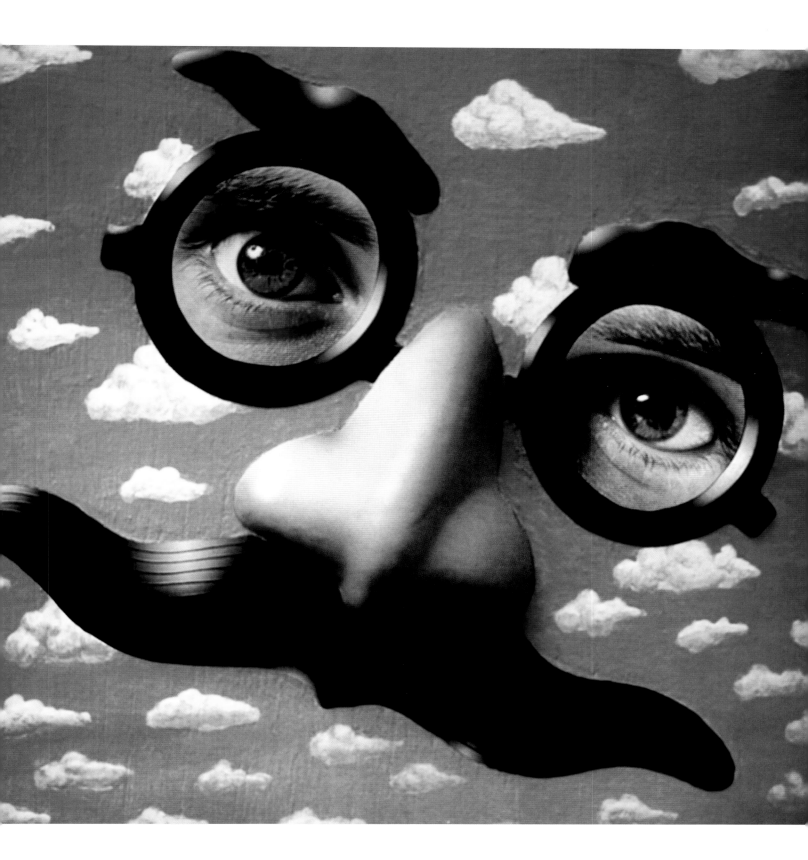

So Alone

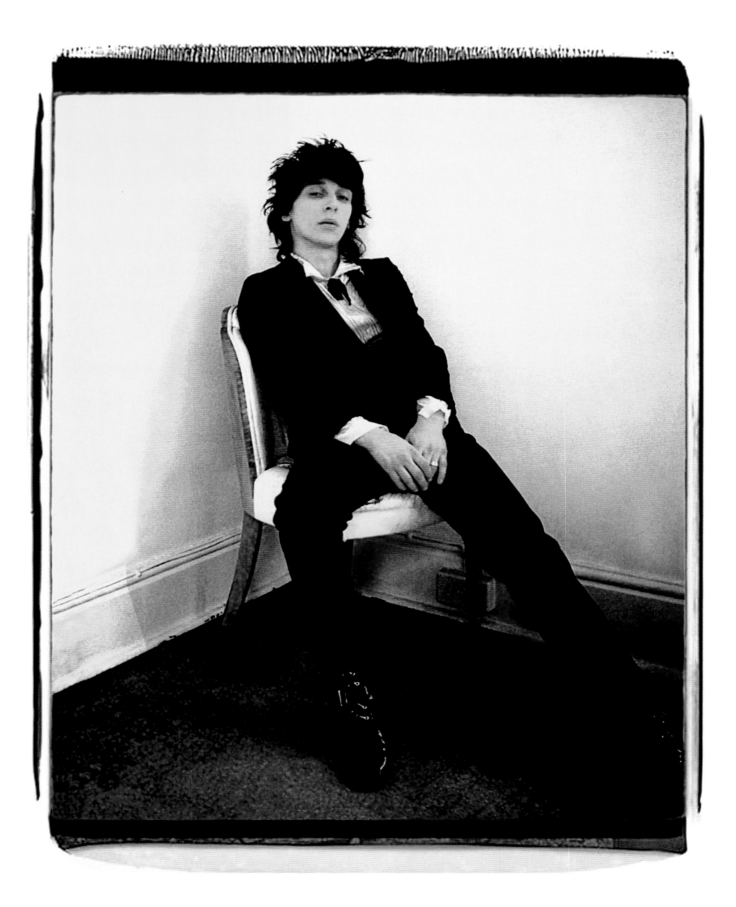

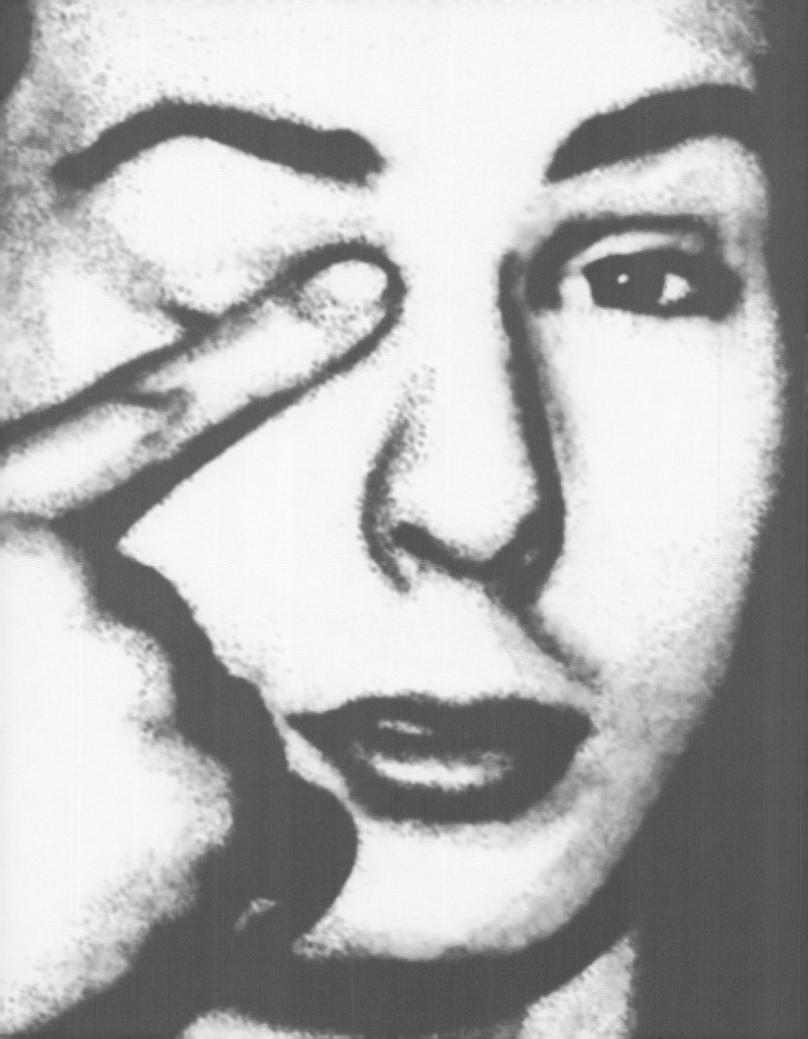

NO ONE IS INNOCENT

The last days of Sid Vicious

"Taking drugs was the one thing we had in common. It helped to avoid the language problem"
Peter Perritt of The Only Ones

LONDON 1977

"PEE-TAH"
Aw, shit: Sid?
"Pee-tah!"
Of course, it's Sid.
"Pee-tah!"

Who else could it be, standing in the street at this hour.

"Pee-tah!"

Must have had another argument with Nancy. Or he's looking for drugs. Or probably both.
His only other adversary, Malcolm, conducted his business a little earlier in the day.

"Pee-tah"

You could try to ignore him, but it would be useless. He'd stand there banging on the front
door all night until you let him in. Which you inevitably would. Everyone used to feel sorry
for Sid, you couldn't help it. He was such a weak person, easily led, totally impressionable,
but very likeable and he played on that, endlessly telling you how hard done by he was.

"Peee-tahhh!"

There was always the couch for him to crash out on. Sometimes he would just crash out but more
often we'd stay up, talk, smoke joints, or maybe we'd walk over to Barry Jones' place to see
if he was up and if anyone else was over there. Maybe someone Sid could score off.

"Pee-Tah"

Yeah Sid. I'm coming, I'm coming...

It was 1977 and I was living in Elgin Mews North in Maida Vale, London. Sid was living a few
blocks away in Pindock Mews. A lot of musicians lived in that neighbourhood at that time.
Barry Jones, who's in Los Angeles now, lived close by and was a friend. There was Barry with
his friend Andy Czezowski, who had set up the famed Roxy club in Neal Street, Covent Garden
using the money Barry got from pawning his guitars. Barry also had a band which later became
The Idols and had all kinds of people at one time or another playing in it including Glen
Matlock (who Sid had replaced in the Sex Pistols), and Jerry Nolan of the New York Dolls and
Johnny Thunders Heartbreakers.

A lot of nights, we'd start at the Roxy, see some bands then usually end up back at Barry's
place. The place he lived in was like a big crash pad. There was always lots of people. Half
the time you didn't know who they were or what they were doing there.

It was at Barry's that I first met Sid. Soon after, he joined the Sex Pistols and everyone
knew him. For a band you couldn't get any more notorious than that. When I first met Sid
he was living in some flat in Chelsea Cloisters, and used to come back to Barry's, usually
looking for drugs.

In those days if Punk had a drug of preference, it was speed. For Sid heroin came slightly
later, but even then Sid was into needles.

Back then he could be fun to be around. When he wasn't completely stoned, he could be bright and funny. Meeting him for the first time, I remember people could be a bit intimidated. Everyone had heard the stories of him beating up people at Pistols' gigs before he joined the band, but to me he never struck me as being a genuinely violent person. If anything the opposite was true and the name itself - Vicious - was a joke, because he wasn't.

It was only when he started living out the myth of being Sid Vicious as if it was a reality that he changed and things started to get out of control. When his life ended up revolving around two things: heroin and Nancy Spungen.

Nancy Spungen was a pig. She had come to London with Johnny Thunders and the Heartbreakers who had signed with Track Records, the Who's label, and had come over to tour with the Clash and the Damned. Her reputation as a kind of super-groupie had already been secured in New York at punk venues like CBGBs and Max's Kansas City. At 17 she ran away from Philadelphia to New York where she worked as a stripper. By 18 she was a full-on heroin addict.

Upon arriving in London, her declared intention was to sleep with a Sex Pistol. Her first target was Johnny Rotten, who immediately detested her, dismissing her as, "A titanic looking for an iceberg." Rejected by Rotten, she turned her intentions to Sid who, to everyone's horror, became totally besotted with her. I don't know if Sid felt sorry for her because she was treated so badly by everyone else, or whether he saw something in her, something worth loving, that no one else could see.

Pretty soon Sid and Nancy were hardly ever apart. They shared everything, including the heroin habit that would eventually destroy them both.

No one really liked Nancy. McLaren and the other Pistols were grimly opposed to the relationship and could see it ending in tears or worse. Everyone else who met her hated her. You couldn't blame them. She was simply not the type of person you'd really want to know.

She was crude, loud and nasty. A really coarse, up-front American. You'd dread her turning up with Sid. Sometimes she could be sweet and nice but more often she was a complete bitch. She was the type of person who, meeting someone for the first time would ask them for drugs or money. You would know her five minutes and she'd be trying to borrow money which you had no chance of getting back. If there were drugs around she wouldn't feel guilty about consuming all of them. Nothing was safe around her, she'd steal anything that wasn't nailed down. She was pathetic.

I do think that Sid did love her in a way. Why, I don't know, but maybe put it down to inexperience on his part. When they came over or I bumped into them somewhere they seemed to be always arguing. But that's just the way they were really, some couples are like that. The arguments usually centred on heroin, where they were going to score and where the money was going to come from. But I never saw Sid behave violently towards her. Yes, it was a pretty sordid sort of relationship but then again they were both junkies and if they weren't shooting the stuff, they were trying to score some more or find the money to score. Sid was always complaining about not being paid or not being paid enough for being in what he thought was the greatest band in the world. Anyway I think between Sid and Nancy there was some sort of bonding of souls. Nancy could be as sweet as a good cup of tea or as hard as giving yourself a dirty fix, but they stayed together for a long time and she was Sid's girl, so who was I to say anything and anyway like Iggy said, "I hate you baby because you're the one I love."

The first time I saw the Sex Pistols was at the Screen on the Green in Islington on the 4th of April, 1977. It was also Sid's first gig with the band he had just joined. Because they had been banned from playing so many venues, and they'd always refused to play at venues that would have let them play, like the Roxy, this was the first time many people had the chance to see the most notorious band in the country. Rotten was especially incredible, probably one of the best performers I have ever seen. You would follow his every move on stage. You couldn't

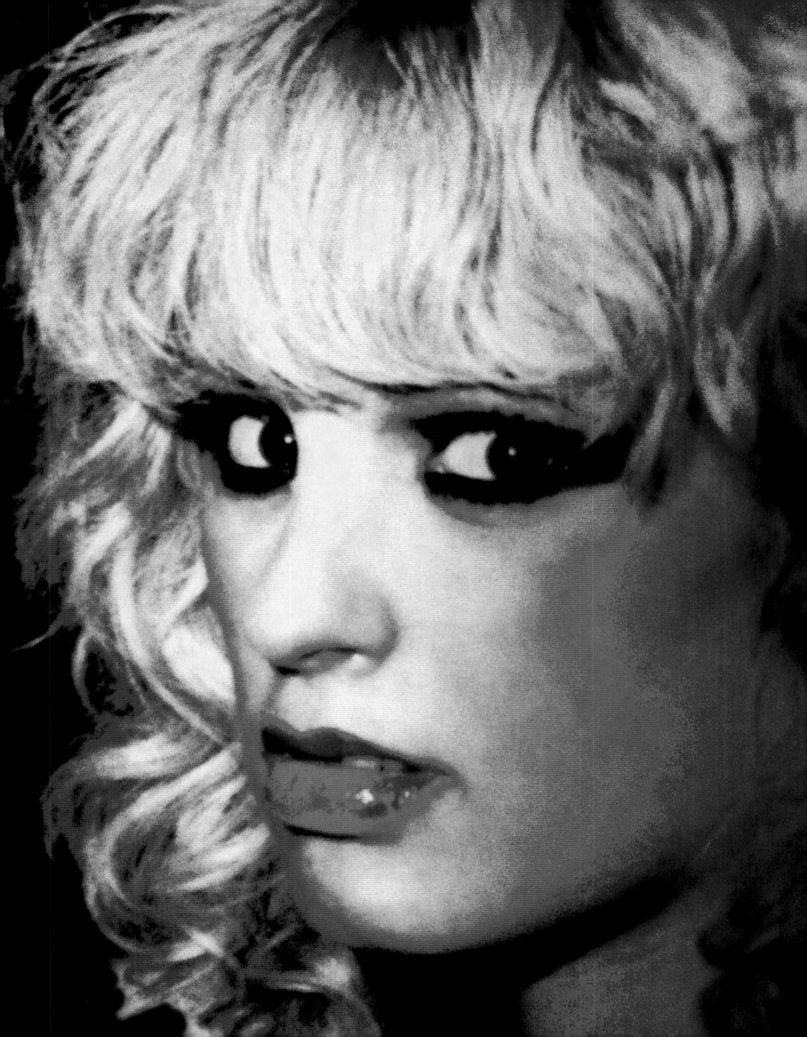

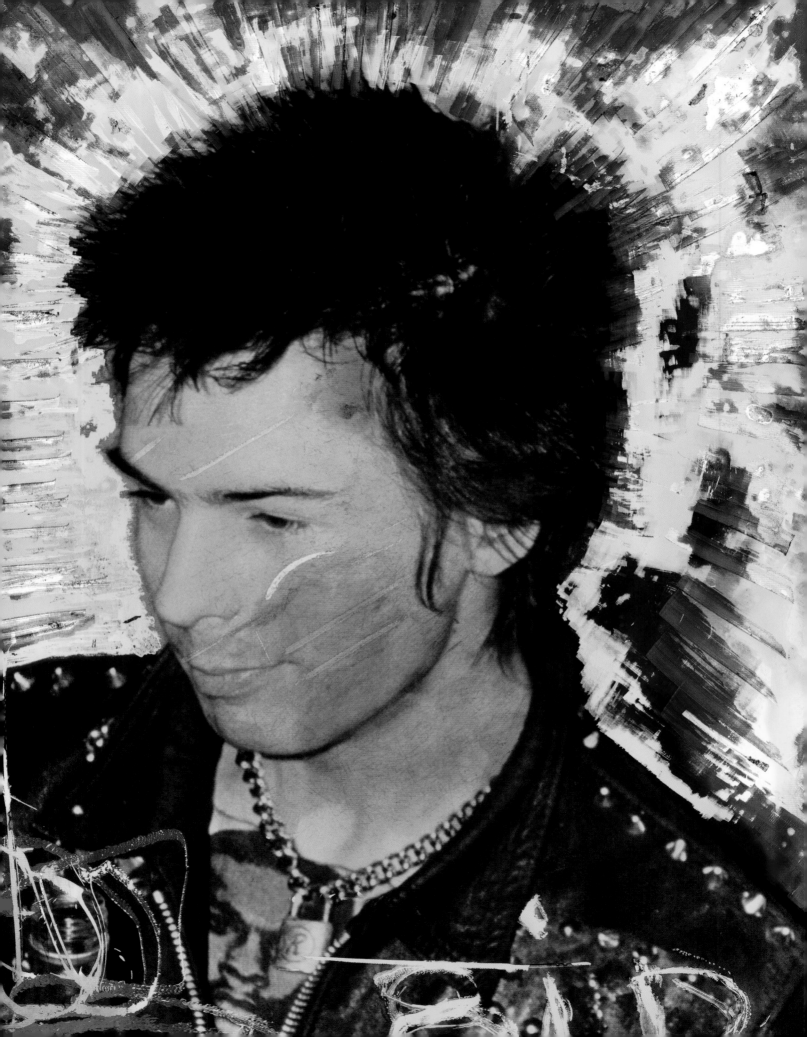

take your eyes off him. It didn't seem like a show, something they were putting on. They really did mean it and you were compelled to listen. Rotten commanded my complete attention in a way that only a few other people have ever done.

Everyone came out of that gig stunned, and if they were convinced of anything it was this: at that moment, the Sex Pistols had and were the power. Which is why what happened to them over the next 10 months was such a tragedy and waste.

Things started getting really bad for them after the release of 'God Save the Queen' and the Jubilee Day boat trip up the Thames in June. The press had been running increasingly hysterical stories about them for most of the year, but starting in June the tabloid's anti-Pistols campaign reached new heights and the violence that had always threatened around the band suddenly became awfully real.

Jamie Reid, the designer of all the Pistols artwork, had his nose and leg broken in an attack. The following week Johnny Rotten, Pistol's producer Chris Thomas and engineer Bill Price were attacked in a car park in Highbury. Ten thugs armed with knives and razors set upon them. The tendons in Rotten's left hand were severed. On an afternoon in late June Paul Cook was attacked by a gang of Teddy Boys as he came out of Shepherd's Bush Tube station and a wound on the back of his head needed 15 stitches. Everyone was paranoid and justifiably so. It had gotten to the point where they couldn't go out without someone wanting to beat the fuck out of them. Rotten was terrified and Sid just shut himself away with Nancy and shot more and more heroin. Malcolm's response to the escalating violence was to get the band out of the country so he arranged a 13 date tour of Scandinavia.

I joined them about half way through that tour. I thought the whole thing was a fiasco. They were playing pubs basically. You'd walk into these places and there would be maybe 50 people there, hair down to their waists. A bunch of hippy Vikings. It was pretty wild really but they should not have been playing these places, it was just insane. Nancy had been left in London, so Sid was pretty clean and together for the tour and he was trying his best at every gig. He didn't do very much, just stood there most of the time. Because he could barely play, he had to really concentrate to keep up with the rest of the band.

What really struck me about the tour though, was the change in Rotten from the Rotten I had watched at the Screen, Islington only a couple of months before. He was so quickly becoming a parody of himself. At the Screen he had been commanding and brilliant. Now he was just putting on a show. OK, they were playing to small crowds in terrible venues and that must have been disheartening, but it didn't really excuse what he had become in such a short time - this grotesque parody, just pulling faces and really looking stupid. It was like he had already lost interest. Something had happened, I think, between him and McLaren. This was the thing about Malcolm; he may have been good at managing the media, but as far as actually running a band, keeping them together, organising tours, he didn't know what he was doing. I mean, for Gods sake, he was used to running a clothes shop. And as far as being in touch with the members of the band and taking care of their needs, from what I saw, he didn't care. He didn't care about them at all. Not one bit. He only cared about himself.

He took a lot of credit for a lot of things he shouldn't have taken credit for. This idea of him being the big Svengali who arranged everything was bullshit. OK, he did help put together a band, and in the beginning he helped finance it, but he was extremely lucky he found Rotten. Without Rotten the Pistols would have been just another band, no better than Slaughter and the Dogs for example. Rotten had a quickness and intelligence that McLaren underestimated and then couldn't deal with. He could never bring himself to give Rotten the credit he deserved. What did he know about managing a group? I mean, look at the way he planned to conquer America. By sending them to play in shitholes in the mid-west, Texas and the South instead of New York, Los Angeles or other major cities where they were appreciated, rather than be treated as a freak show in some backwater where there was bound to be trouble, and was. The whole American

tour was a fiasco. Out of control from the start it led to the end of the band. It was in America that Sid started to believe his own myth and tried living up to it. He would never have got away with that behaviour at home. People would have laughed at him, but here he was in a new country and he was believing his own hype.

Back in England all you'd hear from people was how stupid, disorganised and chaotic everything was. There were bodyguards for Sid - there to stop him taking drugs - who he was constantly trying to run away from because they would beat him up claiming it was for his own good. What the fuck was that about, Malcolm? If you had organised the tour properly the group might have survived. They would have carried on. But it was such chaos it would have made anyone want to quit. Why would anyone want to be involved with someone who is managing a group so incompetently, who had completely messed everything up like McLaren had? No wonder Rotten left the group.

After the Sex Pistols' Scandinavian tour in August of 1977 Sid had moved into his flat in Maida Vale with Nancy. He stopped seeing Rotten as much, who lived in Chelsea and hated Nancy. Also Rotten was appalled by Sid's heroin habit, which was spiralling out of control. What struck me then was how alone Sid really was. I don't think he had any really close friends, apart from Rotten, who he was always in awe of and would never say anything against, even towards the end, when Rotten walked out on the group and there was supposed to be such bad feelings between them.

He had a lot of people who surrounded him and used him, but basically no one apart from Nancy who he was in any way close to. Even when he moved to New York, when it came down to it, he'd see Barry, he'd see Nancy of course, he'd see the few dealers, he'd see me and that was about it. Not that many other people at all.

When he first used to turn up at my place in Elgin Mews North it was as if he just needed someone to talk to, away from all his daily bullshit. We'd sit up talking and over a period of time I found out about his background, his childhood and his mother, who was in many ways a pathetic individual. But in many ways Sid was no better, although there was nothing quite as desperate about him.

When he got back from the American tour, he'd definitely changed. He'd turn up, sometimes on his own, but more often with Nancy, and all he'd talk about was drugs and McLaren, who he thought was using him. Rotten had been too strong for McLaren, had refused to be manipulated, and had quit the band rather than be used. Sid was a lot easier for Malcolm to control. He had become Malcolm's puppet, and he knew it.

McLaren was still trying to make the Sex Pistols movie he had spent so much of the band's money on and took Sid to Paris to film the infamous 'My Way' segment which was included in what was to become the joke he called, 'The Great Rock and Roll Swindle.' McLaren couldn't accept that when Rotten left the Pistols were over as a band. He took Steve Jones and Paul Cook to Brazil to record with Ronnie Biggs, a failed train robber, which was a complete sell out of Punk and anything it stood for. For this Malcolm should have been hung, drawn and quartered. In a stroke the Sex Pistols had become nothing more than a novelty act.

Sid had become a novelty act as well. In many respects, what McLaren was doing to him was no more than turning him into a kind of punk Gary Glitter or Alvin Stardust. Sid was partly to blame though. He'd complain endlessly about McLaren but he would still take his money. He wasn't going to walk out on McLaren like Rotten had. He wasn't going to bite the hand that fed him. As long as there was some money to be made, he'd carry on. It was an ugly situation and frustrating, and although he was virtually always stoned he knew deep down he was turning into a joke.

At the same time he had Nancy constantly telling him that he was going to be a huge star in his own right and by August 78 they had convinced each other at least that Sid's solo

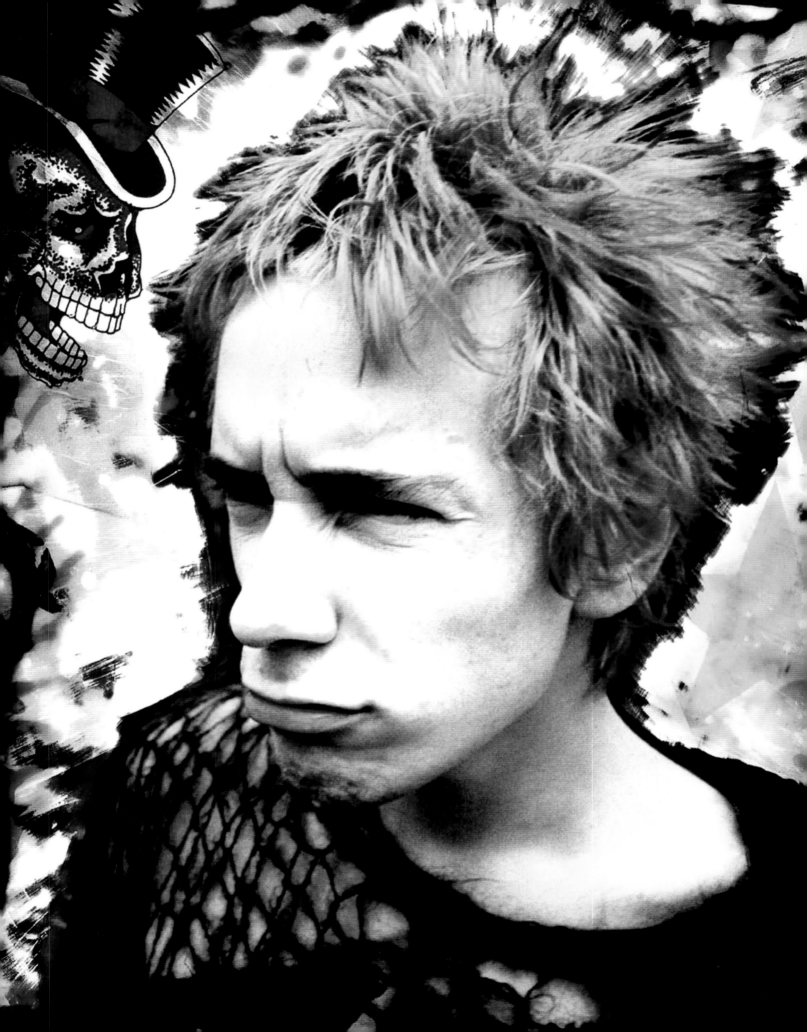

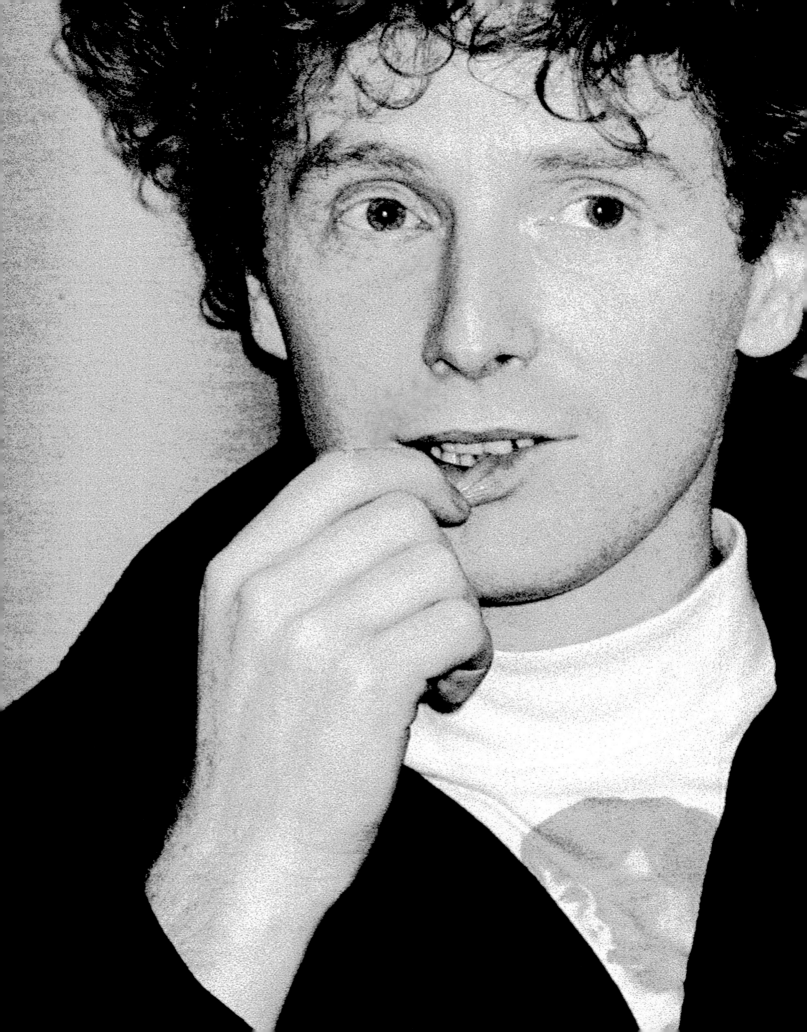

stardom could best be achieved by moving to New York. They were tired of all the hassles and harassment in London. They had been in court in May then again in August on charges of possession of methylamphetamine and had been totally freaked out by the death in Pindock Mews of studio assistant John Shepcock from a cocaine overdose. They had stirred from a dope-induced unconsciousness to find Shepcock in bed with them. It was several hours later before they realised he was dead.

There had also been a ferocious falling-out with Rotten. Sid and Nancy had turned up at Rotten's place in Gunter Grove, Chelsea and Rotten had refused to let them in. With Nancy behind him screaming, Sid had tried to kick down the front door. One of Rotten's friends, most likely Jah Wobble, rushed outside and attacked them with an axe. It was time to split.

To raise the money for their trip they put on a farewell gig at the end of August at the Electric Ballroom in Camden, fronting a band called The Vicious White Kids, which included Steve New on guitar, Glen Matlock on bass and Rat Scabies on drums. The show was billed as SID SODS OFF. Which is what he then did.

New York, October - November, 1978

It's November 21st, 1978 and I'm sitting downstairs at Max's Kansas City. There's a bunch of us. There's Barry Jones and Steve Dior from the Idols, a couple of the Heartbreakers, including Jerry Nolan and lots of girls from Miami. I'd been in New York for two days. A lot had happened since I was last here and we were all trying to take it all in.

When Sid and Nancy arrived in New York they had booked into the Chelsea Hotel on West 23rd Street. They had a small room on the first floor which had a small bathroom off it. It was even trashier than Pindock Mews. Whatever she was, Nancy was no home-maker. In the middle of the room was a double bed, surrounded by the spoils of Sid's rock and roll war: a couple of guitars, a ghetto blaster, cassettes, clothes everywhere, leather trousers, mohair sweaters, T-shirts and leather jackets. In the open drawers next to the bed were spoons, needles, bits of cotton wool and empty drug packets. The last time I was there, the leftovers of takeaway food and drinks were all over the floor.

On October 12th Sid had woken in that room from a drug induced stupor to find Nancy lying under the sink in the bathroom. She was wearing only her underwear - black knickers and bra - and there was a knife sticking out of her side. There was blood everywhere and all of it was hers. The bed was soaked in it and there was a trail of it leading to the bathroom, suggesting that at some point during the night she had dragged herself across the room, from the bed to the bathroom, where she had collapsed, dying some time in the early hours of October 12th from internal haemorrhaging caused by a single knife wound to the abdomen.

Sid started screaming for an ambulance, but it was the police who got there first and to them it looked like an open-and-shut case, with Sid being the obvious killer. The knife in Nancy's side was Sid's - a folding hunting knife with a black jaguar on the handle which he had bought the previous day in Times Square. He was arrested and taken to the third homicide division on 51st Street.

"I did it because I'm a dirty dog" he allegedly confessed before being charged with second degree murder, although he'd been so stoned the previous night he could remember nothing at all about what had happened.

On October 13th, he was sent to Riker's Island. A tough, heavily-guarded remand centre in the middle of the Hudson River.

On October 17th, he was released on bail of $50,000. The money paid into court by Virgin Records.

McLaren was in New York by now, as well as Sid's mother, Anne Beverley, into whose care he was released. They moved into the Seville, a welfare hotel on Madison Avenue.

On the 22nd October McLaren, who had hired a team of private detectives to investigate the case, got a call from a hysterical Anne Beverley: Sid had just slashed his arm with a razor and a broken light-bulb in an apparent suicide attempt. He was admitted to Bellevue Psychiatric Hospital, where they put him in the detox unit.

On November 21st, Sid was back in court for another bail hearing. District attorney Al Sullivan had this to say to the court about Sid, "He cultivates an image of antagonism and has a flagrant disregard for constitutional authority." However, the judge allowed bail to stand, on the condition that Sid reported regularly to New York Homicide and attended a Methadone clinic.

That night he turned up at Max's to a hero's welcome. There's a lot of backslapping and bullshit and I'm glad to see Sid, but it's hard to talk with so many people around and anyway what am I going to say to him? "Did you do it?"

It's a couple a weeks later before we meet again and again it's at Max's. We have a booth downstairs and we order dinner and drinks. There are maybe five of us. We're talking about what it was like on Riker's Island and Sid's playing the tough guy, shrugging it off, when some huge asshole comes up and tries to pick a fight with him. Sid's so far into his own myth at this stage, he squares up to the guy. I can't believe he's reacting to this geek. Everyone at the table stands up.

"Hey, Fuck you!"
"Fuck yourself!"
"Fuck off!"
"Yeah?"
"Yeah."

We all sit back down, order more drinks. Sid wants some pills. I don't think so. More drinks. Sid's depressed. It's time to go. Nothing is happening here anyway.

We get in a taxi and head uptown to Hurrah's, but when we get there it's sort of empty. You could have good nights at Hurrah's, but this didn't look like it was going to be one of them. There was a band playing and a few people standing around watching them.

"Sid, let's cruise."

He's not listening. There are a few nice girls here. Sid talks to one of them. The music is really loud. So you've got to get really close to hear what anyone is saying, you've got to yell at the person next to you to make yourself heard.

Then some guy comes over to Sid and says something to him. It could have been "I think you're great. I'm glad to meet you." Or maybe it's "I think you're an asshole." Although in this case I doubt it as this guy is pretty frail looking.

Anyway the next thing I know Sid has smashed a glass in this guy's face. There's blood, screams.

"Let's get outta here."

I grab Sid, we head to the elevator and split into the night.

"Sid, you're an asshole!"

It was just the most stupid thing to do. But Sid wasn't thinking. He was drunk and Nancy had just died and he's fed up with everything and here he is again, playing out a role he shouldn't have been playing. I had just wanted to get him out of there before the police arrived but it didn't really matter. Everyone knew who he was and people had seen him do it and the guy turns out to be Patti Smith's brother, Todd. And of course, if the police don't arrest him tonight they're gonna get him tomorrow, which they do. The next morning he is arrested.

I'm prepared to go to court, saying it was Todd who had attacked Sid and Sid had acted in self defence. I'm sorry Todd but I didn't want Sid going back to prison.

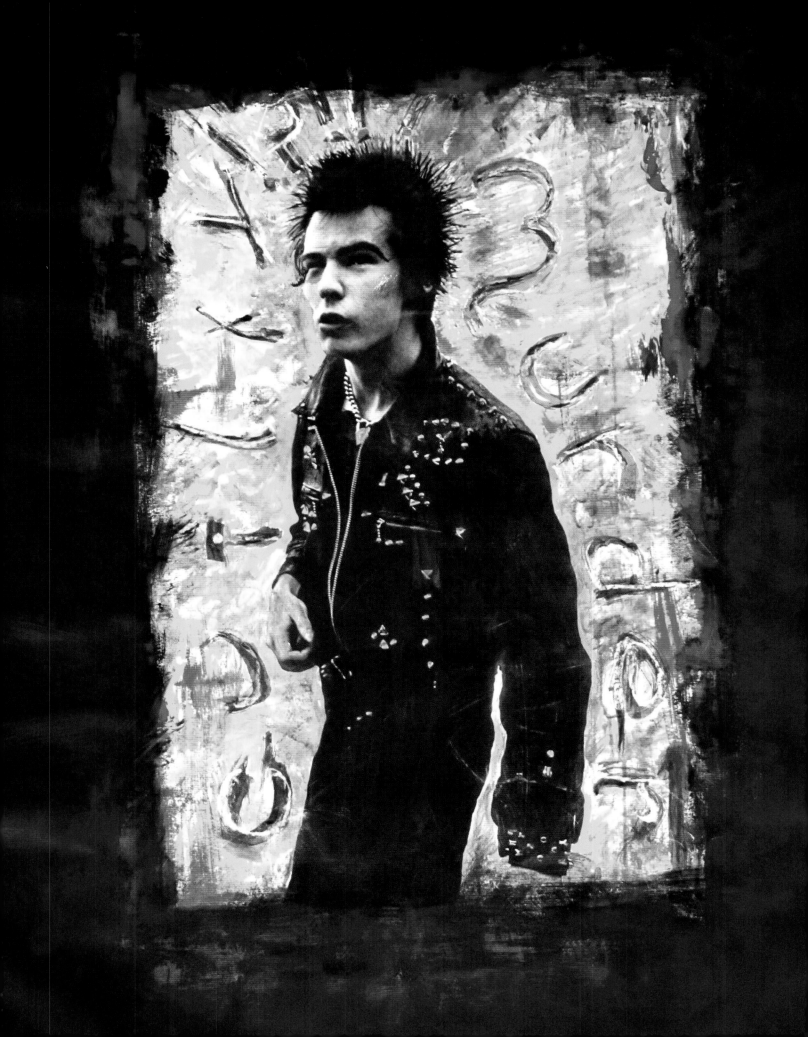

But that's where he is going, no more bail, back to Riker's Island on the Hudson River.

It's February 1st, 1979 and I'm with a friend of mine Terry Ork. Terry was president of Ork Records and had managed Television when they first started. He had been busted buying Quaaludes in Astor Park from an undercover cop and had asked me to go to court with him, so I said yeah yeah and we both headed down to court that morning.

There's a lot of the usual sitting around and confusion surrounding which court we are supposed to be in. More waiting. "Terry, I'm going to smoke a cigarette."

I go downstairs and someone I don't know comes up to me. It turns out he's working for Sid's legal team and he's recognised me from Sid's last court appearance. He tells me Sid is going to be released within the hour. They were bringing him from prison right now. He asked me to stay around.

What kind of coincidence was this?

Anyway, Terry's going to have to deal with his drug bust on his own. I go around to the back of the courts to wait and bump into Sid's mother straight away, the only other person waiting for him. I'd met her a few times before and didn't have too high an opinion of her. If you'd seen her you prayed she hadn't seen you. Put it this way, she wasn't the type of person I'd give my telephone number to. It seemed amazing to me that anyone expected her to look after Sid. She couldn't even look after herself. It was all pretty hopeless.

Sid arrived not much later. There's some paperwork - sign here - and then the cuffs come off and we're all out the back door and onto the street. From one jungle into another. He looks tired and nervous. Gone are the leather jacket, the studded belt, he's wearing just some jeans and a t-shirt and it's a cold February New York day. We're walking fast.

"Did you get it?" Sid asks his mother.

"Yes Sid."

We walk to where his mother is staying, maybe 10 blocks from the courthouse. No one else was there. Sid takes the packet his mother had brought from Jerry Nolan and shoots the whole thing up in one great rush in the hope of numbing the horrors of the last few weeks, but to his dismay the stuff she had paid for was total crap. Jerry had ripped her off. What a surprise!!

It was typical of the people Sid had hung around with. What a bunch of lepers. They were like jackals, everyone on that scene. Junkies with no conscience. They didn't give a fuck about each other, I'm sure it must have seemed really funny to Jerry, ripping Sid's mother off. It wasn't funny, just mean, greedy and pathetic. Sid gets really pissed off and asks me if I can find him anything.

"Pee-tah, can you do something?"

"I'll try. Where are you staying?"

He gives me an address of a girl called Michelle Robinson, who he had met up with after Nancy's death. He and his mother had to go and pick up some clothes Malcolm had sent out for Sid and I had things to do, so we agree to meet up later. I take care of my errands and arrange to pick him up some stuff through a friend downtown.

The way I look at it was like this. He was asking me to pick him up some heroin, which I didn't really want to do but he was going to get something from somebody somewhere and a lot of people would try to rip him off so in a sense I was doing him a small favour.

I don't think there were any other circumstances in which I would have done it for him. If he had called me looking for something I would have probably refused. I just wanted to make sure that he didn't get ripped off again.

It was already dark when I arrived at Michelle's apartment in Greenwich Village. She and Sid are lying in bed waiting for my arrival while his mother is watching TV in the front room.

Sid wastes no time shooting up a good hit of the heroin. I told him to be careful because he had been clean for a while and the stuff was supposed to be quite strong. He gets pretty stoned and it becomes hard to keep him from nodding off. I think - oh, shit!- he's taken too much.

"Sid, wake up. Talk to me."

Over the next hour it's hard to keep him awake. He throws up a couple of times, but finally comes around and we're sitting on the bed drinking tea, smoking cigarettes and talking.

Sid wants some more smack, but I lie, telling him he finished it all. I hang around for another 3 or 4 hours before I have to go. The Only Ones, whose record covers I had done were playing their US debut at Hurrah's of all places and I'd promised to attend.

Before I go I give what's left of the stuff to Sid's mother telling her not to give him any more that night. She could give him the rest in the morning if she wanted but no more that night.

When I leave Sid is fine.

New York February 2, 1979

I had been sharing an apartment in the East Village with a Rastafarian.

It's owner, a record producer, was in Japan for work and had left us to look after the place while he was away.

I guess you could say he didn't like me much and the feelings were sort of mutual. I'd had a long night, and when he arrived home late in the afternoon I was still asleep.

"Your friends dead, man."

"What do you mean? Who's dead? Is this a joke?"

"No, man," he says "That guy in the Punk band. It's all over the news."

I felt like I'd been punched in the stomach.

It can't be. He's got it wrong. Who's he talking about anyway. That punk band! For him, music began and ended with Bob Marley. I was out of the house in a flash.

The front page of the paper said it all.

SID VICIOUS DEAD

He had died that morning of a drug overdose.

I felt sick and guilty.

Sick because someone I knew had just died and guilty because I was the one who had brought the heroin the night before, and sick again because the night before he had been in the most positive mood I'd seen him in for a long, long time. He'd been like the Sid of old and now he was dead.

What had happened???

So first of all, did Sid kill Nancy?

Nearly 20 years on and still no one can say for certain. The version most people believe is that Sid and Nancy had an argument, that Sid stabbed Nancy in a blur of drugs, and that he was so out of it he didn't know what he was doing and couldn't remember anything about it afterwards.

Another theory was that it was a suicide pact gone wrong and Nancy died but Sid didn't. I don't think so. They were pretty self-destructive, for sure, but only to the extent that they lived pretty close to the edge.

I disregard both theories. I think it was more simple than that. They were more likely victims of their own junkie lifestyle. If you hung around the people they hung around with, you've every chance of ending up a victim. Someone killed Nancy but it wasn't Sid.

Sure she was an annoying bitch, but you can have a row with your wife, be angry but it doesn't mean you're going to kill her. You walk away. And Sid wasn't even married to her. I don't think he was capable of killing her. Deep down Sid was a big baby who loved Nancy. No, Nancy was murdered but not by Sid.

The night she died the Idols had played Max's Kansas City. After the gig Barry Jones, Sid, Nancy and a guy Barry didn't know, who said he was from the Bronx, all went back to the Chelsea hotel all searching for drugs. Sid had cashed a cheque for $1,500 from Virgin that day and Barry had money from his gig but it was just one of those nights when it didn't matter how much money you had in your pocket there just wasn't any drugs around. No heroin, no morphine, none of the derivatives, nothing. That's not going to stop everyone trying though. More phone calls and frustration. Even a trip to Alphabet City produces nothing. The mood is becoming more bitchy, frustrating and desperate.

At least there's some Seconal, courtesy of the guy from the Bronx who no-one knows and who Barry doesn't trust, but he's doing his best to find something else so what the hell, keep trying.

Sid meanwhile is polishing off a bottle of Jack Daniel's on his own. The effects of Seconal with alcohol can be a bit dramatic. A couple of them combined with alcohol would make you mighty sloppy for a while. Fighting off the initial sleepiness allows you to speed off them for a while. Take one or two more Seconals and who knows where you would wake up or how you got there.

By the time Barry left the hotel, resigned to the fact that no drugs were going to be found that night Nancy had already passed out on the bed. Sid was vaguely conscious and the guy from the Bronx, who no-one knew, was still there trying to find something.

So, what happened next?

The Chelsea has changed a lot since the late seventies. Back then it was a pretty crap hotel. It was full of transient types - musicians, models, groupies, junkies and dealers. The rooms were pretty basic. You'd be lucky if you had a TV. Usually there was just a bed or someone would rent a room and stick in as many beds as they wanted or could. The people who ran the hotel didn't care really what went on or who was there as long as the rent was paid, there weren't too many complaints and the police weren't called in. It wasn't like you had room service and your sheets changed every day.

So, imagine the scene: an open hotel room, Nancy passed out on the bed, Sid fucked up on booze and pills and guitars, clothes, and money laying around.

Someone is in the room going through all this stuff. They don't give a fuck that it's Sid and Nancy. As far as they are concerned they're just another couple of junkies with money and valuables.

Maybe Nancy wakes up, catches someone in the act of robbing them. A struggle breaks out and she's stabbed and bleeds to death while Sid is passed out oblivious to everything. When he wakes up, there's blood everywhere and Nancy dead with a knife in her side in the bathroom. This was always the worst part for Sid, that he could not remember anything about that night. There were too many unanswered questions. For example, where was the money and the missing clothes? The room had obviously been robbed. And what happened to the guy from the Bronx, who nobody knew or ever saw again?

Because he couldn't remember what had happened, I think Sid at first thought maybe he could have done it. In the beginning, he was shocked by everything and of course everyone was accusing him of having done it.

But the last night I was with him, I think he truly believed he hadn't done it and planned to clear his name. There really was a big difference in him that night. He was more like the Sid I had first met. He was a lot calmer and easier to talk to. We talked about a lot of things that evening. The album he was to start work on with Steve and Paul the next week which would pay for all his legal costs. We had laughed at the tracks listed by McLaren which included 'I fought the Law' and 'Y.M.C.A.' He wanted to clear his name and felt he had some chance. It wasn't as if I was talking to someone who had given up. He was in a really positive mood that evening, all things considered, certainly not suicidal. Which is why I was so astonished when I heard he was dead. When I had left him he was fine, so I was amazed at what happened. Did his mother give him the rest of the heroin that night after I had told her not to? Maybe she just gave into his demands for what was left. Junkies can be the most persistent people in the world. Even so, I don't think that there was enough left to kill him off.

Did some-one else turn up with some more stuff? I don't think so. There had been no calls from anyone that evening or any talk of anyone else due to come over and it had been quite late when I finally left.

Do I feel guilty about what happened? Do I blame myself for his death? No, not really. I don't think so. I was responsible for finding something for someone who had asked me to find that something for them. But when I had left him, he wasn't dead and the majority of what I had brought over with me was gone, I find it really strange he could have died on what was left. Looking back, I could say, that I wish I hadn't got the stuff for him but I don't feel responsible for him dying.

Some people at the time said he was actually better off dead but I wished he had lived. Not for me but for himself so he could have had the chance to clear up all the mess that surrounded him at the time of his death. That he died when he did, with everything so unclear and unresolved around him, was pure tragedy.

Sid was no Hendrix with the guitar or a Dylan with words but he had been a member of the Sex Pistols, and they had, if only briefly, as much influence on the music, style and the thinking of their generation as anyone before or after.

I never spoke to Sid's mother after his death. She had him cremated then proceeded to spill the contents of the urn at Heathrow Airport on her return. So I guess by now there are little bits of Sid all over the world. Punk lives on.

Postscript

After Sid died I returned to London and carried on with my photography, but I stopped doing a lot of music work.

Music can make you rich but it's a filthy business sometimes.

Sid R.I.P.

Sid
R.I.P.

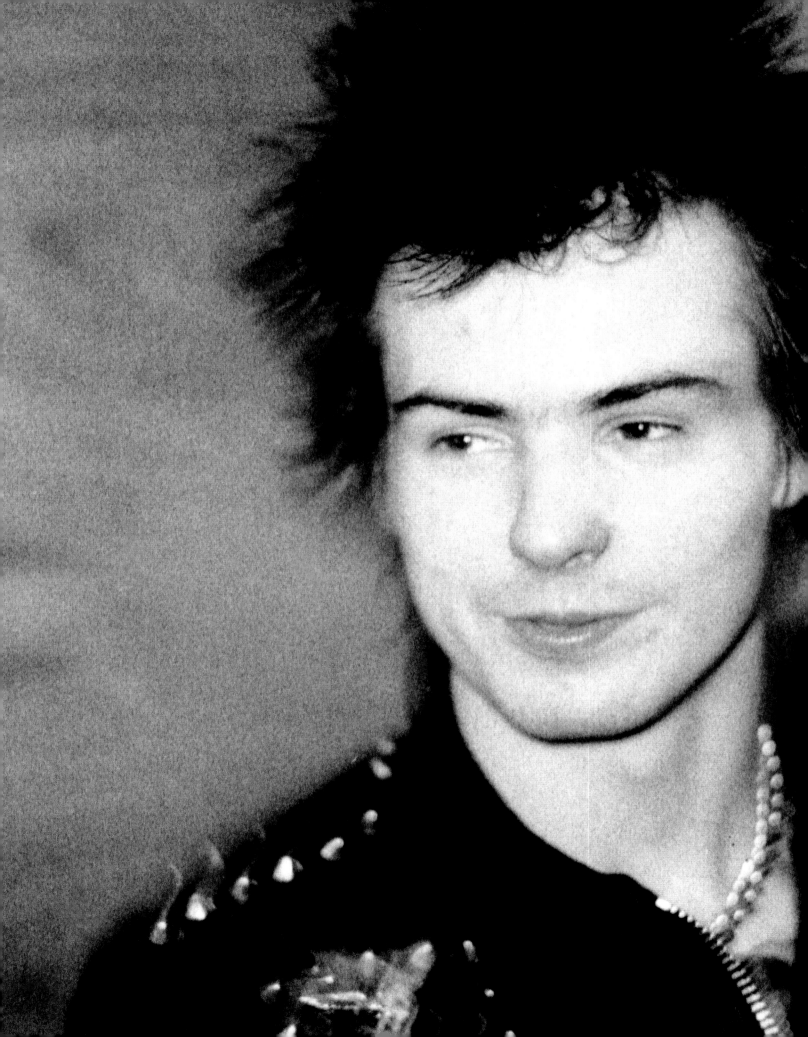

DiRTY PiCTURES

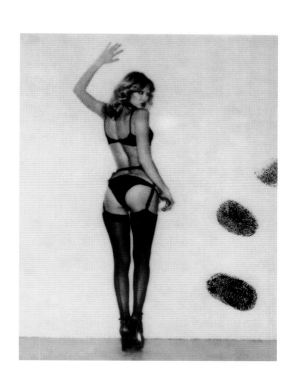

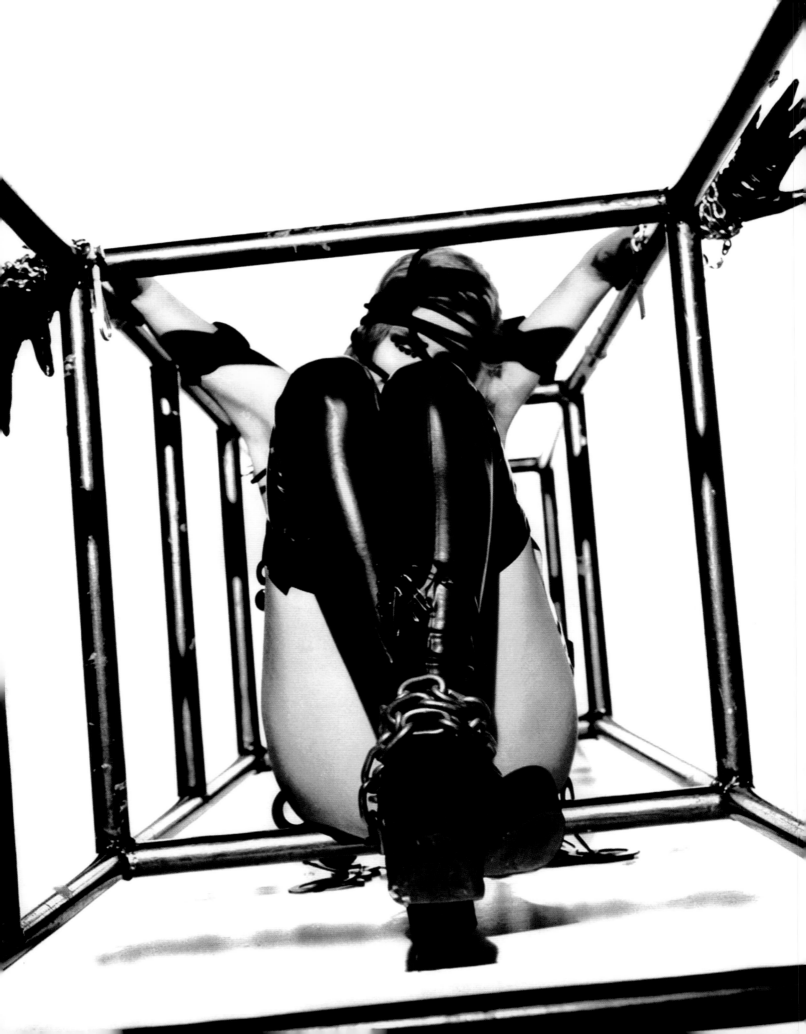

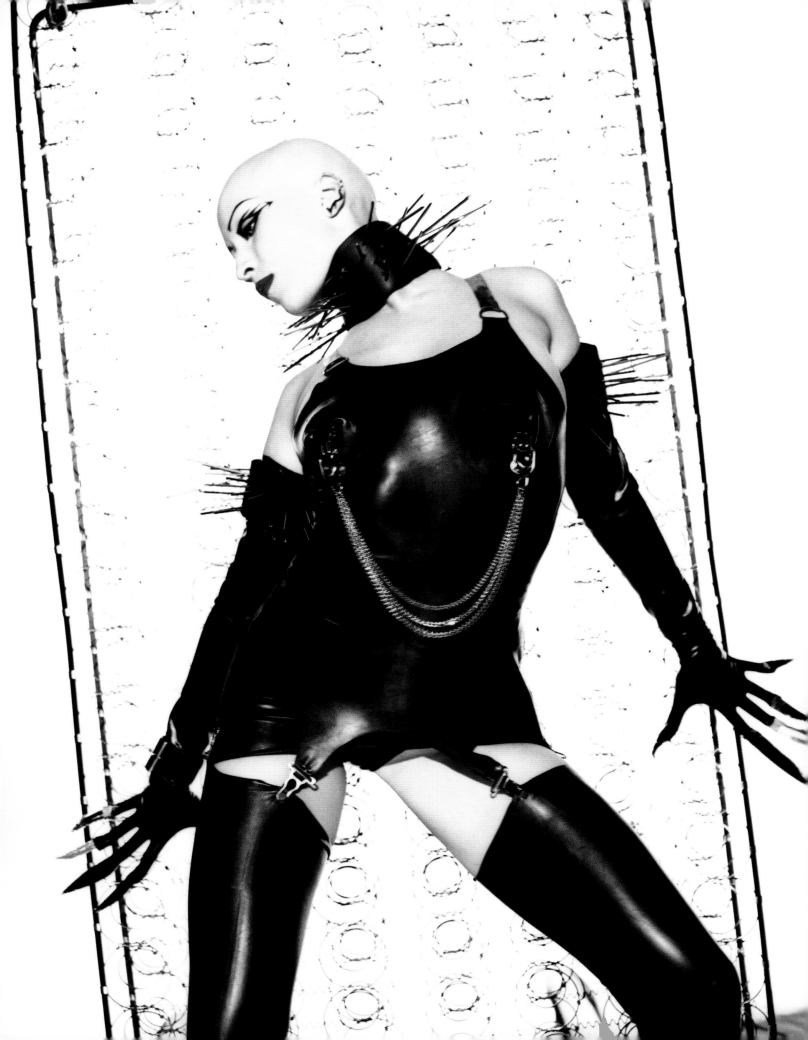

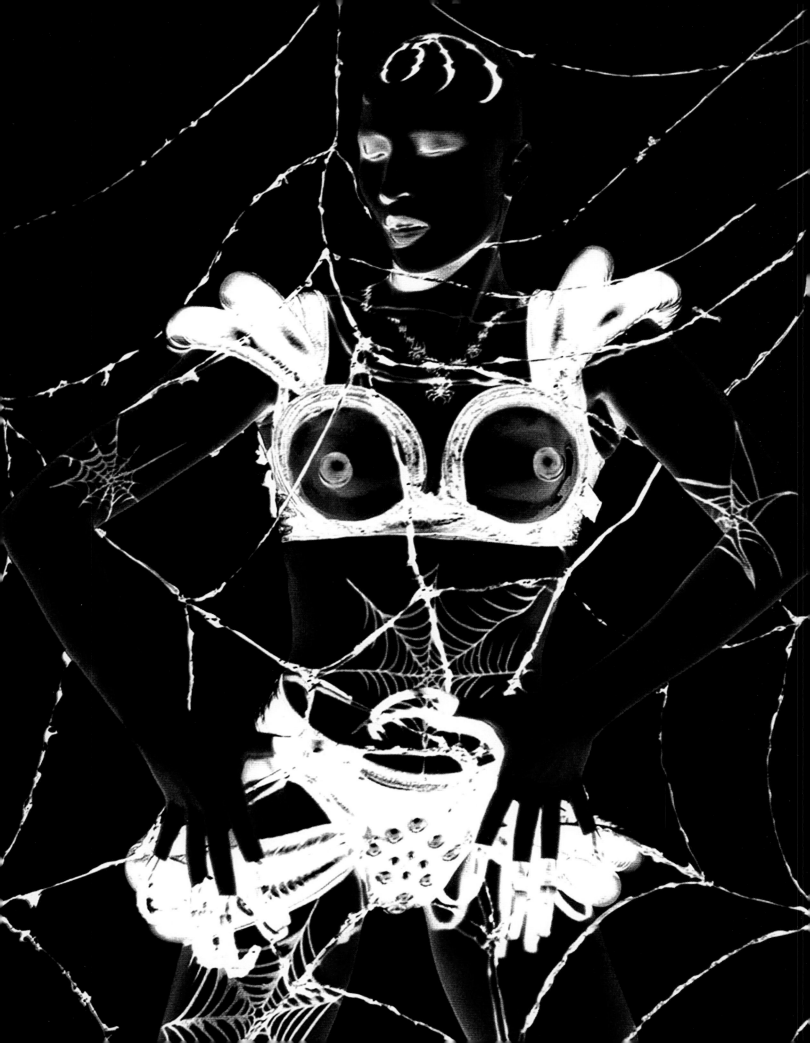

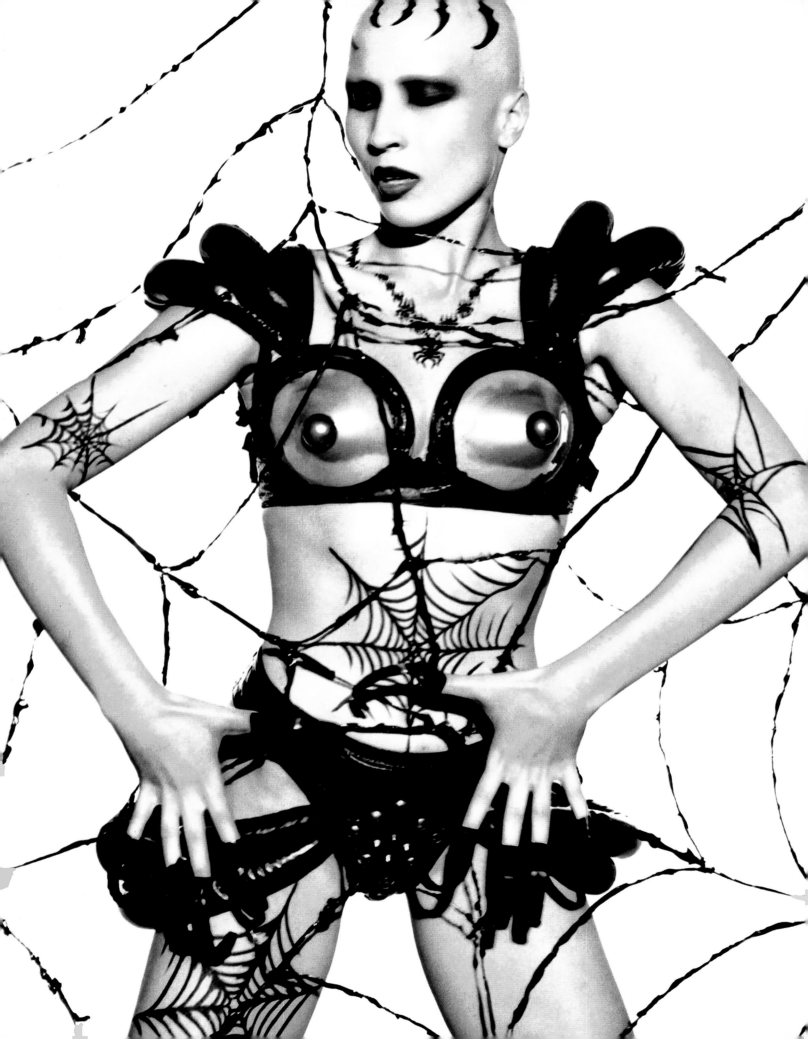

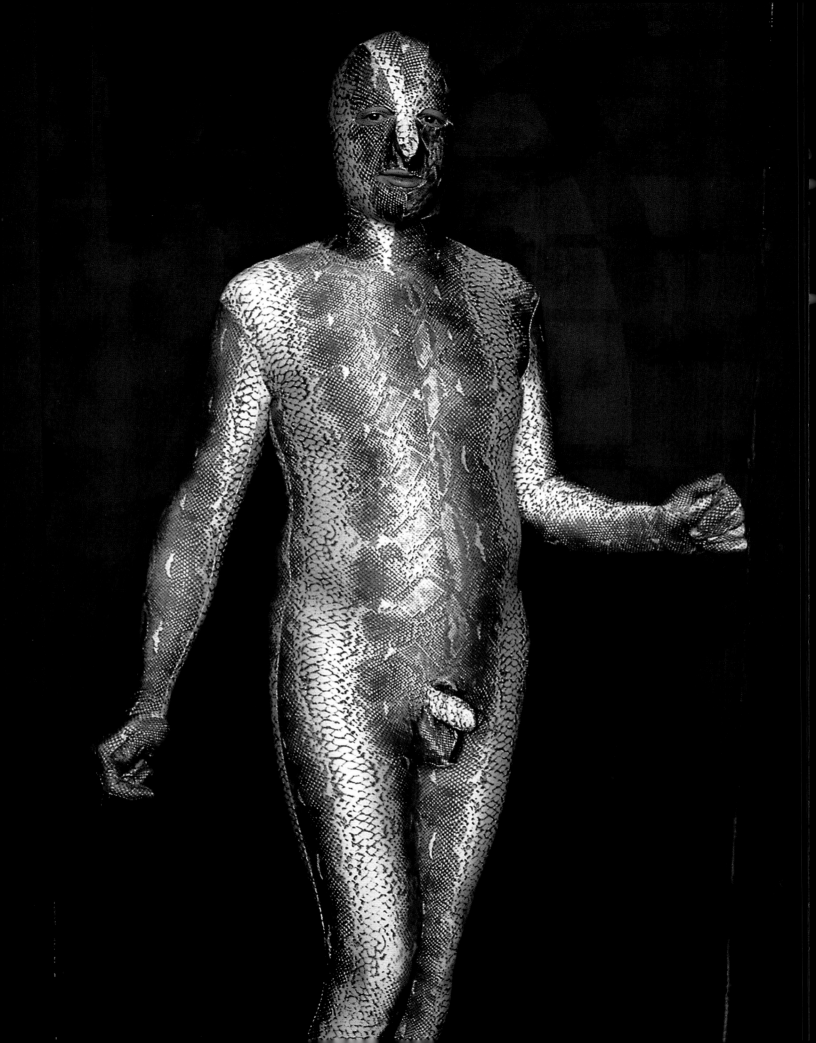

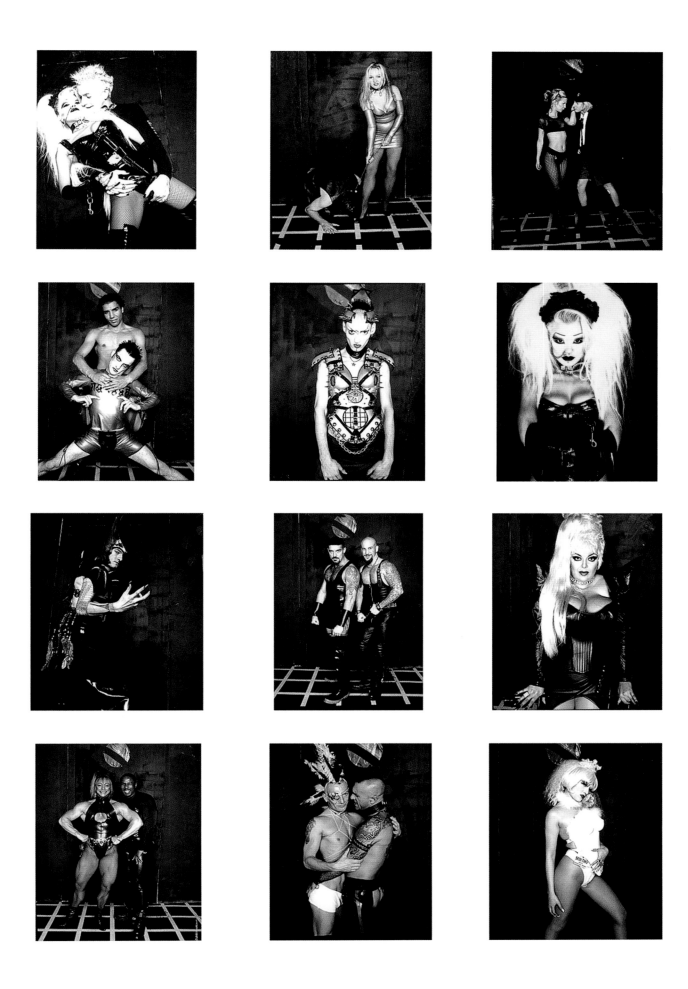

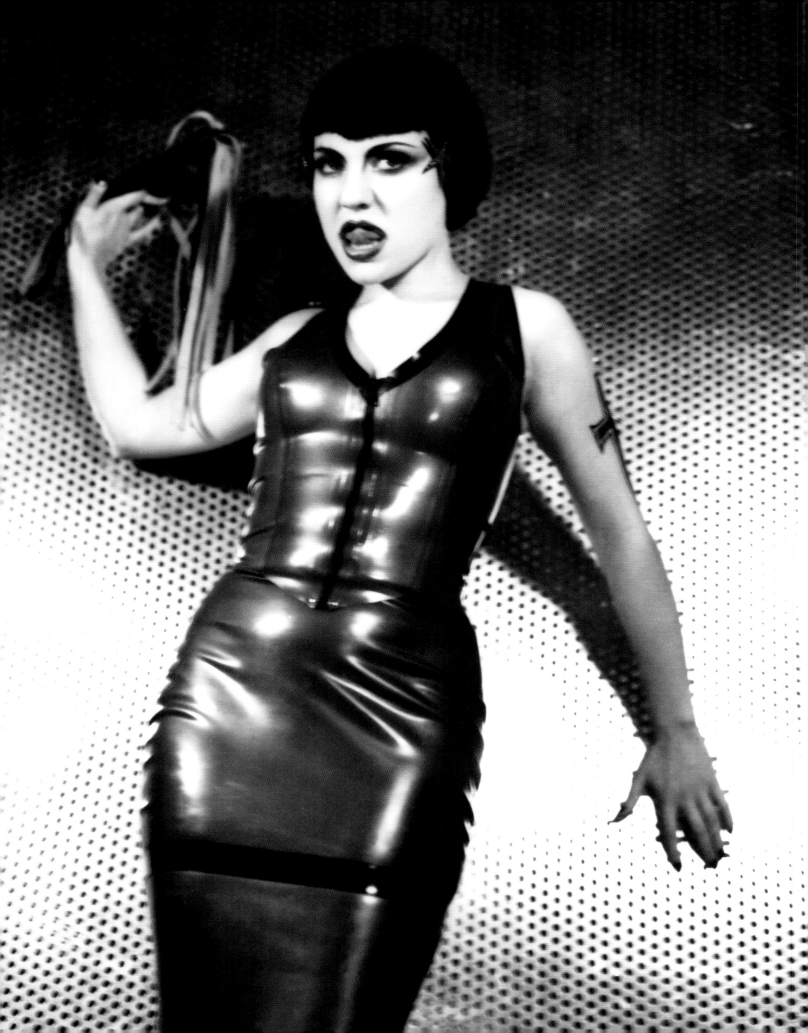

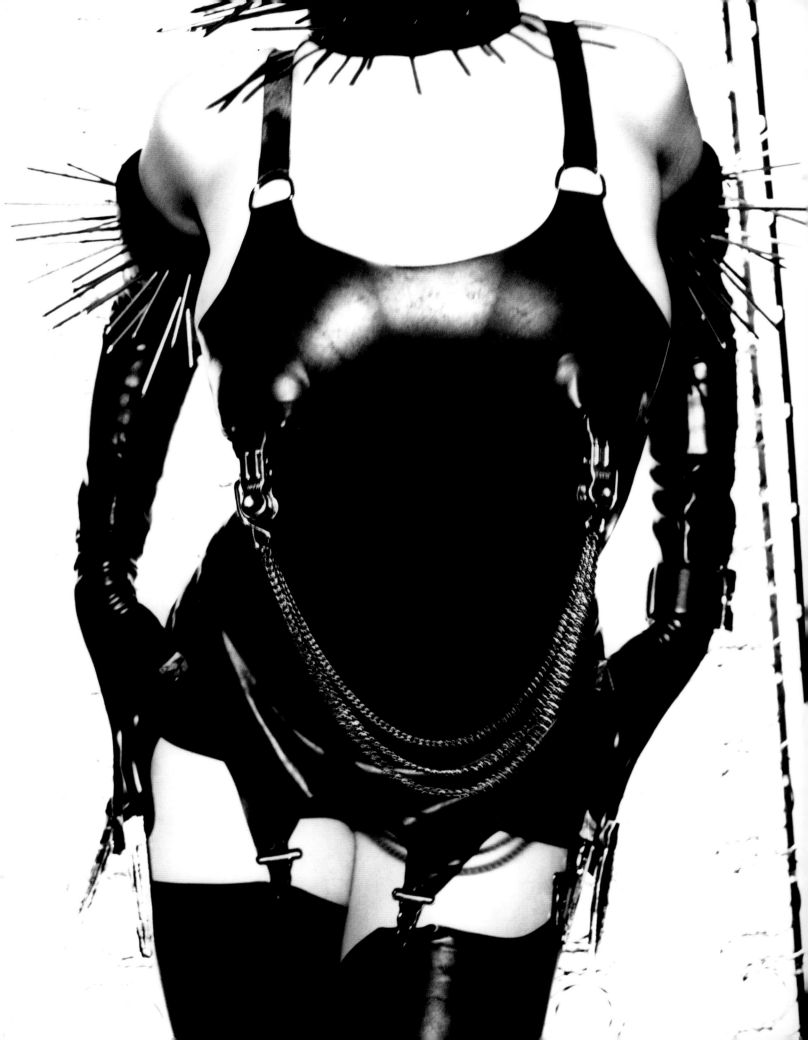

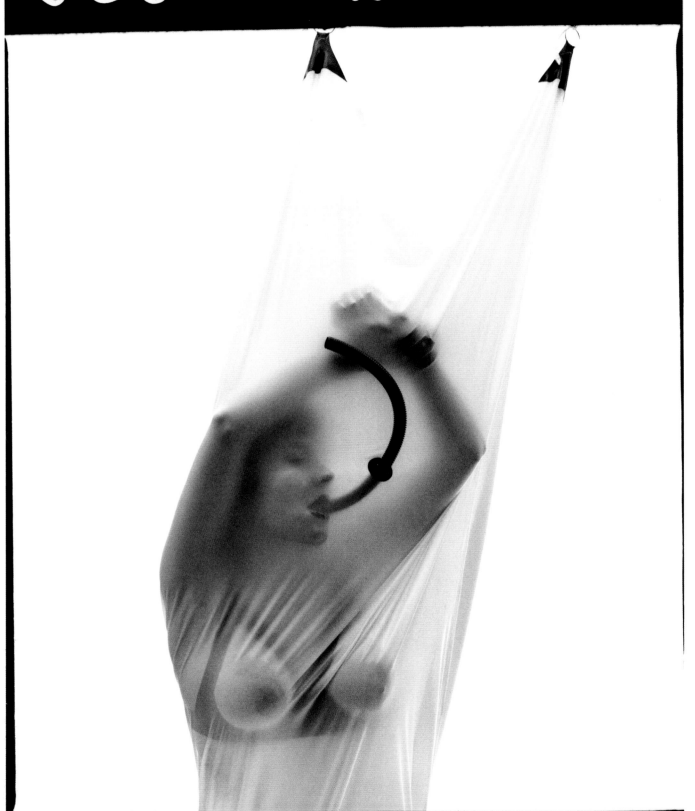

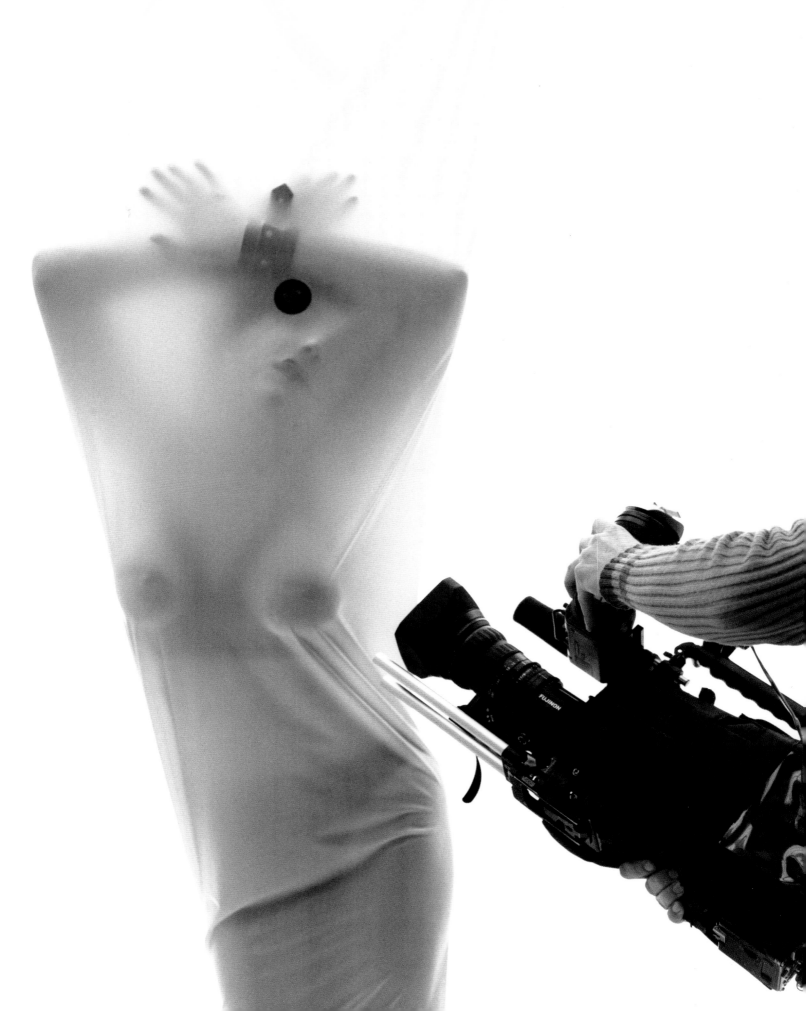

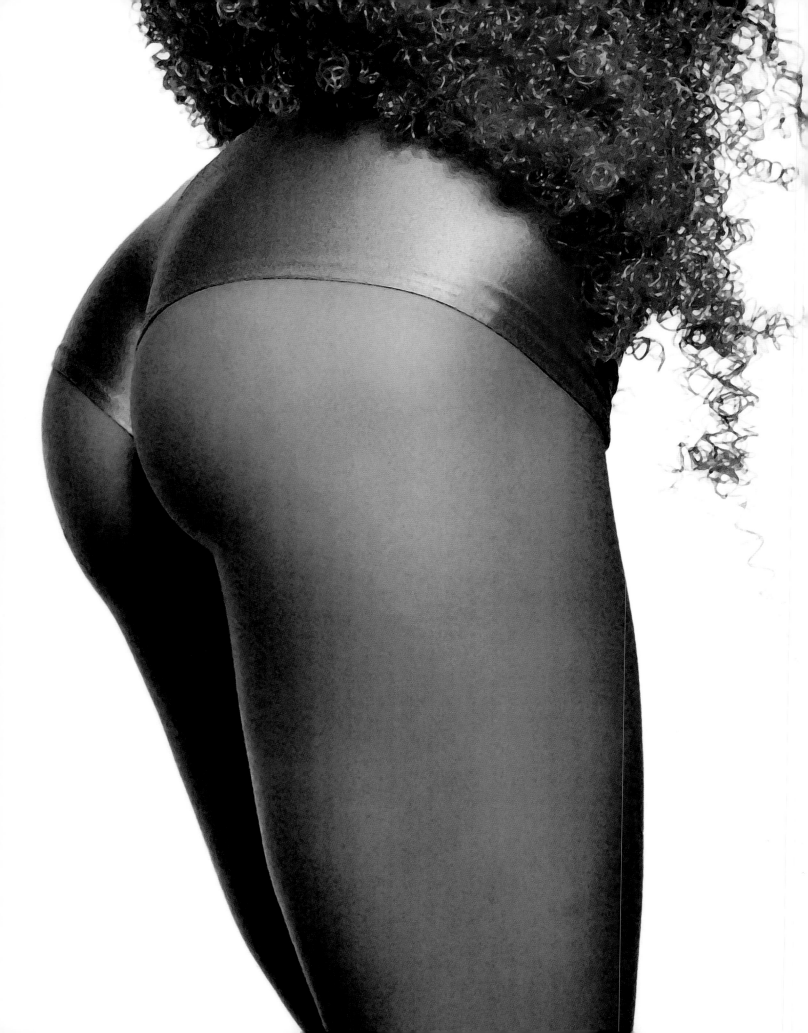

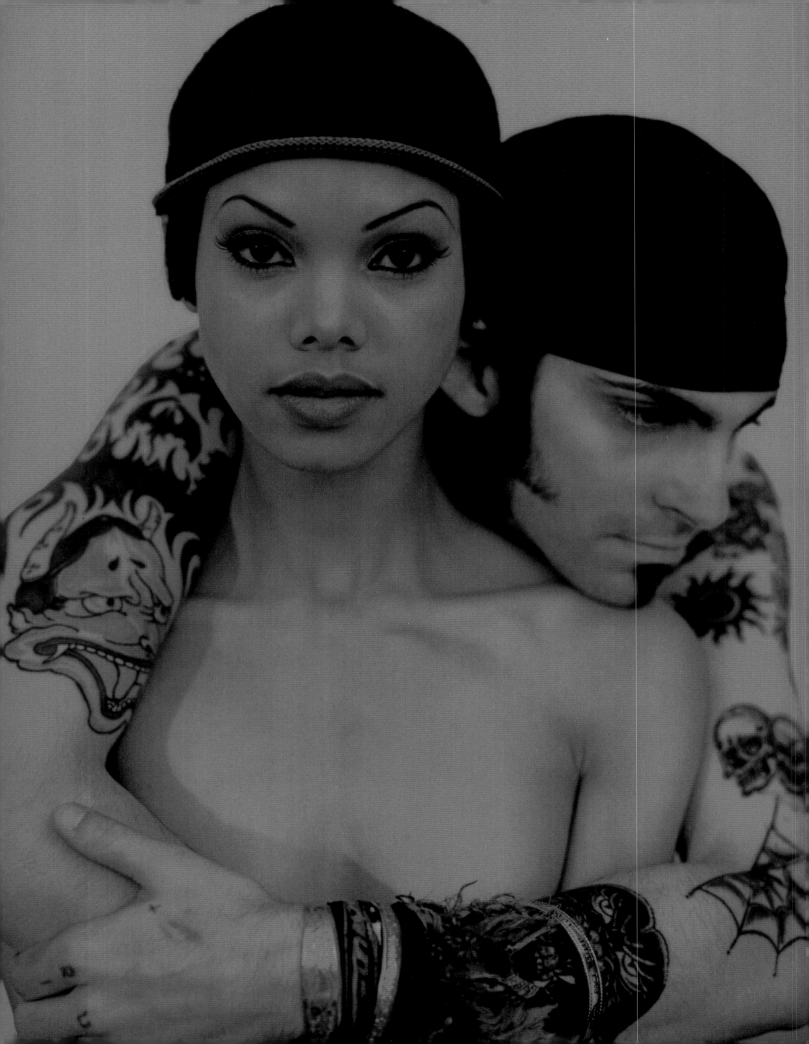

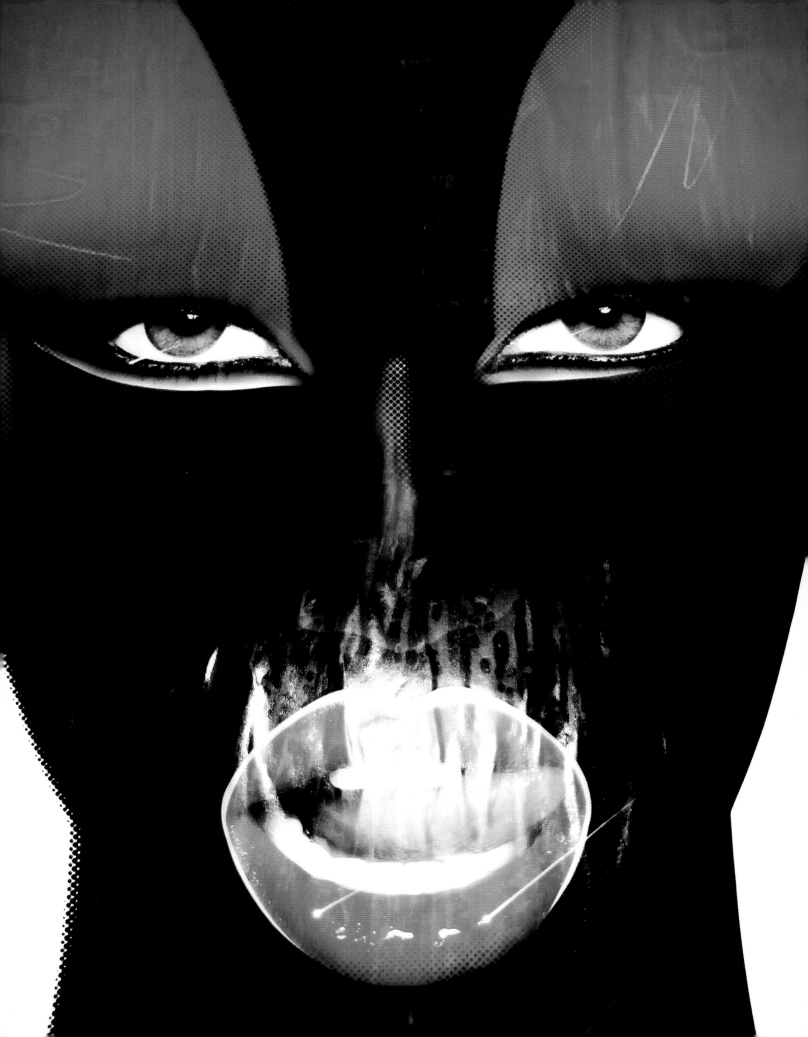

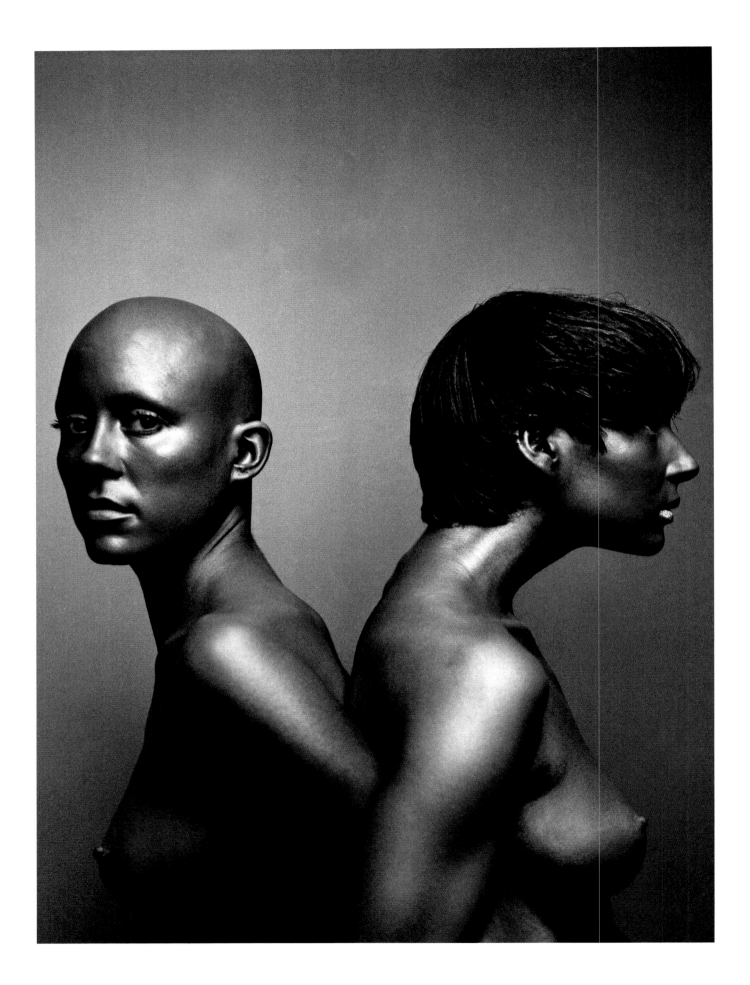

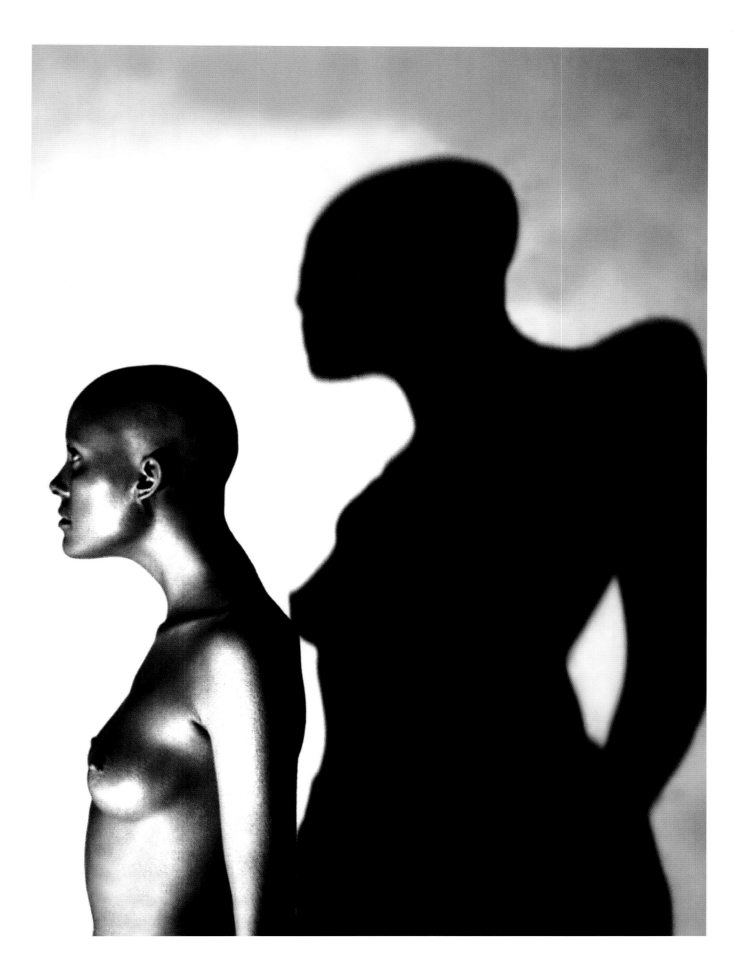

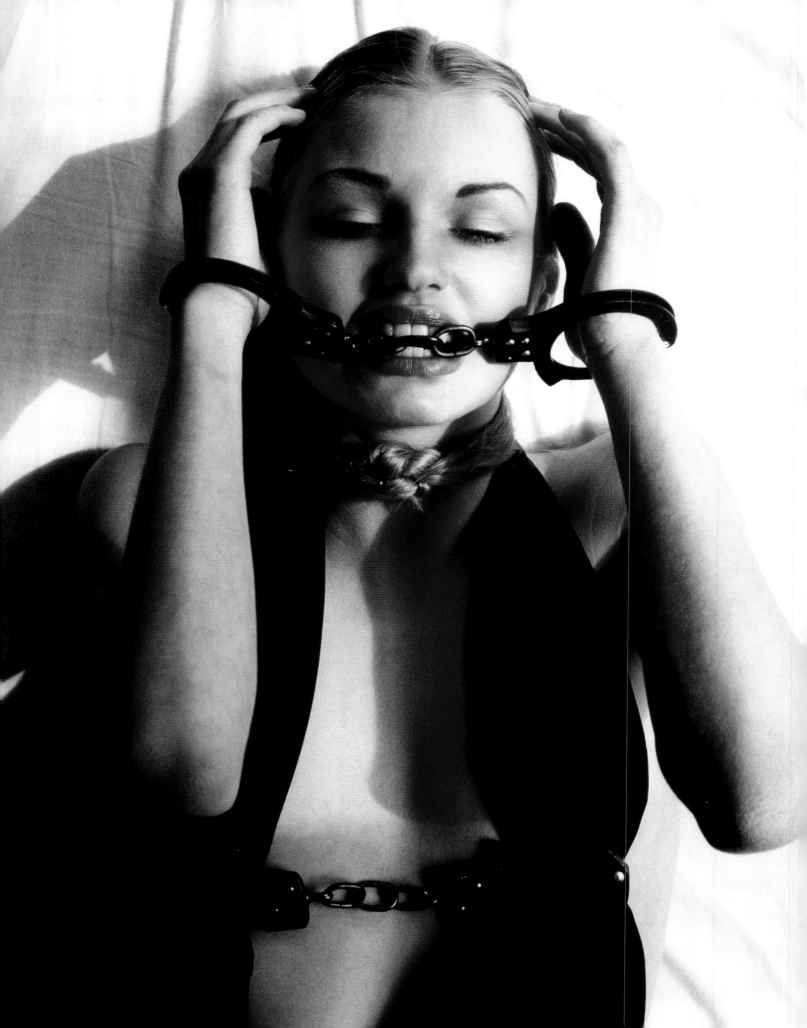

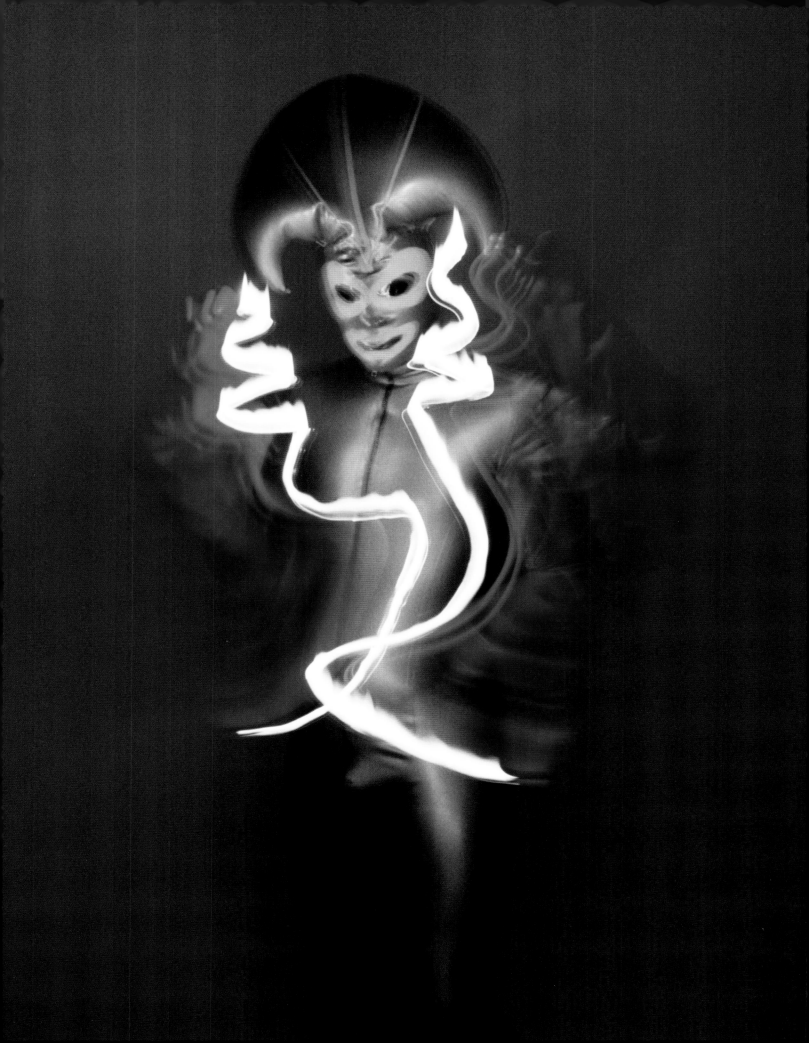

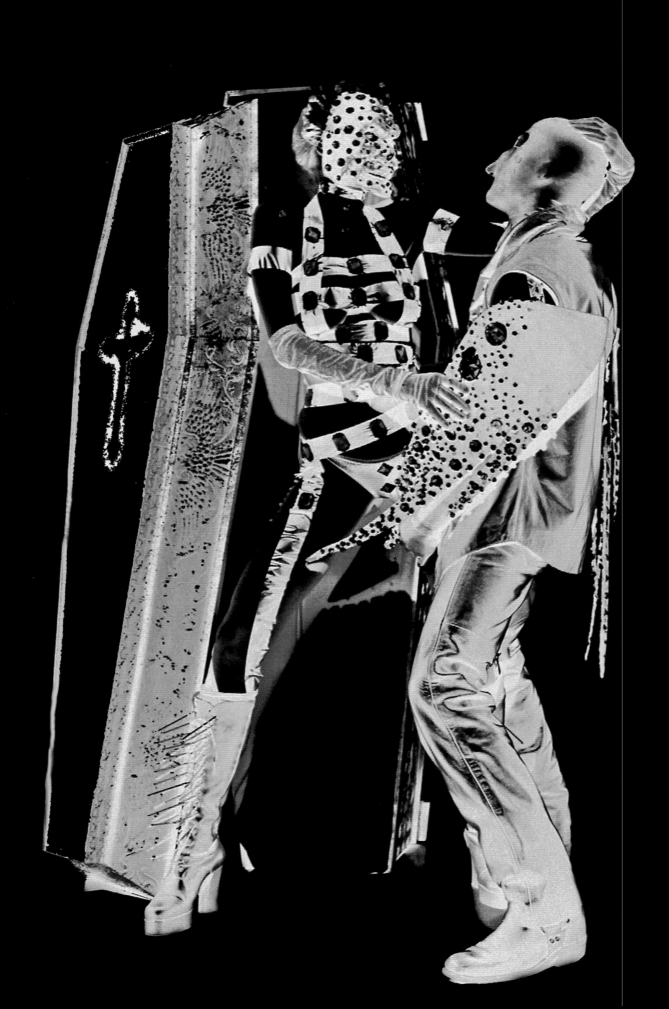

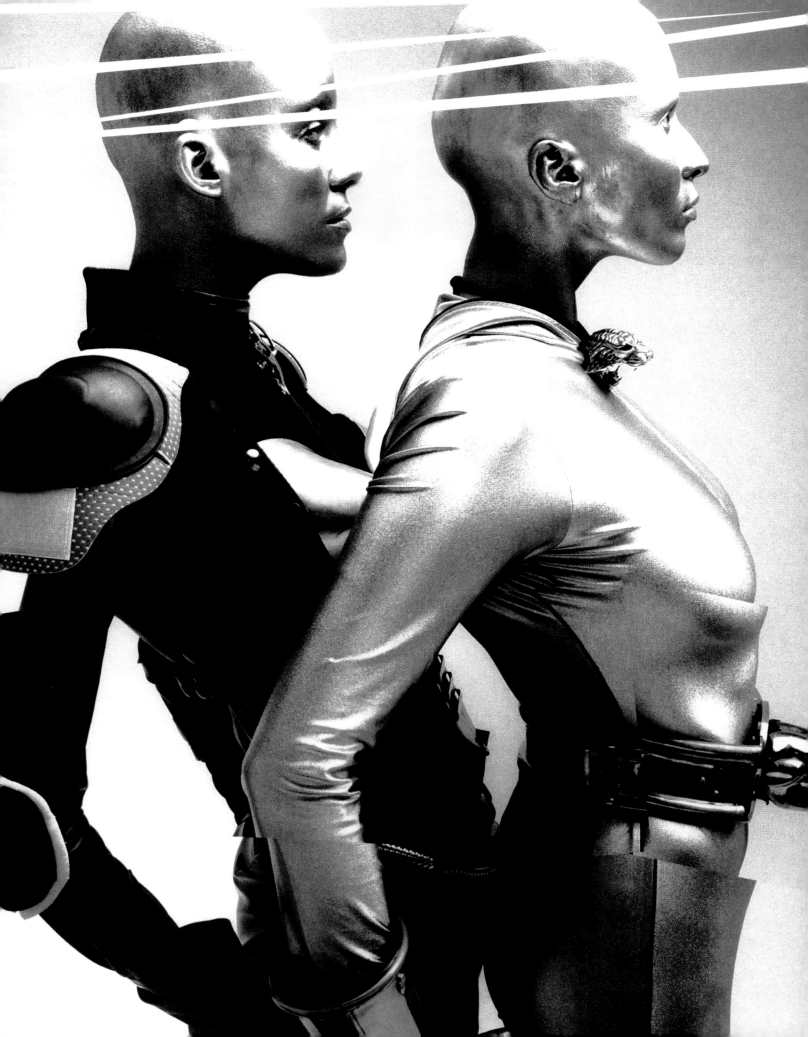

MILANO

NODOLINI

Vogue Italia's offices were right across from the Castello, very grand. You entered to a porter who would confirm your appointment then direct you to the appropriate floor where you were told someone would meet you. Passing through the offices of the fashion directors you were led to a long corridor where you were asked to wait. A row of seats awaited and usually there would be one or two others already waiting, portfolios by their side doing their best not to look too anxious. Appointment times meant nothing here and you would wait and wait. It was as if your patience was the first thing to be tested, which is was. Were you simpatico or understanding? If the wait was for a couple of hours you might be asked if you wanted a coffee at some point but then again you might not. Then after waiting all afternoon someone would come to you and ask you if you could come back tomorrow or maybe next week which you would agree to. You did so because this was the office of Alberto Nodolini, chief art director of Vogue Italia, Vanity Fair and all the other connecting magazines. The following appointment you would go through the same procedure again. Maybe this time someone would ask you to hand over your portfolio while you waited. Then came the reply, either thank you very much or could you please come back the following week. Which you did of course to begin the same process all over again. Finally, perhaps after recognising the same portfolio again, you would be asked into the office were you would be asked to be seated at a chair near the door. From here you could see the whole office or art department in action. Maybe twenty boys and girls all seated on separate desks working on layouts. The only machine there, a large Xerox machine where hand done type was pulled through the Xerox machine to create the warped text so popular at the time. Everything seemed to revolve through one individual, who at some point would look over at you and nod as if to confirm your presence and you would nod back and then wait and wait. Finally Nodolini, assistant on tow, would come over and go through your portfolio with you marking out what photos he liked and which ones he thought irrelevant to him. Then you were asked to come back. I'm not too sure how many times I went through this before he gave me a job but Vogue Italia was my first job in Italy. I was given what any new up and coming photographer was given, a small section near the back. In this case it was accessories. I was to shoot the job at Vogue's own studios. I remember turning up at the studios

at eight o'clock in the morning eager to begin my new Vogue life only to find the studios locked. Finally around half nine the caretaker finally arrived and opened the studios. The fashion editor arrived maybe half ten. Lunch was served at one and included starter, main, desert, followed by cheese with red and white wine and even grappa for the coffee after. A veritable feast it was indeed, although I could hardly enjoy it being as anxious as I found myself. Two or three months later the service came out in Vogue. The pictures had been cropped so much I hardly recognised them. Was this the way Nodolini was trying to tell me who was in charge, basically him. However, after shooting my first Vogue job all the other magazines followed. About four months later I was called back to Nodolini's office, much to my surprise and delight. As I had arrived in Milan via Vancouver, Canada I believe they thought me bona-fide Canadian and because of that I was given two fashion services to be shot in the Alps. By this time, whenever I had to see Nodolini, I was now lead directly into the office studio although I would still have to sit and wait. By now I sort of enjoyed it, as I could watch him preside over his empire, dismissing layouts and approving others. I still spoke very little Italian and Nodolini spoke no English (or pretended not to). I could watch as new sets of prints or slides were delivered. Illustrations by the wonderful Antonio, un-fixed prints by Helmut Newton with a shelf life of only a few months. At the time the cover of Vogue was a yearly contract. Hiro had done the last year and when I arrived with my mountain services the new year was beginning and Bill King had been awarded the new contract and his first cover shots had arrived. King was known for his stark white background photos which always involved movement or the feel of movement. The new cover I was looking at had two models both with very blood-shot eyes. Re-touching, pre the digital age, was used very seldom and usually only for covers and maybe a main fashion story. "Beautiful shot", I remarked, "you are going to clean out the eyes?" Nodolini looked at me with maybe a slight smile. "Why?" he asked, "that's the best part of the photo. In fact, it's the only bit I really like." True to his word, the January issue hit the stands, bloodshot eyes and all.

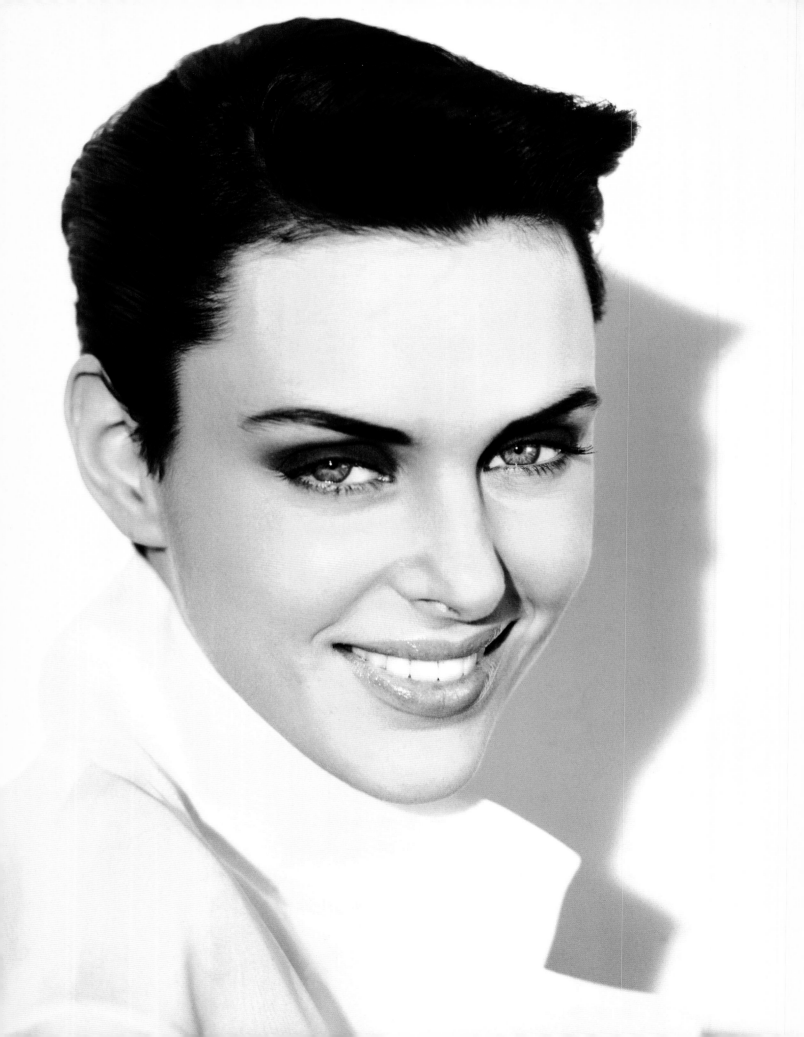

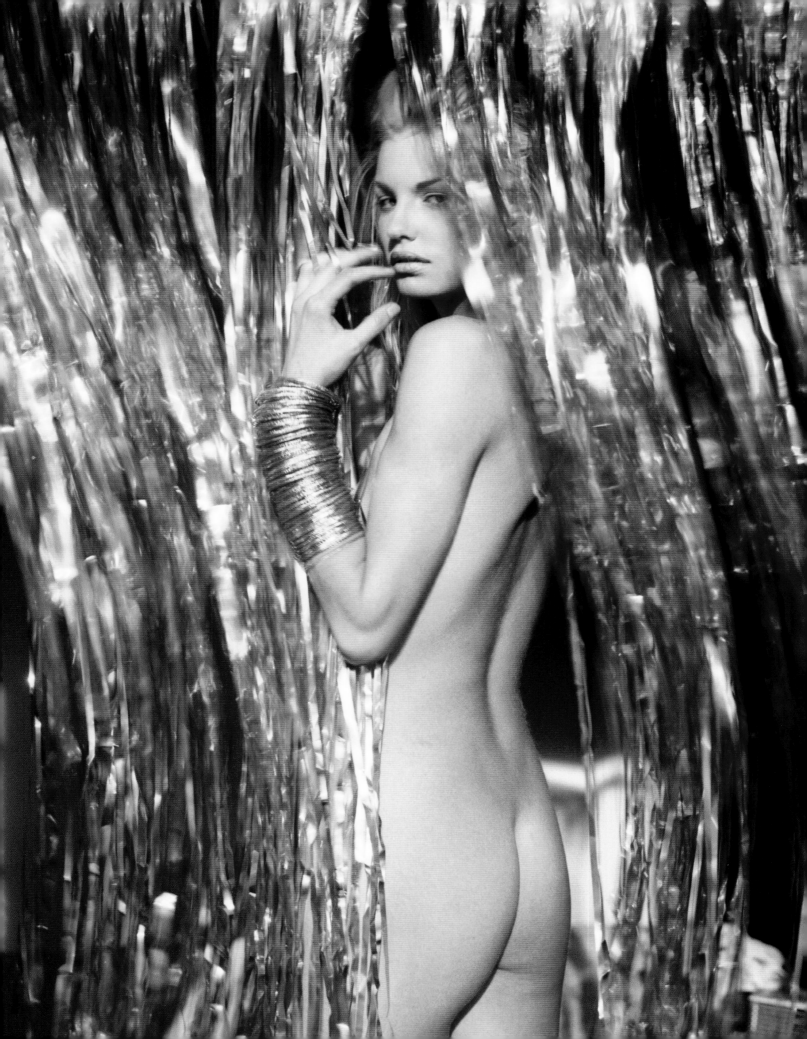

FASHION

X

London: February 13th 2013

Don't worry today if you can't find a cab in different areas of town over the next few days. You might also notice that there are rather more exotic and somewhat striking creatures about than usual. Most of them will be speaking in foreign languages or with foreign accents, perhaps looking lost, definitely stressed, overdressed and on their phones. Oh my, my, my Cherie... For today Fashion Week prepares to kick off.

The castings are on and the shows are about to start and behind the facemasks lies panic. The panic brought about by having to be at a certain place at a certain time, to deliver the goods so to speak, while always looking good, always saying the right things and maybe getting to hang out or be seen with the right people. Fame and glory through association. For one or two of them it might work, but for most it will be a dream filled with lots of hard work, waiting around, strange hours both frustrating and demeaning. Don't let their bad manners bother you. It's to be expected really. It's only fashion.

The Italian magazine Domus dedicated a whole issue to fashion a few years back which was pretty unusual for a design and architecture publication at the time. An intellectual overview of fashion. In it they declared, 'You are what you wear.' In some respects we are, but as we move closer to troubled times it's not so simple, unless you don't mind being classed as poor.

What will these shows tell us? Probably nothing. Most designers will simply rehash older designs with a few subtle changes of colour and tailoring. They will declare a certain style is out and a certain colour is in. They will do their very best to create a trend because trends mean money. The old argument over flares or drainpipe jeans again. I think we all know it's a personal choice by now.

The days of Zandra Rhodes and magical shows are long gone. Is Vivienne Westwood showing again in Paris? A few of the shows will be classed fabulous, but what were we really looking at? The spectacle as a whole, the clothes, the make-up, the hair - or just the bodies that walk the runways? A few - mostly buyers for big department stores - do look at the clothes. I mean it could get interesting. They might even work out a way to screw even more money out of women.

Let's face it, by the turn of the millennium most big designers made the majority of their money from accessories and perfumes. Calvin Klein had showed them how to do it through the eighties. Everything was marketing for Klein. I spend one million dollars on advertising I make five million back. What do people want? Sex. What can we sell them? Underwear and a good smell. Especially in fashion, advertising becomes the pornography of capitalism. Others followed Klein and by the turn of the century with available money we saw the return of luxury accessories and name recognition. Gucci, YSL and Prada returned, not for the first time. Handbags became the new luxury item but at hugely inflated prices. How you can charge thousands for a well made leather handbag still amazes me. All it meant was that handbag prices shot up all across the board. You now have to pay hundreds at least for a decent handbag unless you are prepared to go down the market and buy a copy. Forget name recognition. Are you that insecure? Are they paying you to go around and advertise their products? Greedy, elitist, wanting and unnecessary. We are still in a system that encourages big profit where possible, but please, not over the people and their basic needs.

The really innovative fashion will more likely come from the small studios. The ones who don't have the big shows or big backing. These are the people one should source if you are really interested in fashion. The new designers experimenting with re-cycled clothes or even waste

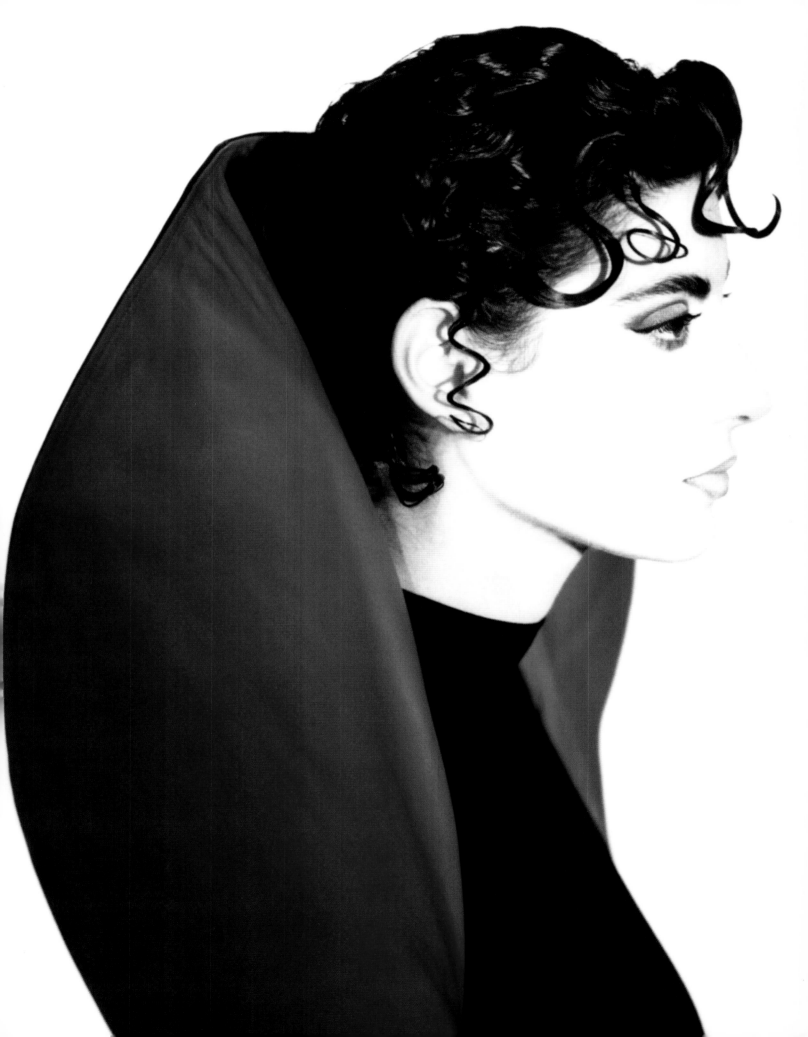

products in their wares. I find this both interesting and heartening. These are the people the Government should be helping.

I worked in the fashion business for years in Italy. They used to say to me, 'The English come up with the ideas, the French make them cool and the Italians, we make money on them.' Ok, well done Italy, you make stylish, well made clothes, but why is it that anyone with money or good taste wants to look English? The Italians always seem to over-do it, the French have great style but what makes Britain great is understatement. Restraint. Something the Government shouldn't have when it comes to fashion funding.

Too much, I feel we look down on fashion as being a silly frivolous business. Maybe when Britain was busy with Hong Kong and other more profitable trading it was considered so, but please, not today. When I first moved to Italy in the early 1980's the government was pumping money into fashion. Designers were backed with grants and magazine advertising rates were kept very low to encourage clients. The result was magazines that were followed all over the world. Where else could a new designer put a ten page ad? And designers now known all over the world like Armani and Versace. Any new up-and-coming British talent is immediately snapped up for these type of companies now. The proportion of English designers working for foreign labels must be scary.

Fashion week has always been a messy affair, with top designers coming in then falling out. A Draper's Record kind of week. I feel it really could do with some serious backing. We all need clothes to wear and the better they are made, and the more functional they are, the better. So let's make clothes here again. Celebrate English style and creativity. No more tacky rip-offs of foreign brands. Go for style and quality over brand names I say.

So, what will happen this week? Probably nothing. And what happened last year? Whatever happens the shows will go on, there will be a few parties and everything will be fabulous, darling - the same as it always was. The rent-boys will see their business boom and the playboy billionaires will give out jewelry as if they are giving out candy. The luck of the few. Oh, and those strange people you might have noticed, don't worry, most of them are harmless, some are even quite nice and a few are friends of mine. It's the Calvin's you should watch out for. In more ways than one...

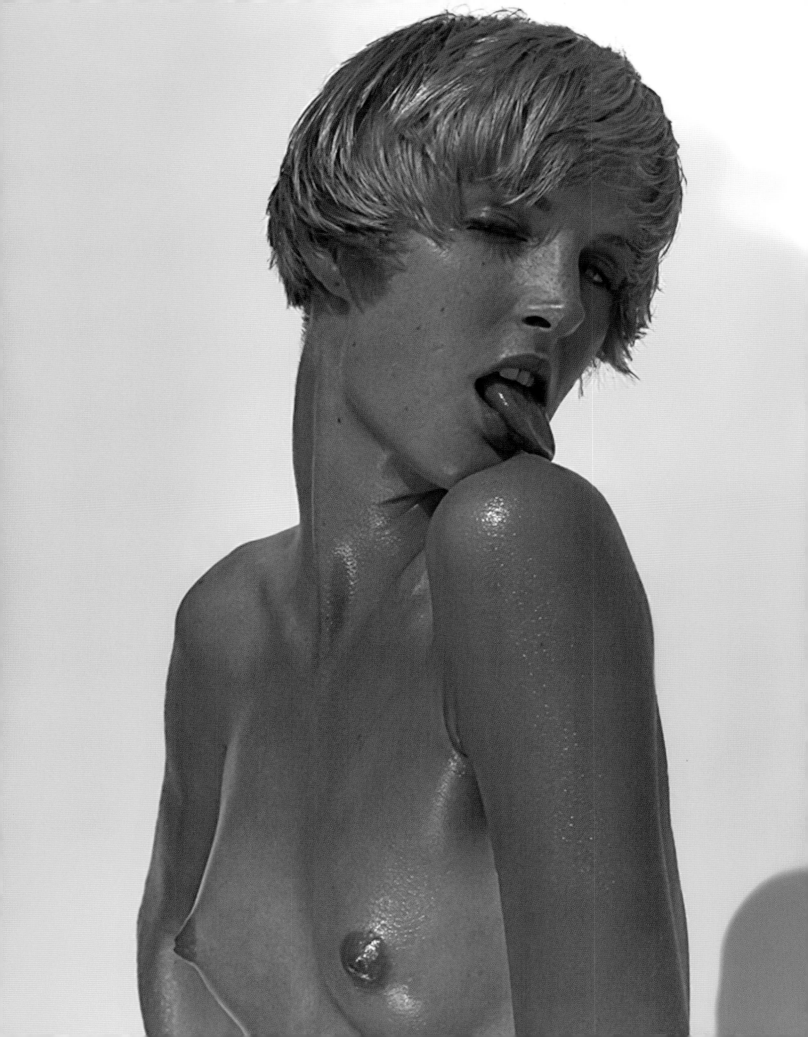

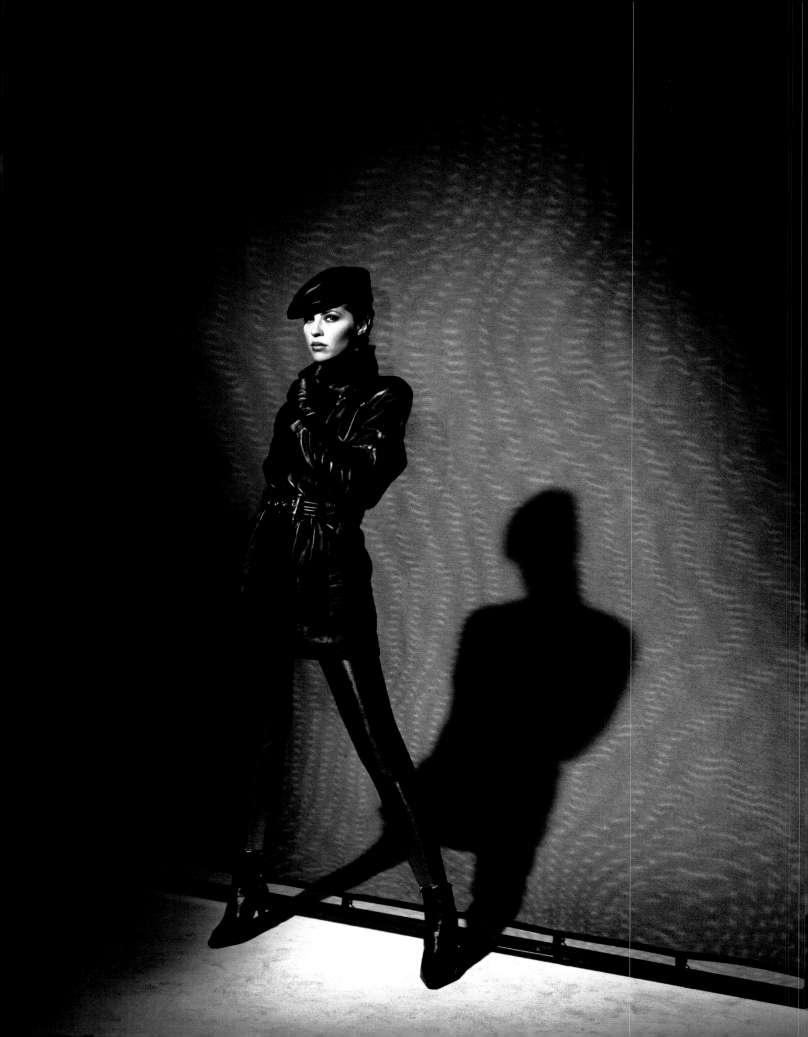

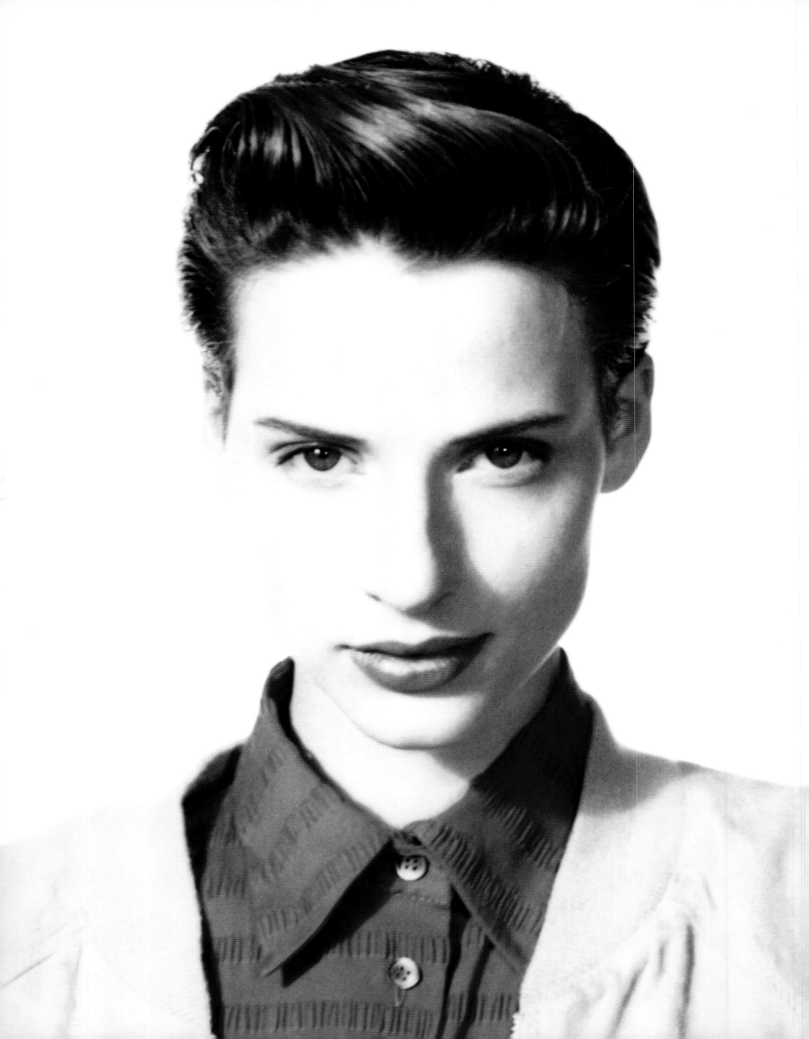

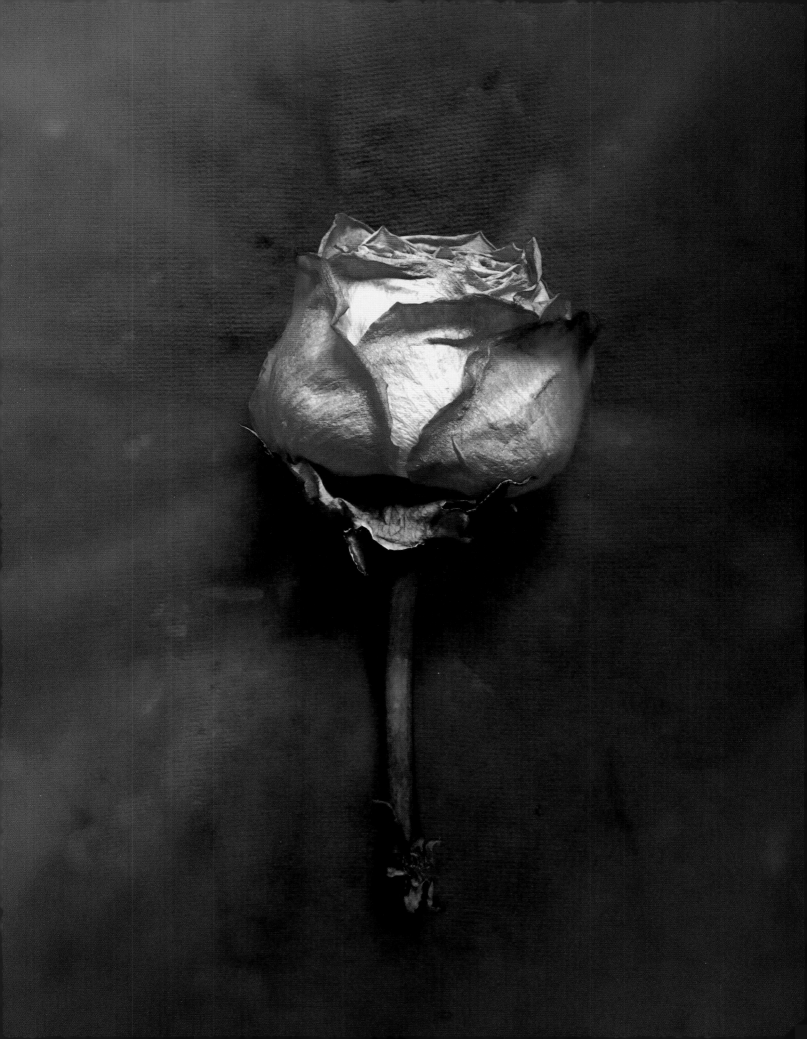

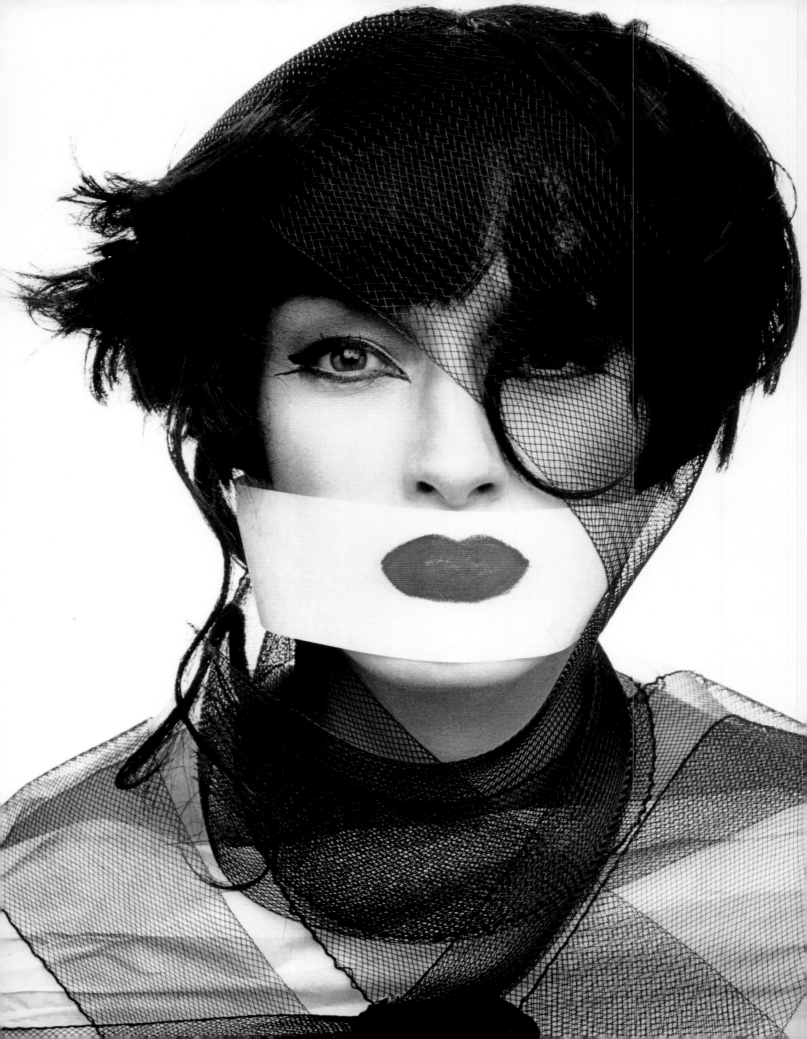

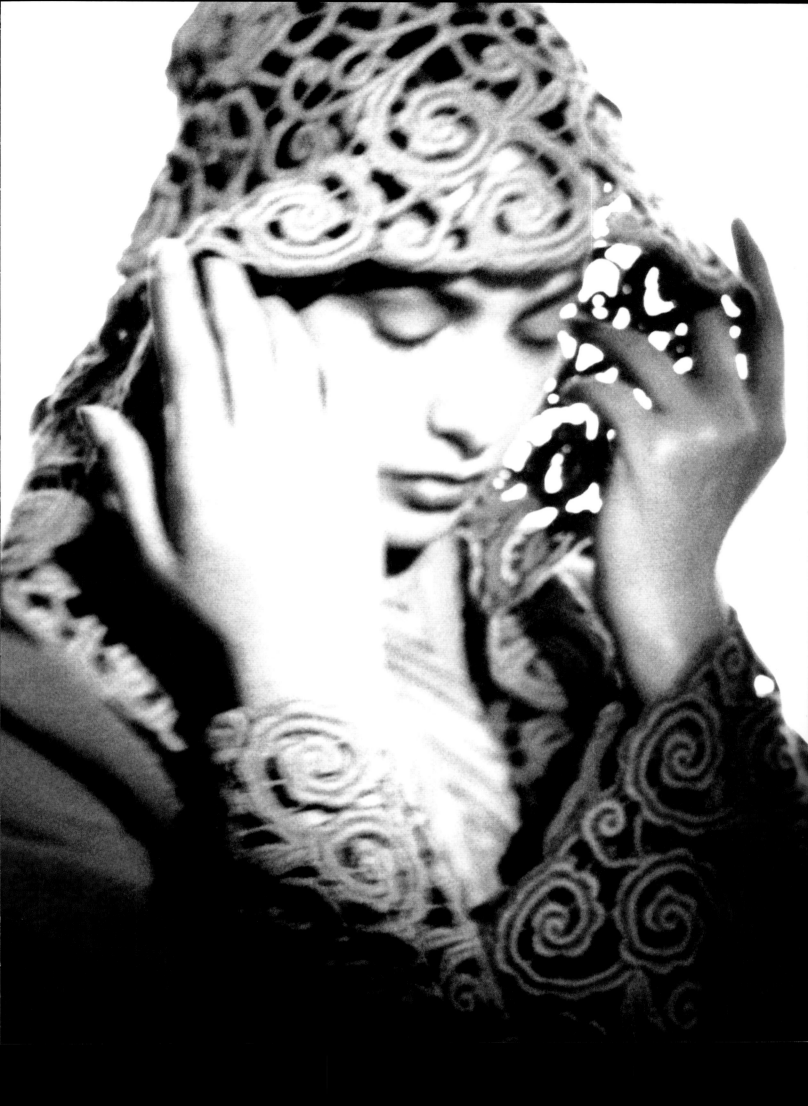

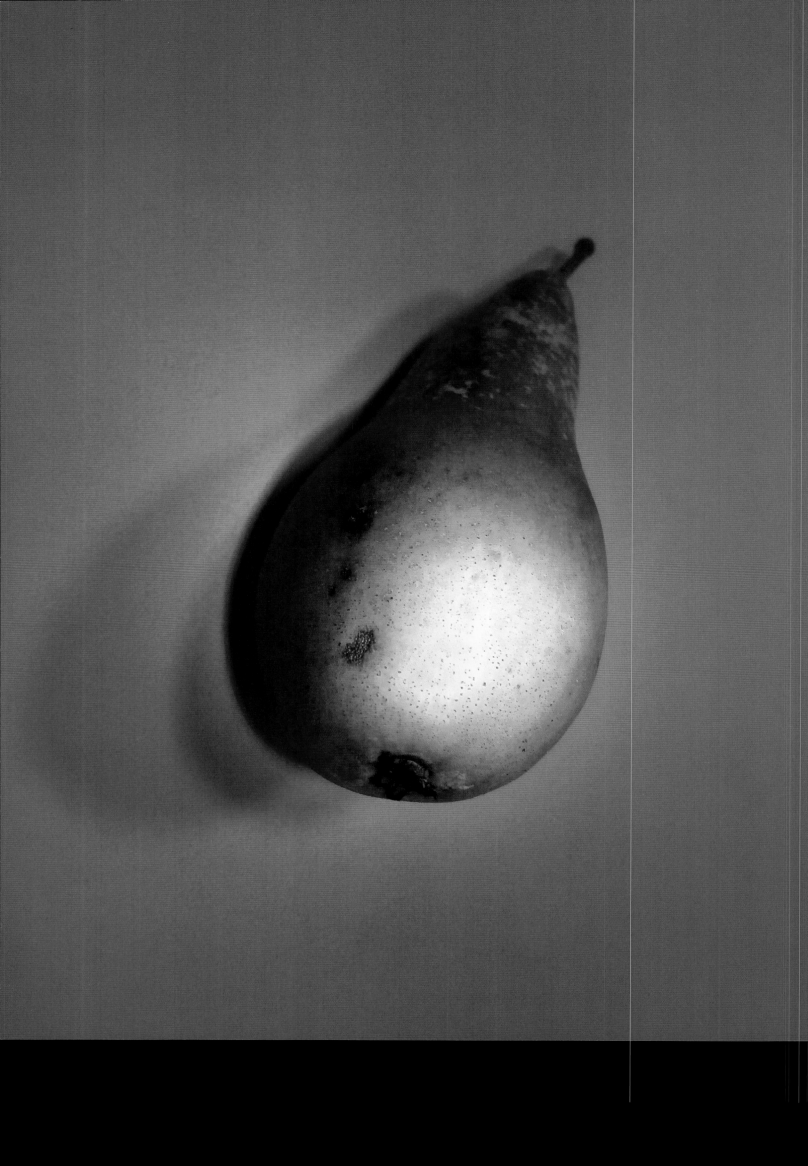

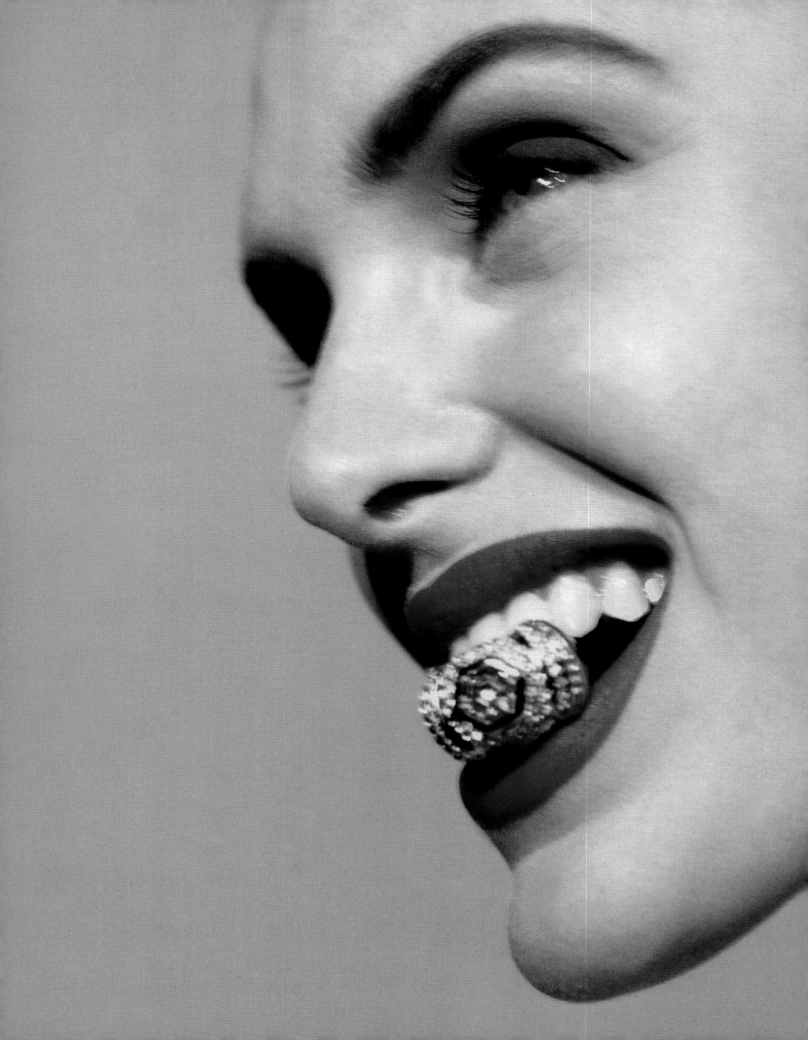

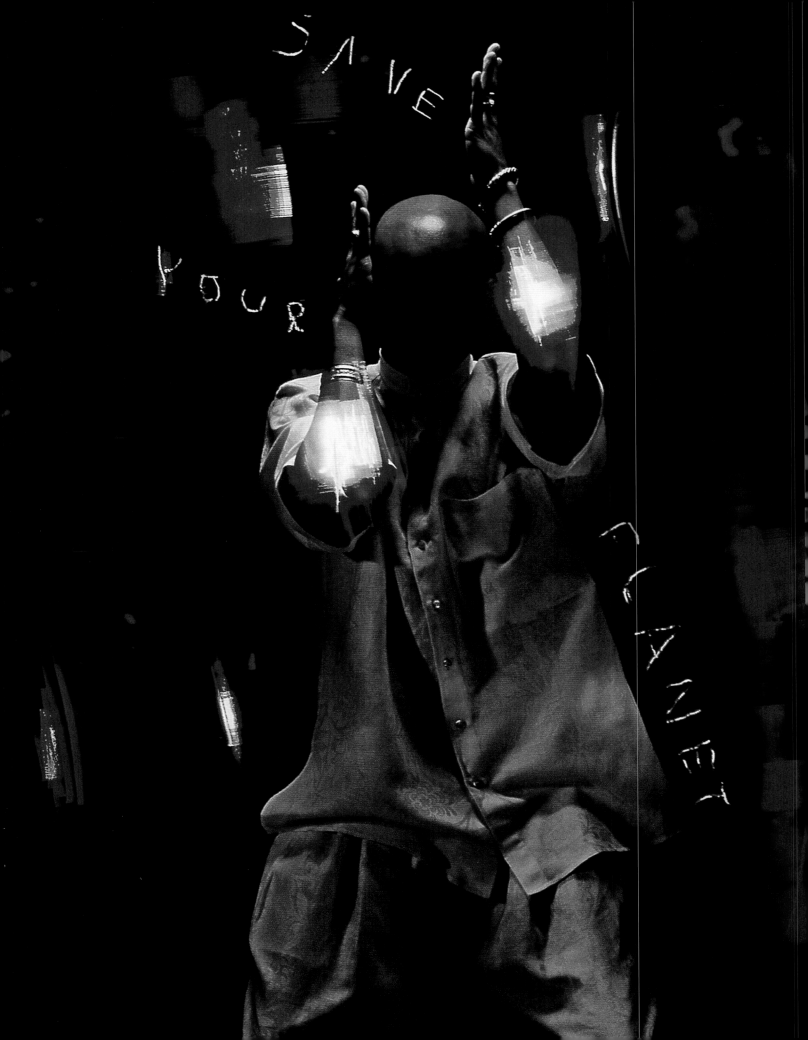

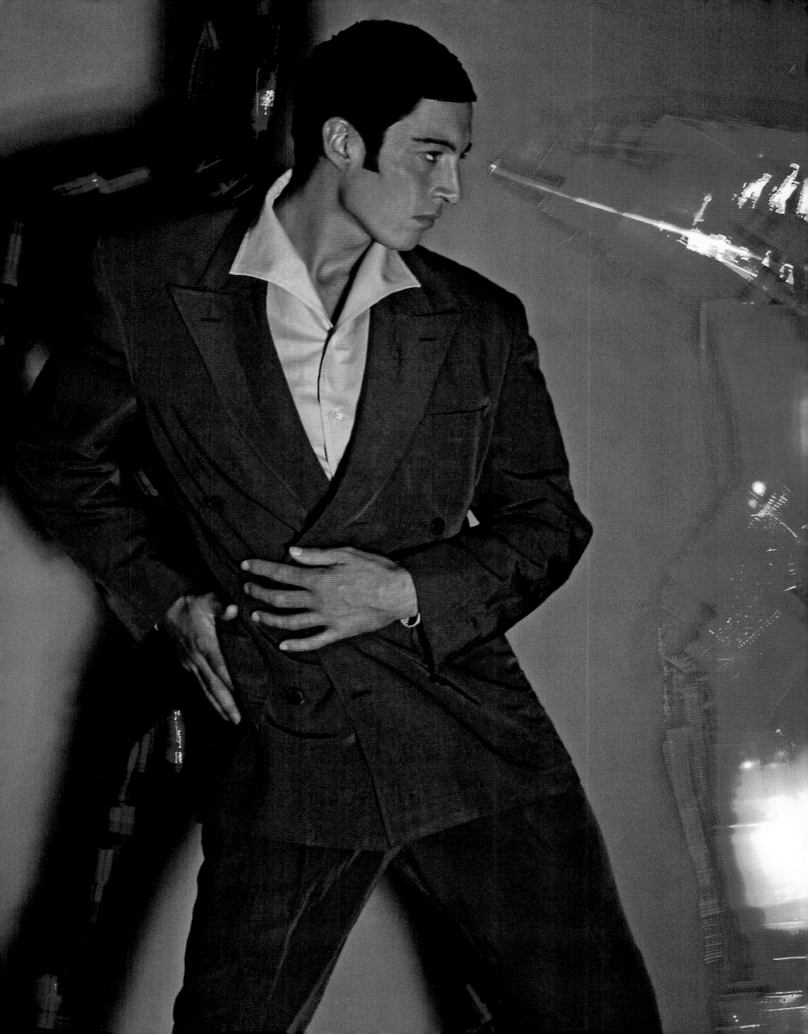

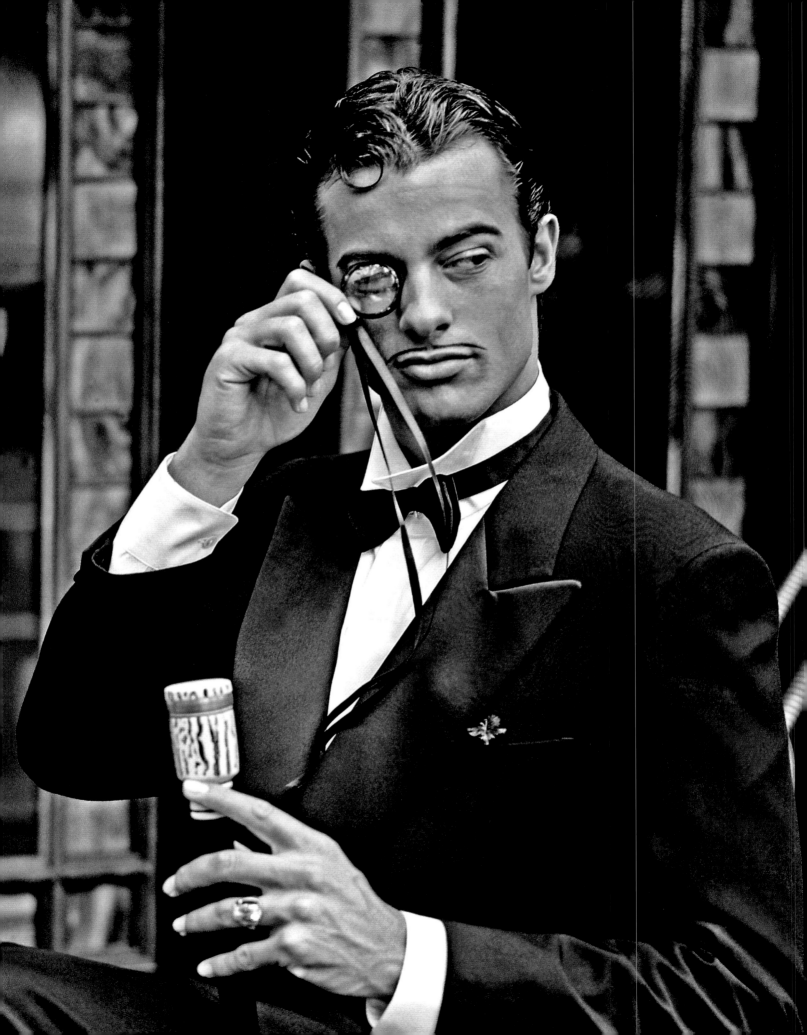

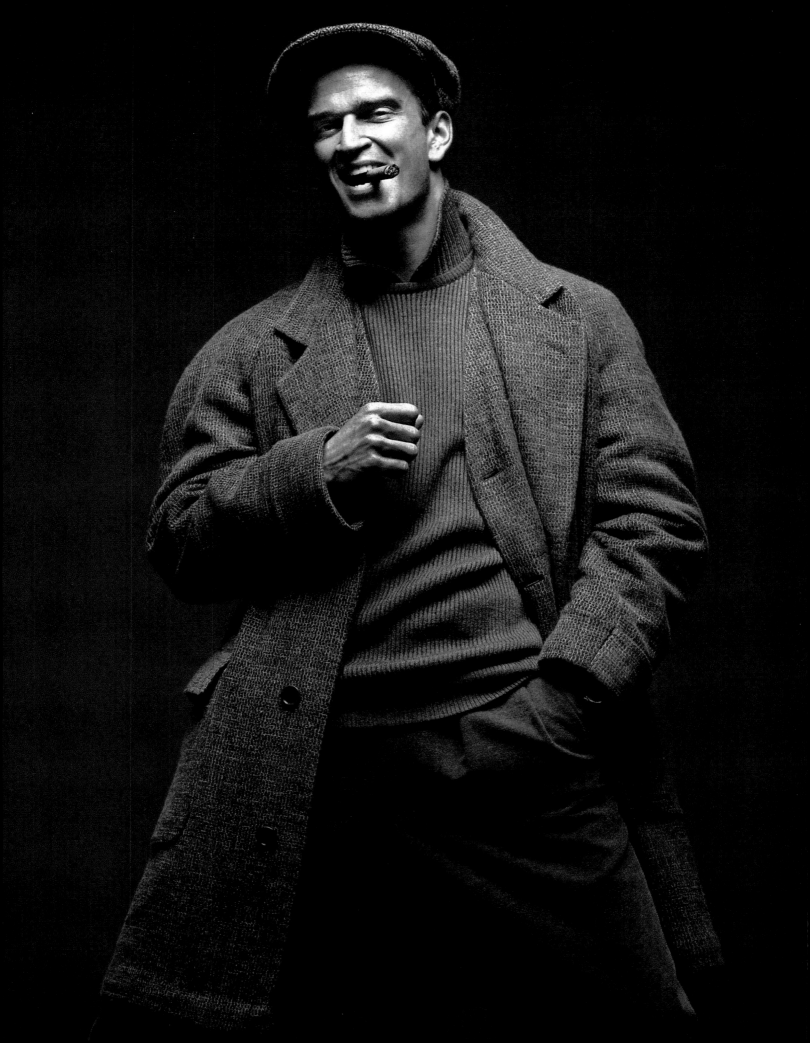

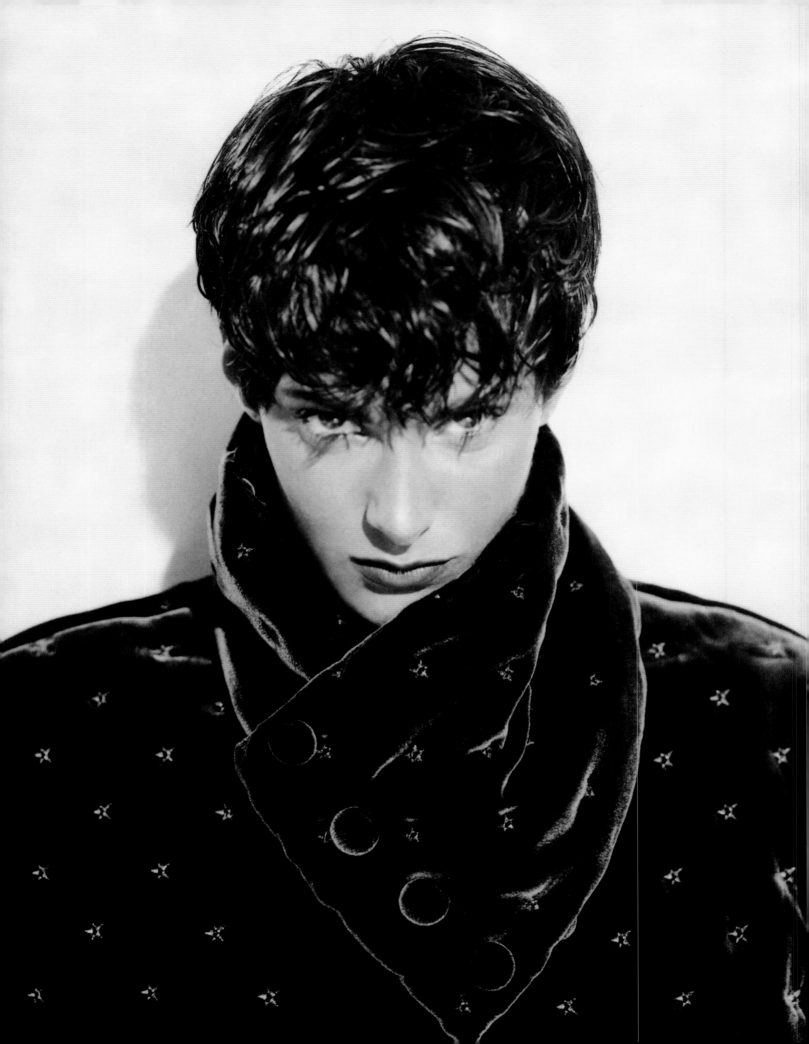

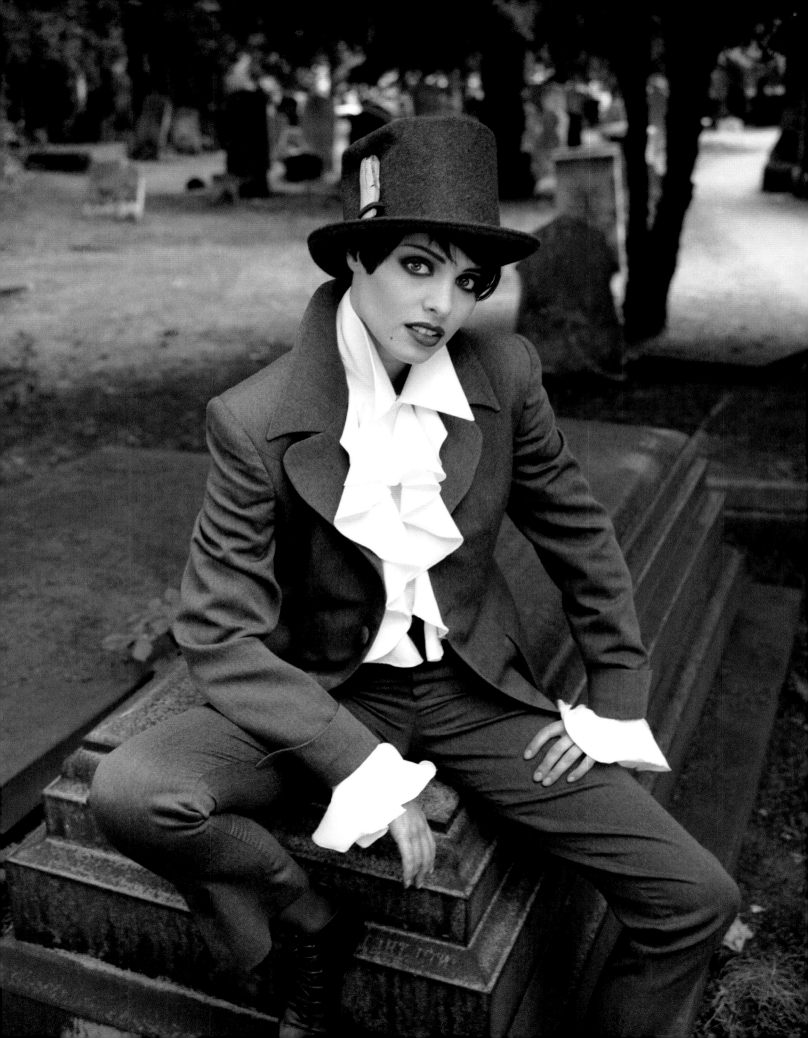

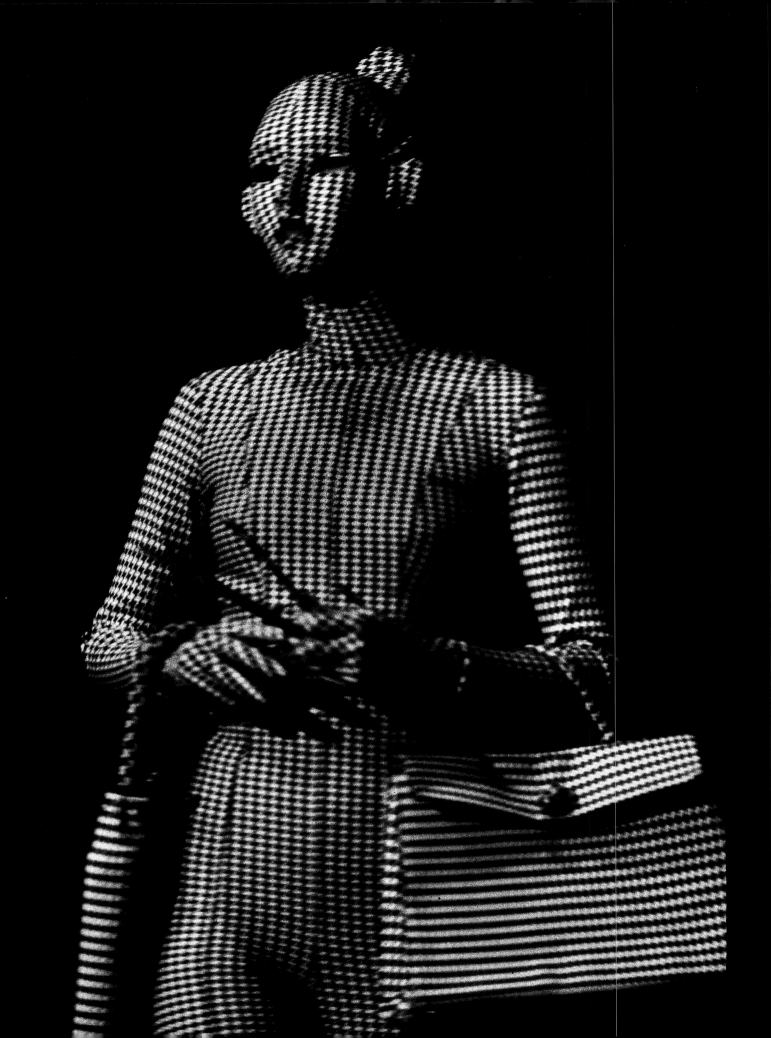

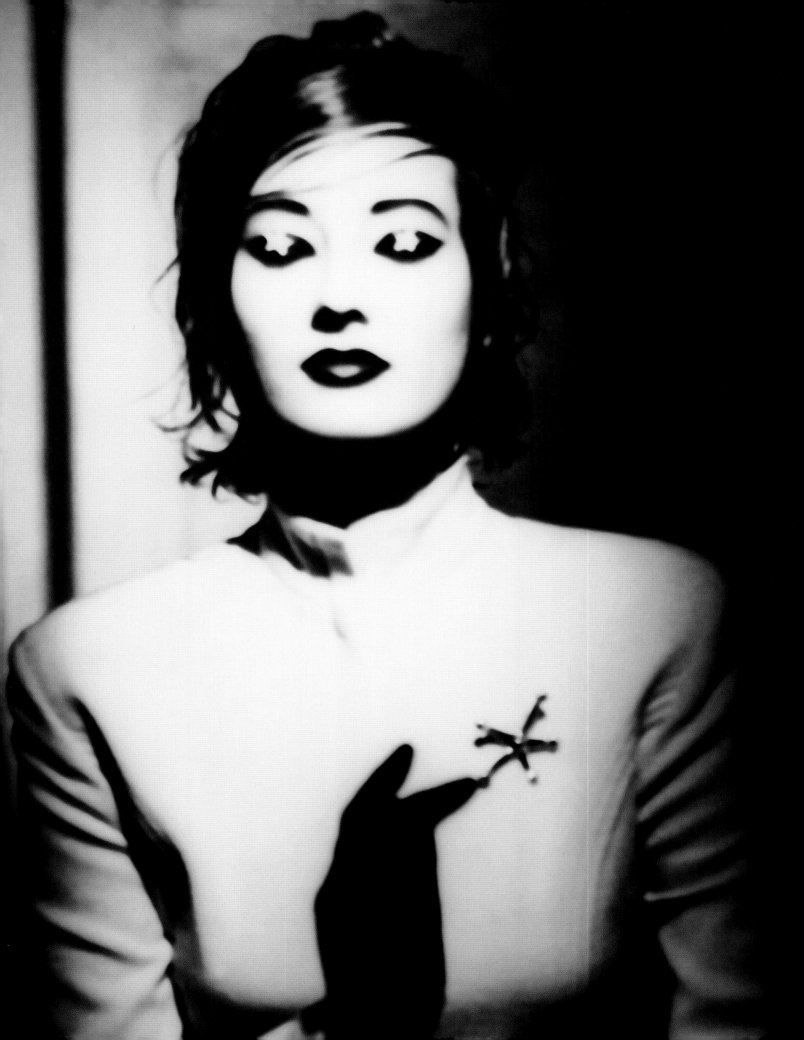

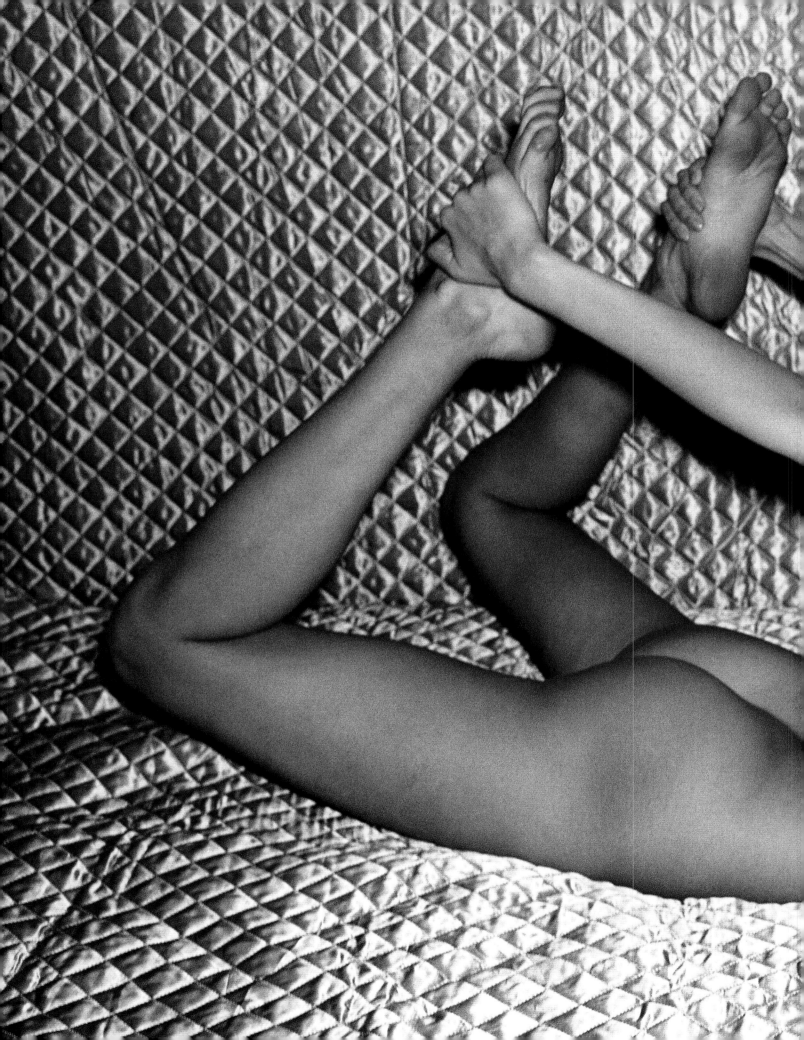

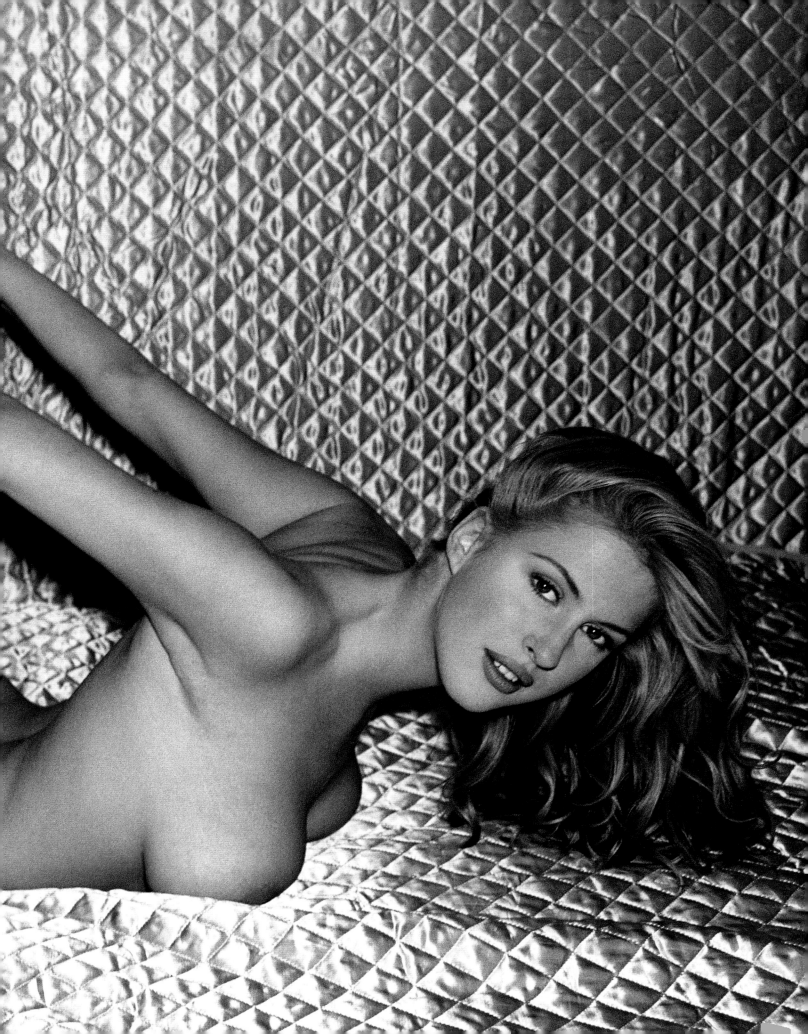

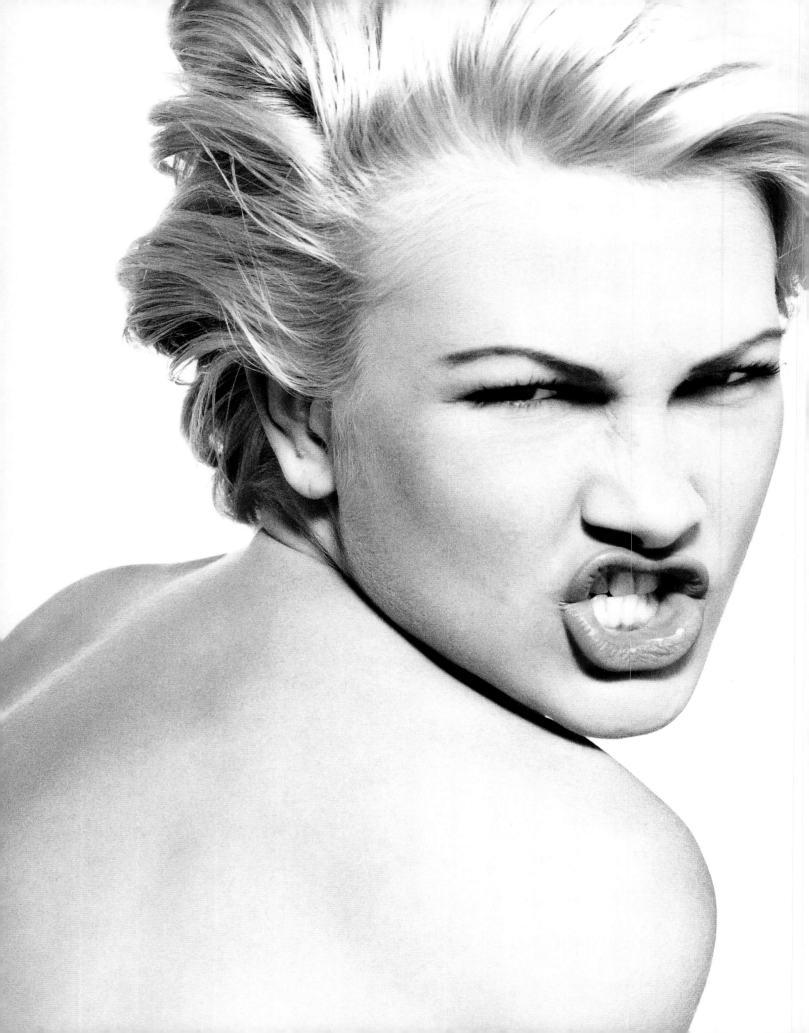

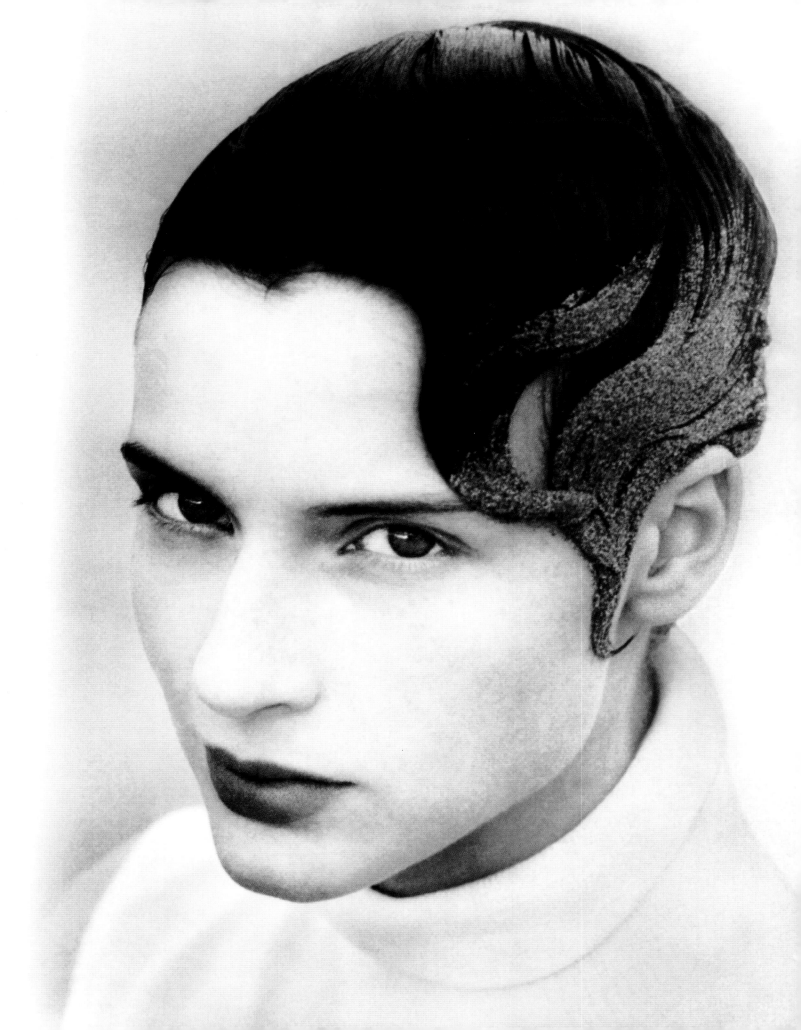

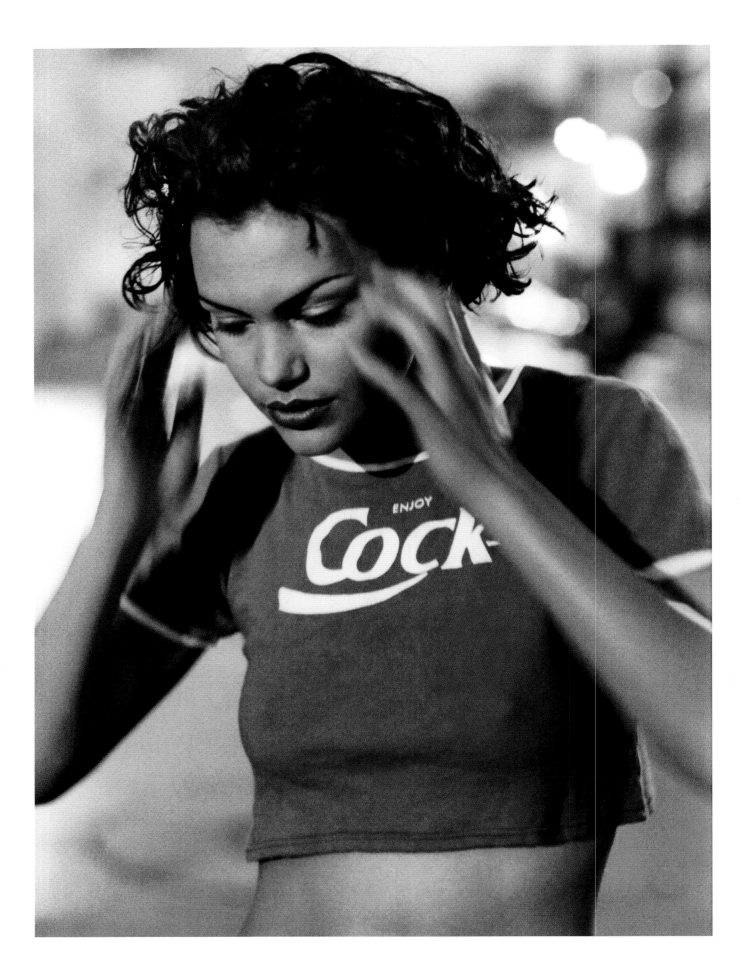

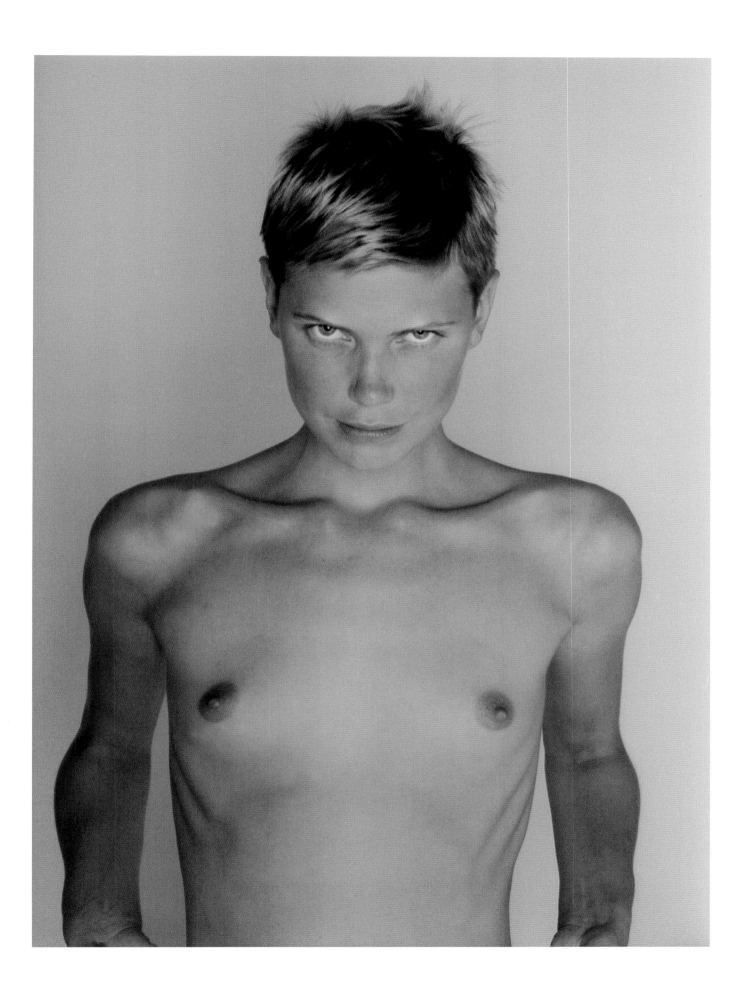

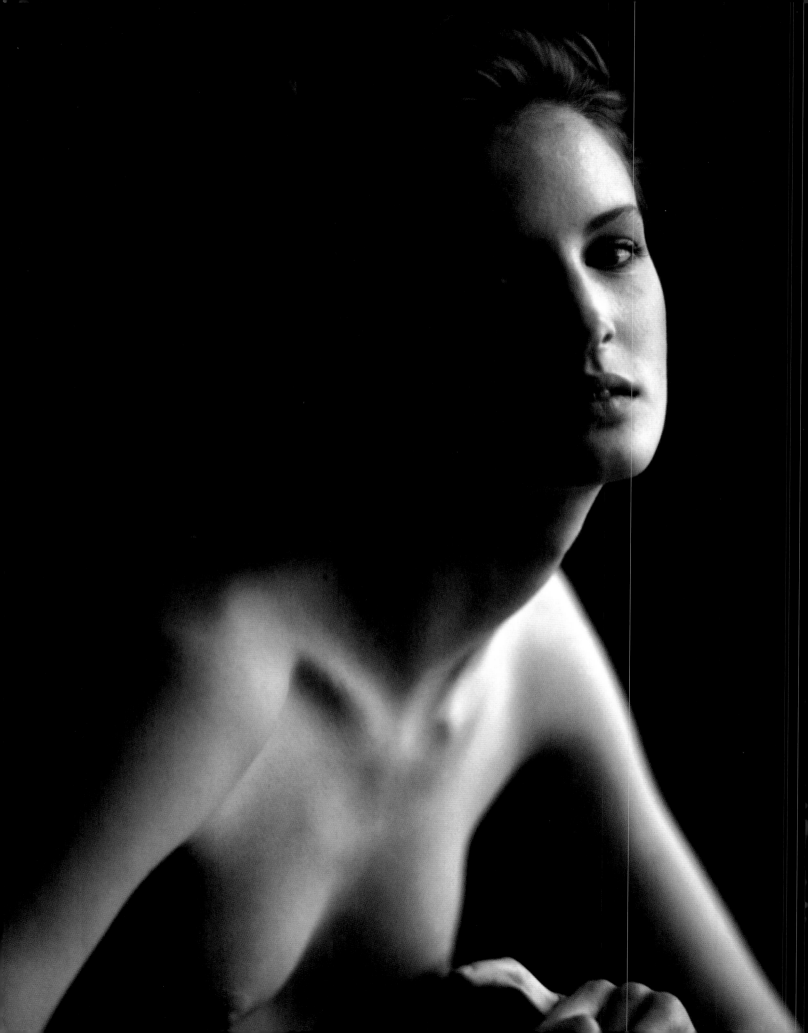

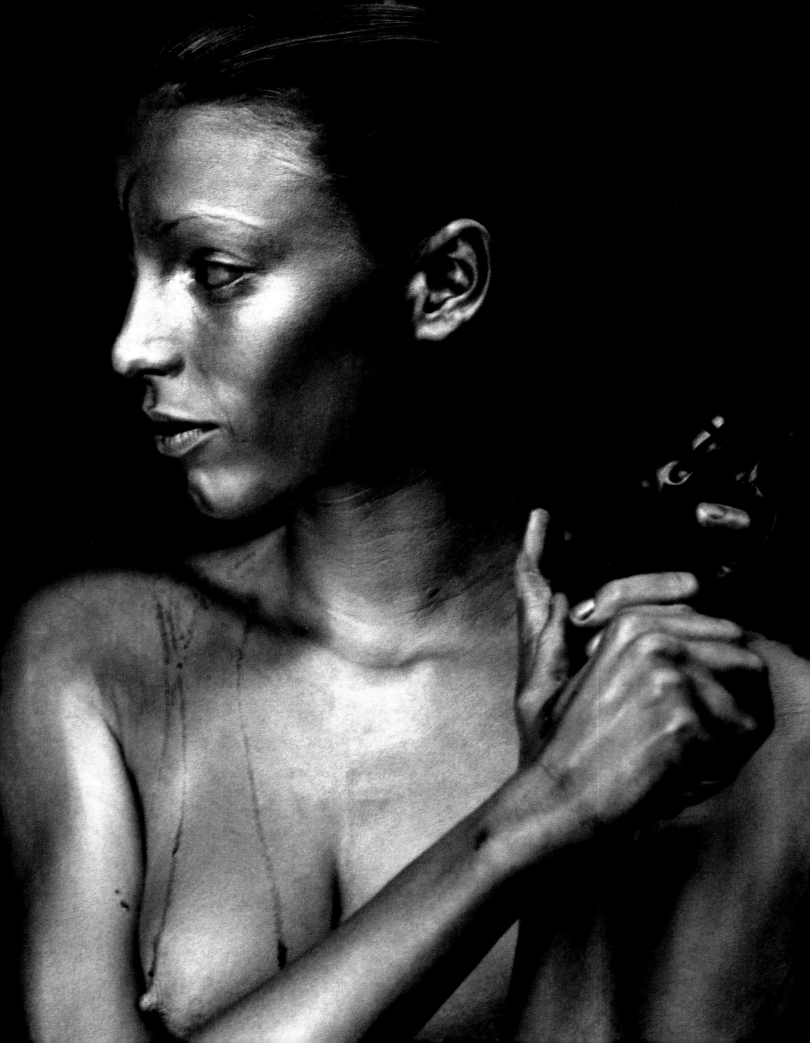

This is Not A Drug Story

Do the Right Thing

Dateline: 7th October 2003
Location: Inner London Crown Court

"Do you have a verdict?"
"Yes."
"Was your verdict unanimous?"
"Yes."
"How do find the defendant?"
"Guilty."

My heart dropped. The trial had gone on for three days but it had taken the jury little over an hour to come to a decision and the Judge only a few minutes more to ruin, or was it save, the life of Jesse with his sentence.

"I sentence the defendant to Ten Years."

My heart dropped again. I couldn't look at Jesse as she was led from the court. I stood up before anyone else. Looking at both the Judge and the Jury I blurted out TRAVESTY, which is all I could manage, before walking out through the door nearby (my experience on Angel Dust flashing through me as I did so). My head was flying around in circles as I paced up and down outside the courtroom.

Eventually the Prosecution Barrister came out and I berated him loudly, thanking him for a job well done and hoping that he would sleep well now. His assistant arrived and I did the same to her.

"I don't think this is the proper place to discuss this."

"Well this is a court, isn't it??!! Maybe we should discuss it over tea at your house?", I suggested.

It was time to get out of the building before I got myself in trouble. The judge had been better than the prosecution in his summing up of the case against Jesse. I just wanted everyone to share the guilt though. All the faith I had in the great British Justice System went flying out the window that day.

I had met Jesse In Milan in 1997 where she was working for Italy Models. We enjoyed a love affair that lasted for over a year before we went our own different roads. Her road led to Miami. Over the years we kept in touch, if mostly by phone. It was in Miami she fell prey to the people who hover around the fringes of the music, model and recreational businesses supplying the social lubricants that we all indulge ourselves in. The only thing Jesse was guilty of was being too nice, too trusting. Not the worst of human flaws one would hope.

Social Lubricants

Drugs in the entertainment business are nothing new of course but today drugs reach into all facades of life and affect us all. My own dealings with first the music business then the fashion industry had showed me personally the heavy hand narcotics played and had left it's own personal scars. I watched first hand the punk generation destroyed by heroin. To say there had been some greater plan to nullify a generation might not be too far fetched. You don't worry too much about society and it's problems when you have to worry where your next hit of heroin is coming from. Opium for the masses. Feed it to the people. Didn't the Japanese open all the opium dens after their invasion of Mainland China?

The situation worsened in London after the Shah of Iran had been deposed. Those wanting to leave Iran could do so, but only if they took no cash or valuables out with them. So everything was converted into heroin and the exodus followed. Every other day the British newspapers were full of stories of token busts. Grandmothers arriving in London with two suitcases stuffed with clothes and a couple of kilos of top grade heroin in the lining. Of course the bulk was never found and London was awash with Iranian heroin.

Prior to this Britain had fewer than 10,000 registered addicts who could all get pharmaceutical heroin free from the state. This was all to change. Heroin, a drug whose price today is the same if not slightly cheaper than twenty five years ago, stopped becoming the drug of the rich and infamous and went mainstream.

Maybe there is some truth in the saying "The only reason drugs aren't made legal is because you can make more money on them being illegal". I was to find this out first hand, when I became a drug dealer by chance...

Drug Dealing

I was a drug user. I never planned to become a drug dealer. Moving to New York to pursue my photographic career I brought an unfortunate piece of baggage with me from London. A

large heroin habit. Unable to find any good heroin in New York I started bringing heroin from London with me for my use when I travelled. From grams, I moved to half ounces then ounces as I became bolder and I had more friends to accommodate. I would wrap it inside a newspaper that I would carry under my arm. Airports didn't have cameras everywhere then and newspapers don't show finger prints so if I ever thought I had trouble, I could always put the newspaper down and claim it wasn't mine. I never had to do this. I was paying about $80 per gram in London for the heroin. In New York the same gram was worth $1,000 and I usually had to cut it or I would kill everyone. I started supplying a couple of friends and a few rock stars. I could afford to be generous. "OK, make that $2,500 for three grams."

Soon all my camera cases were stuffed with cash and it wasn't from photographic work. This went on for a year. My clients were the rich and infamous. At those prices that's all who could afford to buy it. At one stage I was thinking of buying a loft, but easy come, easy go, especially when you inevitably become your own best customer and fuck it anyway, I never saw this as a career move, more like a nice little earner on the side.

The following year I moved back to London courtesy of my newfound girlfriend whose family just happened to be rich. She was going to save me from my addiction. Trouble was she was an ex addict herself. What started off with good intentions soon found both of us up to no good again. I went back to dealing to what seemed like, every toff and rich kid in Kensington, Chelsea and Mayfair. I couldn't obviously make the same profit as in New York so I had to expand my business. It wasn't long before the police knew my name but they had a problem. They couldn't get a warrant to bust the house where my heiress girlfriend and I stayed because of who owned the house. Who says there aren't a different set of rules depending on who you are? Undercover cops tried grabbing me on the street one day but with no luck. How dare you? Time to clean my act up. I had been lucky. Alone, I left for LA and managed to get my life together. I was not going to remain a drug dealer.

The Fashion Capital

By 1986 I had been free of Heroin for nearly three years and it was time to expand my horizons and my career. Where better to go than to Milan, the fashion capital. The wonderful world of fashion, magazines and all, awaited me. The Italian government had been pumping money in for some time and business was beginning to boom. A few established model agencies, supplied mostly from the model schools of North America and Northern Europe, serviced the growing business. There weren't too many Italian models at this time. Monica Bellucci was one of the notable exceptions. To some Italians modelling was still only one step better than prostitution. Quite strange I thought, when on terrestrial TV at that time, you could watch hardcore porn. Berlusconi was starting to amass his wealth. Photographers' agents and quite a few playboys surrounded the model agencies. You heard rumours of how the model composites were sent to them first. But big deal really, there were lots of models and plenty of work. Though sexual favours would probably do you no harm this was a bit too hardcore, shall we say, for the time. Smoke was available in the parks but drinking was the favourite pastime. The models were treated pretty good. I felt the Italians did look for love, be it only for the season. The sheer carnal pleasure of Paris would come later. I was determined to make it in Italy and after about a year and a half of shitty hotels and travelling back and forth to North America to earn more funds I was finally working enough in Milan to afford an apartment and settle down a bit.

Of course, as fate would have it, my most successful year work wise, would be marred by a serious incident. This in turn would lead me back to heroin.

I had been in Milan for two years when after some good work I suddenly started working seriously for a number of major publications. A series of campaigns followed and even some work for French Publications in Milano, which was unusual. Although of course there are

no set rules, at the time the route for a young photographer was to work in Milan then in Paris and if you achieved both, there was a pretty good chance you would work in New York and stand the chance of making some serious money.

I worked up to the very end of July in Milano marred only by me breaking up with my rather beautiful, red headed, German model girlfriend. That, and the bathroom floor of my lovely old Via. Cappuccino apartment falling through onto my neighbours below and the Public Health authorities forcing me to move out.

Not to worry though. I had been offered lots of work in Paris through August from a prestigious French publication.

I Love Paris

Arriving in Paris with a photographer friend, we decided we would go visit every model agency we could. (Well we did have some legitimate work.) I'm also not one to tire too easily of meeting and looking at pictures of beautiful girls.

Paris was different from Milano. For a start at the Model Agencies, the owners or head bookers tried to exert much more control. They wanted to tell you whom you could or should use. I would ask about models I knew personally to be told they were working when I knew they were not. Some of the smaller agencies were no more than fronts for prostitution. An owner of a major agency was about to begin a jail sentence for distributing cocaine. He told me so within minutes of meeting him. Sorry man, jail is not cool. Paris was much more corrupt than Milano. Strange then that they were always telling their models to be careful of Milano.

Limbo

The next five years were to see me lapse in and out of heroin addiction. As fate would have it the girl who had delivered my bail money and I started having an affair. She was a bright, multi-lingual product of State College, Pennsylvania or Transylvania as I called it. She was unusual looking which meant she did a lot of work for Marie Claire, known as the Lesbian magazine amusingly to those in the biz at the time. This meant lots of location work for her and space for me. Cool for the moment.

It was only after settling down in our new Milan apartment that I discovered she had a liking for exotic substances. The liking turned to an addiction. The people down the road, just around the corner from those people I would buy my Hash from before, I realised were selling heroin or as they called it Roba. One word not in my Italian/English phrasebook. I joined her and became a good customer for them. Anything to forget Paris. I continued working non-stop. Working under its influence was not a problem except when I couldn't get it. I would find myself leaving the studio mid session, usually on the pretence of having to check film at a lab while I criss-crossed Milano on my Vespa searching for the drug my body craved. After blood was found on a studio bathroom floor the Editor of a prestigious publication stopped me working for them. "It's my assistant's blood," I protested. He wasn't having it. A year later when we bumped into each other again I was astonished to find him completely zonked. Maybe his dentist had given him too many heavy painkillers. I wasn't having it. Apart from him though nobody said anything to me. My different agents over the years knew, and some were sympathetic to my problem, but no one was going to say anything. I was making them too much money. Work, work and work. I would continue to do so, for anybody who would pay me. I had to. I had expensive habits but it was becoming exhausting and I was slowly burning out.

King Heroin

There have been many songs written about heroin over the years. At the moment, my favourite is King Heroin by James Brown. If I ever feel myself craving heroin these days I play James. It seems to work. Other heroin classics, which I enjoyed while taking heroin included Slow Death by The Flamin' Groovies and Sister Morphine by the Rolling Stones. Heroin by The Velvet Underground is pretty much a classic. Chinese Rocks by the late Johnny Thunders and his Heartbreakers band is a good stomper and for a recent one, The Streets' Stay Positive has a modern message. It's all in the names I guess. Don't forget Billie Holiday please.

Anyone thinking of trying heroin should try listening to King Heroin first. Anyone else unlucky enough to be using heroin and who feels its use doesn't change them should try what a friend did with me once. They videoed me before I took heroin then shot more footage after.

The longer the segments recorded, the more revealing you will find them.

A lot of my memories of these times consist of me coming off heroin, which I seemed constantly to be doing. Each time was becoming more difficult and painful. I realised I was going downhill and would constantly leave Milan whenever I could. Japan offered a new market and I started travelling there twice a year for up to 6 weeks at a time. North America offered work but only a cartoon culture in return. I could stand going there only sporadically and only for very short periods. Amsterdam opened up but it was too easy to get everything there. I concentrated on Tokyo.

Only trouble was, it was half way round the world.

High Touch Town

The usual scenario over the next couple of years would see me arriving in Tokyo sick as a dog on heroin withdrawal. I would be lucky if I could procure some methadone for these times so, more often than not; a few sleeping pills and a bottle of whiskey were my only comforts. Stuck inside my hotel room, sweating profusely, literally banging my head against the walls, I would claim severe jetlag or food poisoning to my agent when he arrived to try to drag me off to some appointment or, God forbid, work during those first days. After four days of this you would usually be able to function again if not a bit slowly. Over the next few weeks I would start drinking like a fish, something I didn't normally do. Heroin and alcohol do not really go too well together. My sexual urges returned, no longer subdued by the heroin. The model nightclubs of the Roppongi district of Tokyo, High Touch Town, with their free drinks and young models became my second home.

A very infamous lead guitarist, once half joked to me when we were discussing heroin addiction, "The only reason I take heroin is so I can enjoy coming off heroin". A bit hardcore but I guess it comes with the territory. This renaissance period, as we called it, filled with ridiculous epiphanies, usually starts one or two weeks after coming off heroin and can be quite enlightening and productive. Enough of heroin though. Out with the old and in with new. There were new drugs to try, model bars to visit and work to take care of.

If someone says you can't find drugs in Tokyo don't believe them. Maybe the Japanese just aren't too keen to sell to foreigners or maybe they just want to keep all the drugs for themselves. The quality was always good and the exact weight it was supposed to be. Walking into after-hour bars I was gladly surprised to watch locals openly sniffing coke and speed right off the bar.

The economy was beginning to boom and the agencies dealing with foreign models were thriving filled again from the model schools and agencies of North America as well as

Australia and New Zealand and a few Europeans. It was only years later that I found out the only reason foreign models were so popular in Japan was because they were cheaper than their Japanese counterparts. All the foreign models thought everyone wanted to look like them.

The foreign models the Japanese liked were different than in Europe and America. They liked them young, very young. It was not uncommon to find twelve year olds there, with their mothers or a carer. Fifteen was a good age for the market and by twenty it was thank you, don't bother coming back again. The cramped living conditions endured by most of the models meant the bars and clubs were full. Teenage Americans enjoying the freedom and free drinks they wouldn't be able to indulge in legally, in their country, for years. It wasn't unusual to find yourself standing next to Quincy Jones for instance at a bar, alongside Poison and the dregs of other glam rock bands still big in Japan at that time. Los Angeles was reasonably close and lots of high flyers would arrive, sometimes for the weekends, to cruise the Roppongi model clubs and the after hours. Tokyo was busy, busy, busy.

These trips to Tokyo were invigorating and exhausting for me. I'd return to Milan, large wad of cash in my pocket, and do my best to keep away from heroin, often successfully for periods of up to six months.

Love is the Drug

The years passed and the drugs changed. Aids was in full swing so heroin wasn't a good route. The Raves of England fuelled on Ecstasy spilled over onto the dance floors of Milan and Tokyo. Ecstasy or MDMA in its pure form I remembered from London in the early seventies when it was referred to as the Love Drug. Rebel, Rebel meets the low spark of high-heeled boys. In Milan Roberto Galli and friends were opening clubs like Hollywood. Love was all around and good times for all, for a while.

I was everywhere and nowhere, so around this time I decided to move to Japan for one whole year. Only travelling to Bangkok to renew my visa every three months interrupted this. Danger, Danger, Health Warning.

No matter what people tell you about Thailand, it is definitely one thing, and that is dangerous. Especially if you go looking for all the wrong things. Each trip there was marred by some bad experience or some experience I could have done without. Anyway it's not my idea of a good time to watch obese fifty-plus-year-old ugly northern Europeans with pretty fifteen year old girls and boys, even if they do have to make a living. Thank you, gentlemen. There was little love to be found in Bangkok.

It was during this year in Tokyo I was to come across heroin yet again. Who needs Bangkok!! To top it off, the quality was even better. In Tokyo I found, for one of the few times in my life, pure China White. A heroin purer than the pharmaceutical heroin of the west. Surprisingly, or not so, it came through one of the foreign military bases around Tokyo. I indulged for a month before deciding to kick it in the head. It was getting too heavy and I was meeting too many people it wasn't good to associate with. Well, they do say it's the favourite drug of the Yakuza. Anyway, Soul to Soul were singing Back To Life and there was smoke and ecstasy and alcohol and ice and ketamine to keep me busy. Who said you couldn't find drugs in Japan?

ECCO

MDMA in its pure form is quite an amazing drug although I do agree with Dr. John C. Lilly that Ketamine is more interesting. It was on a location job to Maui from Japan that I first met the man, staying as his house guest for over three days. Dr. Lilly, inventor of the Flotation Tank, cosmic mind and explorer, I could go on and on. The movie 'Altered States' was based around him, as was 'Day of the Dolphin'. A truly unique mind. Dr. Lilly,

who used to inject large quantities of pure LSD, made personally by Hoffman of course, then later MDMA and then Ketamine, was doing so only for scientific purposes. "I don't believe in drugs for recreational purposes", he once said to me and I smiled. Time passed, Soul II Soul released one two many albums and were replaced by The Shamen, The Stone Roses, Oasis, Pulp, The Happy Mondays and more E's. Everyone had a favourite band and music was fun and exciting again. There was little or no fighting under E and good times prevailed in Tokyo and Milan. I was getting bored.

City of lost angels

By now I had lived in Milan for nearly ten years and decided it was time for a change. I'd try America one more time or to be more specific the city of Lost Angels. LA or Lah Lah Land as the locals called it or Hell as I came to call it.

LA had pretty good weather if you're an orange, but fuck, you drove to your bathroom. The model scene in LA was predominately plastic, if you get my drift, and pretty, no, a lot sleazy. Most of the work is film or TV oriented and I should have had my head examined for moving there instead of New York. Maybe the ghosts of Sid Vicious and my dealing days still haunted me. The social lubricants in LA were mostly pot and coke. Alcohol isn't a good one in LA due to all the driving. Alcoholics Anonymous is where you go to get work and meet people. Everything was cute. No, I'm acute. A city in denial. LA sucks.

At first I would travel back to Milan and Tokyo for work. After a year I found I was working in LA. The only trouble was I couldn't stand living there, if you can call it living, any longer. My last three months saw me lapse back into heroin use. The heroin this time was dirty Mexican brown that looked liked tar. Of course there were your Hollywood Hills dealers but I preferred going downtown into the city of Los Angeles. The one with all Spanish Street names. There, just a few blocks down from LA's biggest police station, you could buy heroin openly and quickly on the streets. Do you see a connection? Crack had appeared and that too was openly available. At night, even the police would disappear. Cars or garbage cans filled with burning contents would block off the streets. You would slow your car right down as you approached. If they thought you looked the part you would be let through, if not you would be forced to turn around and leave. Kill City. Give me danger little stranger rang in my ears and I imagined I was in Beirut.

By the time I was driving mostly Mexican dealers around downtown by day, helped by the fact the Police probably thought my green Dodge Monaco was an undercover cop car, which it originally was, I knew it was time to leave. Where to? Back to Milan of course.

The drugs don't work

Back in Milan the scene was changing. The E's were wearing off and "heroin chic" had entered the vocabulary. I was trying to keep away from my bad habits, but was still close enough to know the tell-tale symptoms of sick models and their food poisoning stories they tried on me. Hell, I'd used all the same stories myself. There were times when I would have to send my assistant, or go myself, to obtain dope for sick or wanting models. Often, if I knew the girl had problems I would try to bring something to the studio with me just in case. It saved time. The whole fashion scene had become a lot sleazier. In the clubs the whole PR scene had developed and the models were being herded around like sheep. To me a PR was someone who told her to stop talking to me. Controlling bastards, most of them. Hollywood got a VIP section. UGH!. The word supermodel was starting to be used. UGH! Are you a model? Why not try being a model citizen!

Tokyo wasn't much better. There too, there was less work and too many models and a resulting sleaziness about the whole scene. In fact, it had become a Real-Estate scene. Owning agencies to put models into apartments you owned at exorbitant rates.

Well, it was time to move again. Where to this time? I was running out of options. I'd burnt too many bridges. Spain? No. Greece? Why not. I had started to see Greek tear sheets in model's portfolio books and some of them weren't bad. Time for another change.

Greasy

I arrived in Athens and remember smelling only burning oil. Mmmmmmmm I love pollution. Not even Milan in August smelt this bad. I also brought with me a heroin habit courtesy of two weeks recently spent in New York. After three days sweating and shitting stuck in a hotel room, I escaped to the island of Hydra where as a teenager the girl of Leonard Cohen's song had taken me down to the river. There are no cars on Hydra, no burning oil. One week later I was ready for Athens, and to find an agent. At this time there were only two. The first one I saw accepted me, though she did wonder what I was doing in Greece. "I love Greece", said I. Later that day she called me to tell me she had a job for me. One week in Thailand, to Phuket or Fuckit as the locals call it. Me back in Thailand. Was this some type of test? This marked my entrance into the Greek fashion scene, which lasted a good year. The beautiful people and architecture of Athens reminded me of Naples. For a country with such a small population Greece certainly had a lot of magazines. It was a mini mini Milan in the sun. The photography work sort of fizzled out after I punched the best friend of the publisher of the top magazine group on the nose at a photo session because he was being a pig with a model though. Those Greeks do have to stick together no matter what, bloody island boys. By this time I had other interests in Greece anyway and photo work I could continue in Milan or Tokyo where it wasn't such a Mickey Mouse affair.

Nightlife was good. Athens had winter and summer clubs. The latter, large sprawling complexes about half an hour outside of Athens on the coast similar to the ones I had visited on the Mediterranean and Adriatic coasts of Italy. The winter clubs were smaller affairs in central Athens.

Models came from nearly everywhere. North Americans who didn't work in other markets and lots of Eastern Europeans. There were quite a few Greek models and others who would come to Greece in between seasons from other markets to enjoy the sun, nightlife and cheaper living costs. These were mostly German, Finns and Danes.

They copied the Italian PR style in the clubs with lots of free drinks, taxis paid for, dinners and thank you. They might not have had the style or finesse of the Italians but the Greeks loved to have a good time. Profit was not their only guiding motive, thank you America.

During this first year I forged a close friendship with a PR named Alex. A former journalist and musician with deep interests from Serge Gainsbourg to Carlos Castaneda. He had a brilliant music collection and a love of beautiful women. Of all the PR's he was really the only one that mattered.

Going to a nightclub with Alex was a dream. A typical night would see you arriving with fifteen girls to a nightclub in four taxis (you work out the male-female ratio). You were immediately given the best table in the house, and free booze by the bottle as the owners tried to impress you and your pretty company. What impressed me most about Alex was that he really did seem to care for the girls. He would run around all night making sure everybody or 'all the bodies', as he referred to them, were fine, that they got home ok if too drunk etcetera.

For the first year there was only booze and smoke. I always thought it strange that Greece with its ideal grass-growing climate only had two beers, both Dutch. Things were about to change though. Greece was about to see Ecstasy arrive in a big way. Alex, with a five-year prison sentence for its distribution, was one of those who paid the price.

It really started with the university kids putting on raves on farms outside of Athens. Then two of Alex's close friends, Manos and Elias started taking over large Bouzouki nightclubs for one off all-nighters. Thousands were packed in and the drug of choice was ecstasy. This led to their own club Million Dollar Babes that became Billion Dollar Babes the next season and finally Magna. Alex didn't like selling E, he liked taking it. If anything he liked to think he was enlightening people through its use. He gave away as many E's as he sold. It got to the point that I didn't have to take anything. Just being around so many people using it made me feel it's effects. Good times were had by all over two seasons of love and our pockets were stuffed with cash until everything started to go wrong. The culprits? Cocaine then heroin.

A Greek Tragedy

It started with cocaine. Too much booze, too many E's, too much to smoke or plain exhaustion made you feel you needed a boost, a short burst. Well, I'm not going to praise cocaine unless it's the type of coke I can sleep on, which I've only had on the very odd occasion. What most people buy as coke today is little more than a mixture of washed industrial speed, lidocaine for the numb nose, ephedrine for the rush, heroin for the consumer comeback - glued into rocks. Just in case you thought it was cool.

After cocaine came the heroin, used to calm you down, take the edge off the other things you pumped into your system. Trouble is, the people you associate with change. I could see it was time to leave Greece. You can warn people of the dangers of heroin but some people have their own road they must go down. The summers of enlightenment and love had ended. Like Milan, the club scene had been reduced to Dancing for Dollars. I re-located to Milan one more time.

Everything in Moderation

I'm not going to say whether drugs are right or wrong but I do believe the sentences handed out are ludicrous. Our prisons are filled with people on drug convictions. We have the problem of countries whose economies are nearly dependent on the illegal drug trade. Mexico is one such example. Hadn't the British financed the building of an empire by their opium dealings through Hong Kong? Today we talk of the Cocaine Dollar. The real solution would be to legalize all substances but maybe I'm being too much of a dreamer. Today I joke with my close friends that I don't need drugs due to the amount I believe still flow through my system. Alcohol, especially spirits, I find much more dangerous than any of the soft drugs and I put Ecstasy in the soft drug category. My worst addiction is probably to cigarettes, which has gone on for thirty years and will probably be the one that kills me off if I don't stop. One day at a time though. Everywhere I go today there are people taking drugs of some sort. Recently in Texas I was offered Percodan (synthetic morphine) by some cowboy businessman I struck up a conversation with in a hotel bar. "Try a couple of these, they're great with a few drinks." Pill-crazy that State. Then again, not so long ago, they were giving out ecstasy free in the bars there. A month or so ago I met a nice girl, a bit older, beautiful, single, lovely ten-year-old son, perfect. After knowing her for a couple of weeks she asks me one evening, "Do you take drugs?" "What do you have?" I asked, "Crack" she replied to my amazement. "I don't take crack unless I have smack" I replied thinking it would get me out of the situation. "I have some of that too", she replied. Our relationship has gone on hold.

So, I guess hard drugs have gone mainstream. But to lock people up for what amounts to social lubricants is mad. The sensationalist stories of ecstasy killing people that the press feed to us daily are crap. More people probably die per day from alcohol related problems than in five years of ecstasy use or abuse.

Stop the hypocrisy, legalize everything or at the very least reduce all the sentences.

Of course there will always be people who abuse anything and everything but I feel they are in the minority. Most people are quite responsible. The day they legalise what drugs or social lubricants you are using now will be the day money as such dies. Then the hypocrisy will stop.

In my view Jesse is innocent. It is a travesty that she serves ten years while the people responsible freely walk the streets of Miami. Justice for all!? There is no justice. John Lilly once said to me, "There are just too many lawyers in the world, Peter." I agree with him. Too many lawyers and too many laws.

Remember, there is always the other side of the coin. The other side of the glamorous fashion industry. The industry full of young girls from modest backgrounds thrown into unknown cities on their own to pursue modelling careers that foreign agents had promised them have only golden paths. Their parents often saving everything in order that they may afford the air or train fare. They, not wanting to disappoint their parents, not wanting to return home a failure become merely perfect fodder for those who are the scum of the industry, the drug them and fuck them crew. And as you enjoy the illegal social lubricants that you may partake in, spare a thought for all of those behind bars like Jesse, victims of the drug trade and our outdated laws.

I regret not the drugs that I have taken but only the quantities. Maybe John Lilly was right when he said, "I don't believe in drugs for recreational purposes". For that to happen society would have to take one long look at itself. Is it ready?

So, what road you decide to go down is your choice. All I hope is, that you find it well lit. That, and don't get caught.

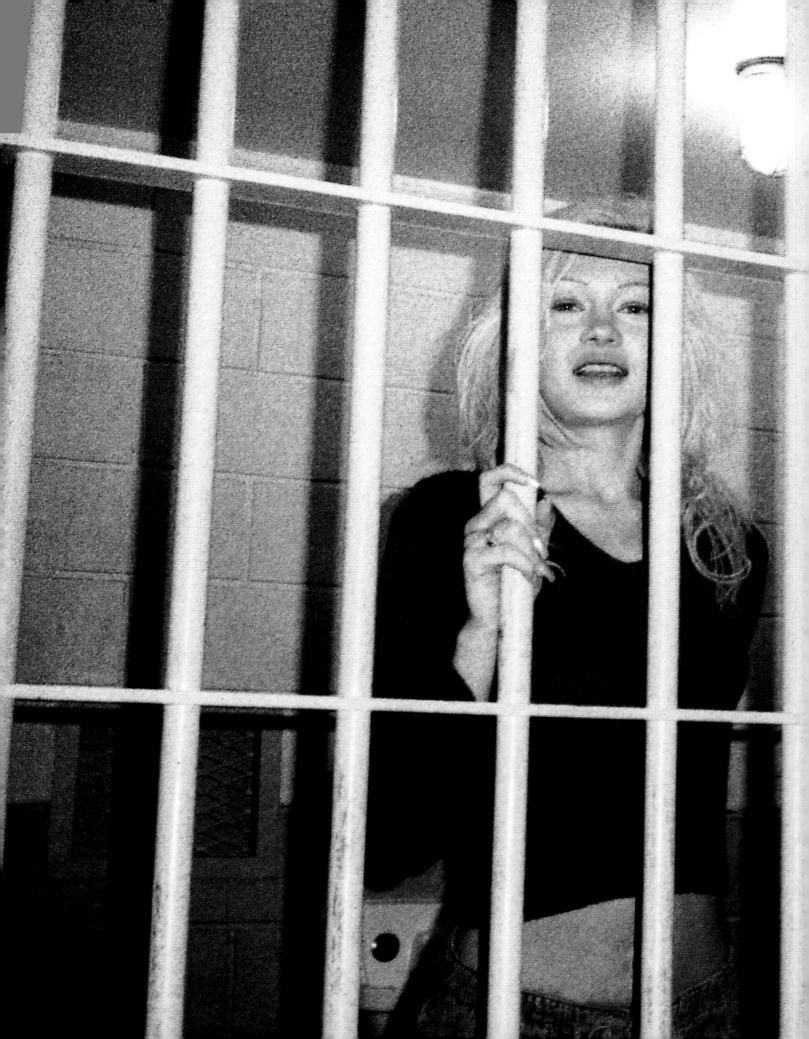

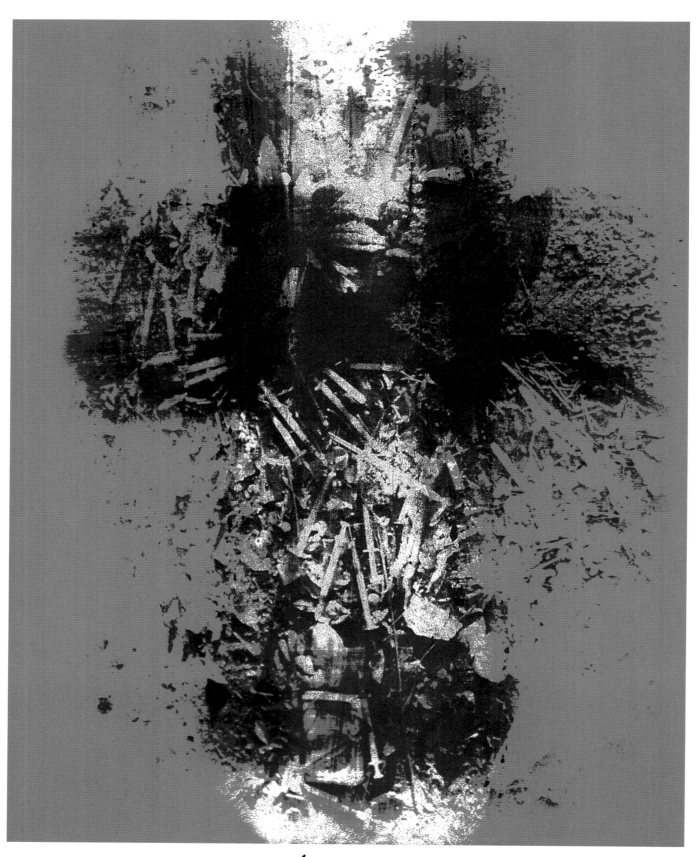

SOCIAL LUBRICANTS

Chapter One 'Downloading to software'

Heroin has ruined about anything and everything it has touched. It is my life, my wife. No small surprise then we have fought wars over it. Empires were financially run through its profits. Do they not continue to do so today? It's lure so tempting politicians and their think tanks disregard the lessons history should have taught them but maybe CCCP and it's little sortie in Afghan is beyond their desperate, foolish thinking, or worse still, reasoning. Damned if you do, damned if you don't. Obama, on the eve of a historic (aren't they all?) election into the figurehead chair talks of moving out of Iran but increasing presence in Afghanistan. What possible reason do we, the British, or their allies have in Afghanistan if not it's agriculture and in particular a rather small and delicate plant, the poppy. Afghanistan has many wonderful delights in its garden but its jewel is, has and probably will always be the poppy.

I have replaced personally the arrows of David with syringes pumping pure heaven in my soul. For that I must pay the price of supreme torture and misery that comes with it. This is my story of that torture, that pain but also that beauty, that bliss, that so final peaceful ending that must become us all. Will I be strong enough to see this through? You best believe I will. Pumped up with the cure for the common cold. My only problem is supply. Bad, bad, bad, I should be smacked! But, this is a disease I'm talking about.

Chapter Two 'Disease of the mind'

The sanity within the madness. You can't control it. I feel like a monster. Moshe, did Frank control Stein? Memory. Capturing moments. Click, photograph, hear, listen, process. Information. Process. Download. Soul on ice. Overload. Process. Mistake. Process again. Repeat. A thief in the night. You can't control it. It consumes you. The thief of Bagdad. You consume it. A shot in the arm. There's a monkey on your back. A fusion of jazz and funk called junk. Clarity overcomes you, then you tire. You become moody. You become upset. A cosmetic soul repair. The money flies out of your pocket. Don't wish it away. Then suddenly, you are only normal when you partake and the divine paradox confronts you, do I continue? Of course you must. What is normal anyway? Stardust enterprise. Then you are consumed and you have become an addict and really you should be considered to have a disease. Love doesn't live here anymore. Death, play a song for me. Processing. Positive. Click. Syringe time. When I'm low I get high. The poet Richard Hell compared heroin consumption to being lazy, like sloveness. it was a bad habit. A word interestingly junkies use to describe their predicament. 'Bugger! I've got a Bad Habit.' This should be said, young ones, with a large grin. I buy my drugs wholesale. I shoot my life away. What's the catch then? Climb onboard. For the day is long and the road is usually good and you do not usually make too many mistakes. So smile when you talk shit otherwise let's end this now.

Whether smack has been a mistake for me I am still unable to decide on. This despite me saying that smack has ruined everything it has touched including me. As life should have taught us, the boundaries between right and wrong can and do become less definite as time passes on. I feel only an uncompassionate man would think otherwise. That or a brave fool!

Oh, bugger me. You should be smacked then snatched. Heroin, heroin, you win. I'm closing in on death. Look at me but do not touch. Fuck forever. That velvet morning when I awake. My doctor

is a holy wholly. A shot of morphine. Cocaine. Lasso the moon. Crack? Even better. Freebase? Better still. Maybe some MDMA if in company. Viagra? Never wanted to fuck like a teenager, so for me, no thank you. Ketamine? Ecstasy? To the government it's a killer; to everyone else it's a killer drug. An intelligent playful evening then. Some wine? Feeling the need to be heavy, so Port instead. I go out. I change the combinations, I change the doses. That's better. How did I know? Speedballs are my thing, my downfall. A Science run through us, making us Gods. Every movement is justified. All is right around here. I'm a murderer. Of time. I still want to be human. What am I? A murderer? I've a murderous habit. I'm confused. I'm vibrating. Now showing, Crack Smack, a two part special. I dream myself into a coma. Another speed-ball. A fine line between life and death. Lie, cheat, take it all. Don't join the silent majority. Death awaits. Renounce Satan. This is not a good time to be making enemies. The Gods all suck. Show me you're real. Smack baby smack. Don't look at me like that. Show me you feel. Give me your clothes. The atmosphere was kind of heavy, but many an interesting individual breathed it. I think therefore I am. Find yourself washed up in paradise. Heart, body, spirit mind and habit. Change your night, the night. Knight. Stop smoking that. America has run out of infinity. The land of plenty seems to be running dry. Get up off your back. A murderer. Be a killer. A killer of time. Who's that girl? My mistakes were made for you. I'm the Mayor of Sodom and Gomorrah. I felt deep within your bones. Who's that scummy man? I have to dream you off my mind. I've seen him with girls of the night. You are trying not to listen. I know what your story might be. You are riding in the white horse. Right in the white horse. Inject, change the doses, and change the combinations. They call me the seeker. I've been searching low and high. Enter the Martini Castle. I know your story by looking at you. Don't change your story now. Surprise me. Tell me nothing. Vibrate. Look for mysteries mysterious for it changes when the sun goes down around here. I'm wasted all the time. I don't even feel it but God do I need it. There's a nasty plan and you're not involved at all! Smoke it. Suck it. Fuck it. She's making violent love to me. Stop. What did the sadist say to the masochist? No. But you talk a good game. You, speak for yourself. I wish I could talk again. And so and so, so, so oh, oh so clever, I know, and so and so has got to go. To the light. Why? Or is it the darkness becoming light? Saxophone on lipstick. I'm disturbed now. You're talking a good game. Please teach me the same. We talk the same. Illegal. The light behind you. Right behind the eyes that you gain. Maybe it could be forever. The blinding. The savage binding. Earth secreted madness. Oh, beautiful lover. Cut it to the cutting room floor. The last thing that you ever saw.

Oh, spending all your money thinking it's cool. Maybe it looks tragically beautiful. Walk across the edge of no escape. Independent existence does not exist. Maybe I had reached that dark, foreboding wood. I had ventured off the straight path. No sense of cock whatsoever. The wages of sin are death, but the hours are good. Sold yourself to the passion. What do you know? I know it's the faithless that know love's tragedies. I do declare I was surprised I caught a glimpse of your soul. A little heartache on a dirty road to fame and pain. We're just friends. Are you tuning in? And I want to go on, like the rest of my life. Mainline to my pain. Moby Dick in the heart of my fix. I feel kind of strange. I've lived only half my life. Photographs like music. Click, klik, whirl.

Are you tuning in? Again I dream myself into a coma. No inhibitions. Time to hit the streets. Connect. Feel people. A bachelor's life is endless masturbation. Flash. Cool. City people are paranoid. Go round and around. Are you going round and round? Sleep in a city that doesn't sleep. I want to kiss the sun, but it's oh so grey. I'm going round and round. A thunderbolt through my brain. Mainline pain Ashcroft. An English tradition. Are you tuning in?

Have some tea. Are we back in Gibraltar? Attitude on a plate. Earth has a lot of things people want. Like a few changes. Leave your invitation at the door. I'm with the invasion. There is no truth, only one's interpretation of. Fuck the fame time. I disagree with conservative factions. Others disagree. We are all much better than you believe. The theatre is closed. Smash everything. Everything must go. My tears are painted. The graffiti says all the things I should say. I need to shake away the guilt. It's a long, long way. Fuck, this stuff is good.

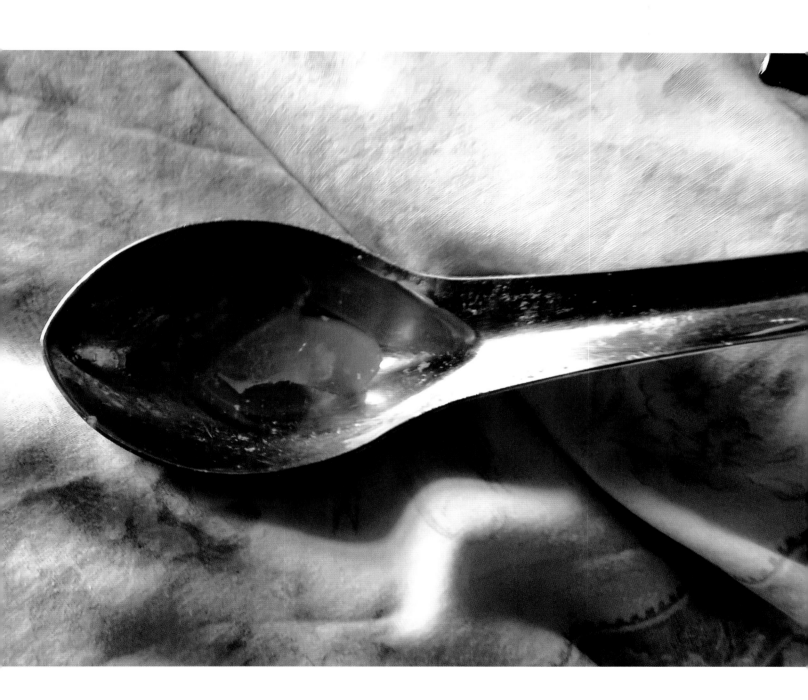

We are conditioned to believe that a white guy in a black neighbourhood will get killed. It's more likely he's employed as a driver by them. Buy, consume, buy, consume. There is no way back. Can't go back. There is nothing there. Nothing there at all. What type of writing pays the best? Ransom notes. Got any? I need another hit. Give us a bit more. Please. Pretty please. You know I love you. They seemed very nice! Then again so was dinner. Nothing there. My grey life to the silver screen. It's in the can. Photography like music. Photographs like musical notes. Rhythm-Shutter-Code. Glimpse your inner soul... Special effects courtesy of Weegee. Every perversion is justified. She is always in parties. Born with a four-minute warning. What's your leisure, your pleasure? Words. Shear code. Download. Process. Speak. Don't save. Do not resuscitate. Born to beautiful decay. The lights are flashing. Don't pretend it's not happening.

The idea of speaking to another species. Will it happen ? Whether by ourselves or whether it is forced on us, it will, as we explore both outer and inner space. 39% of Americans believe the world will be destroyed by fire. Ronald Reagan was amongst those. You always do the same. Time for chemical parity. I'm balancing me. You have something to prove. Clichés. A second in time. An eternity. Everything you believe to be true, becomes true.

The Government want you chemically dependant, financially dependant and stupid. Feudal thinking artists in Metropolis. Tell the congressman to wait. You are not me. Brain to mainline. Last night it made so much sense but today it makes no sense at all. Round and around. What do you do? You don't do anything. You don't know anything but you say you know. You don't know passion. We speak to you from the non-virtual, actual future communications laboratory. You fucking lab rat, look into my eyes. Let me look into your eyes. I'm never coming down, falling from the sky. Three Kings from an orient far. We are all here to go. A stopping off point. Earth is but a space station. I'm receiving a signal from outer space to build a biological robot. What are you? Would you like to meet? Do you like the meat? I wish I was born a thousand years ago. A million years ago. Surprise, I was, I am and I will be. I'm going to try for the kingdom. Try harder. Push. No babies. Mainline for my pain. My baby is on fire. Throw her in the water. Flush it down the toilet. Take a picture.

If I succumb to a dream world I will end up in a nightmare. You have to say yes to excess. We must present you to the faithless. Waiting for photos, it's time to change the subject. Smile. I take the photos so I will remember everything but. No evidence here then. One of them is going to prison but it's not me.

Shoplift. Steal. Experience is necessary for your learning. Satisfaction guaranteed. Collect information. And we are back again. Hello, Hello, Where are you? I am lost. Hello, where are you? Where have you gone? God, you won't find me failing this time. I've stated my side, you say yours. What are you doing madman? I am destroying this world. Making fortunes selling second hand. Re-lapse. Re-load. Collecting all that I've collected. Shooting up the dropper's neck. Oh, some velvet morning. Morphine and mushrooms. Zero-zero. Afghani gold seal. When I'm straight. What is straight? Garden gate. Flowers growing on a hill. Hear them scream.

Wouldn't it be nice if we were bolder, then we wouldn't have to wait so long? Learn from us, very much. Download. Process. Download. Are these secrets? Are they looking for you? Better put on your dancing shoes. Blue suede shoes. If you skimp. Yeah, Elvis took all my drugs. Split. Move quickly. Move in the shadows. Seeing clearly in darkness. Better to ask permission than forgiveness. Madness is a choice. Insanity is a decision. Suicide is a selfish act, the lights are flashing. Don't act like it's not happening.

Robots as lovers. Robots will give us guilt free slavery. Tell me how can I let go? Change my skin like a snake. Chameleon. Darkest hidden light. Make no mistake. I implore, forget all that you saw in just one glance. I saw your soul again. There it goes. A little pain. Waiting for the candy man. Getting burned. Thinking you are finding out what life is all about. Wouldn't it be nice to find yourself in paradise?

My dealer. I visit him every day. I've been trying to control it. As a junkie you spend a quarter of your life taking drugs. The rest you spend waiting for them. Half an hour. Half an hour. Twenty minutes. Fifteen minutes. Half an hour. Ten minutes. Ten minutes, Fifteen minutes. Five minute. Five minutes. I'm just round the corner. Like before you will not mind to find yourself washed up in paradise. It was as if I was blind. Unafraid of the dark. Don't be unkind. Take it back. I lost my thoughts in paradise. Nothing absurder. Think I might change? This can't continue. I must change. We only just met. I have a portrait on my wall. I thought it wouldn't escape. The rules are all wrong. Anything goes around here. We are floating in space. All just objects floating in space. What am I? I'm a murderer. A killer of time. Download. Processing. Remove yourself. Your Gods mean nothing to me. The problem is in the atmosphere and I'm with the invaders. We are no more united than you are. I need a glass of water. I need more drugs.

Do I have any words of advice for young people? Always scrub your ass because there is always someone who will kiss it. The Devil works bargains. What are you going to spend it on? The old fool sold his soul. There are no bargains when it comes to selling souls. The drug is money. Oh, city of vanity. It's getting late. No money to score. Poor quality living. Limbs cut apart, disfigured. Is it dead? The doctor was not pleased to see him. "I'm going to lose my licence. Get out," he screamed, "I'm a professional man, you know." It was a cold and long walk back to the boarding house. The blood shoots quickly back up the syringe. Red, as in revolution. Round and round. Transfer. In the still of the night. Delicious night. Honourable Knights. Death penalty for all drug pushers. Well then, I think we should start with the executives of the tobacco companies. It's a beautiful life on the South-Sea lines.

The doctor and the priest move slowly in. Heads bowed as in prayer. Give me Frank and Sense. They smelt the truth. Brotherhood, togetherness, love and peace. Ecstasy with no consequence.

The junk hit like silent snow. He was found in the organ of the church. We don't need any characters here to give the room atmosphere. Only feelings instead of worthless feelings so I let them all go. Don't wish it all away. I'm waiting for the flames to happen. Those glorious flames. Turn me to cinder, then less then lesser still. To do so you must let go, they cry. I need love. You must have love. We are numbered, labelled, do we ever know? Do we ever break the mould? This is so high. I walk on by.

I never let go. Try. Fly. Cry. Oh, dear Sinderella! You know the trip has just begun. The trip was overcome. Each life touches another life. Let me touch you. Are you real? I buy it. I can't let go. Looking for the good life, dressed to kill. There's someone out there. Waiting. Loose and loaded, out in the night. A minute, an hour, a second, a millisecond.

Concentrate on the moments in life because this life is but a moment. Click, klik. Clichés, more clichés. Tantric matchmaking. Looking for attention, this will surely give you some. He lives the poetry he cannot write. The others write the poetry that they dare not live. Slip into the arms of your secret thrill, in the filthiest of minds. Illicit. Painless. Unfearing. Aloof. Self centred. Self obsessed. Oh, so self obsessed. Lovely, narcissistic, loving, caring and selfish. Pinned, cold, self important, anal, and obsessed with fucking themselves. Innocence and arrogance entwined. Stick that needle in. The Gods will obey.

The process of becoming moral through damnation. I hate needles. That doesn't last. I love needles. Now, I'm a fucking pincushion. Acupunctured. Oriental. Pocket sized cameras. Japanese her. Digital. Digit her. Stick it in. Take a foto. Rush. Add coke. Inject again. Just, please don't lie to me. Don't sell me your shit, which I do not need. Don't sell me dreams whose sell by date is long overdue. Life is the first, the greatest of the arts; the other arts are but a preparation. Tolerance levels are increasing. Increase dose. Better. Dream machine. One of them is going to prison but it's not me. More increases. Subconscious dithering.

I don't think of the future, it will be here soon enough. You've had a wonderful life, don't throw it away. Infectious and contagious. Need better quality. Change dealer. Change combinations. All

these fucking dealers are the same. No Doctor, no state dealer will see me. They will legalise all drugs one day although that day will probably come the day they have dispensed with money, legal tender... that filthy lucre. Then they will have face their hypocrisy.

Stuck forever in my mind, all my feelings are being erased. I'm weightless. This is being written in the air in dust. I'm on my own.

Chapter Three The Serious time

What are we here for? Tell me, what do you think? I am here. What for?

I must know. What for? It's the only question worth asking. A divine comedy called 'Glorious Decay'? The story of life on earth. Fuck me and fuck you, I didn't get the joke. All I got was TV where it seemed you had to be a fucking comedian to get the job of weatherman. Everyone is a fucking comedian. However, I seldom laugh anymore. My laughter is saved to share with those who are on their final chapter. The down and out, the down trodden, the poor, the weak, the lonely, the salt on this open wound. We must join them in laughter too. For they have deserved the right to laugh, to scream and to cry at this glorious wart that continues to grow on Pinocchio's, or is it freedom, or capitalism's runny nose. A nose in denial stuffed with cocaine. Shove it up your radical conservative arse.

Chapter Four Stopping

I think that was my fourth hit of the day. I just smoked a joint and it is now I realise how stoned I might be. I have to have a bath. My leg is in a bad shape. All this and two days ago I'm nearly in tears. Ready to tear myself limb from limb. What a wasteful time I'm in. I'm trying to stop but obviously not doing so well. What's time anyway? Great highs followed by terrible lows. I feel I try to help everyone but receive little if nothing in return. I rub my legs. Poor abused limbs. What's smack like?

Well, the bath I just go out of was the essence of bathing. I bathed for eight minutes, mostly keeping my infected limb submerged. All the time I hoped this wasn't going to be a Morrison bath. This is the end my friend or the beginning of the end. I tell myself again that this love affair with the demon witch known as Heroin is finished. A hero in me is what I will be. How I think this will be possible is beyond me but I will continue.

Step one: get rid of all the drug paraphernalia. The needles, pipes. Vitamin C, citric acid and so on. Better finish what I have left first then. I'm going to bed alone again. What a stupid, dismal and pointless life I am leading. Worse than useless. I can't sleep of course so I get up and walk around. I have taken too much again I realise. I'm afraid to lay down in my bedroom again. I'm afraid if I do I might just not wake up. This is not an unusual situation for me, just two days ago I had the same worries of death, caused that time by excess coke. I'm clean for one and a half days then I fuck up again big time this morning. Couldn't get enough. Smoking crack and smack topping it up by injecting the same.

Receive a letter from Jesse in prison. Professor Richard calls worried about me. A letter from the bank about a bounced payment. Spend the rest of the morning looking at various photographer web-sites. All the fashion work looks suspiciously the same. Boredom. I feel empty and plastic and as meaningless as the models portrayed. Their skin seems lifeless. A result of the same Photoshop techniques maybe. Photos with a green tinge. The colour of envy. I get bored again and afternoon TV gives me forgettable programmes interrupted by ad after ad for insurance companies, disinfectant products and more ads concerning debt. Tonight, watch the twins who share the same body. Ummm, well compared to this creature I don't have a problem. Diane Arbus or Joel Peter Witkin would love it. Snort a line this time. Too much hassle shooting up. Trouble finding a vein these days. Really have to give my poor veins a break. Really have to give my whole body a break. Ha-So, drugstore body. Maybe I should have been that person with two heads. At least then maybe one of the brains could tell me, stop,

stop, stop. I'm really not doing too good a job with this stopping. Hold on, the past is the past so just stop. Ummmm, feeble thinking from a feeble mind. Get it together Peter.

Trouble is it's now day two, that's after the four lost days. Today I've got nothing. Nothing to say. It's all gone. No money, no pleasures, no friends. The number one love of any heroin user is heroin. Complimentary hearts are few to be had. I guess I have wished this on myself. To have nothing except maybe this roof over my head. How long that will last I'm afraid to think. I feel mentally raped and physically destroyed. Have I learned anything new? That I am a weak fool. I think I knew that already but to that I must add that I am also weak in being, mistaking it for being humble. Sensitive child, threat so mild. Lost in my little self obsessed world I've missed the bigger picture. To set one's ambitions too high is an excuse no-one, or maybe it's everyone, should use.

FACTS

22,000 people will die from alcohol related problems this year in the UK. 40% of youth have tried drugs by the age of 15. Illegal drugs in Britain are a 9 Billion pound industry. The U.S. of A. accounts for 4.5% of the world's population. It consumes 60% of the world's drugs. The NHS spends nearly 2 billion pounds on alcohol related disorders. There are at least 5 million illegal drug users in the UK. There were over 121,000 drug dealers convicted in Britain last year. Only about 10% of the people using drugs will have a drug problem. This though probably says more about the drugs than the people using.

Oblivion

observations of another world

An escape route out of life from the chaos which we started
Broken and fragmented when human order is retarded
Illusions and aspirations are all forgotten at her door
Say good-bye to reality - you won't be seeing it anymore

Pondering in a limbo were the party never ends,
Indulging with total strangers, who soon become your friends.
Vultures bearing smiles that only run skin deep,
Creatures of the night, those have no need for sleep.

She is feeble from exhaustion and ravaged by excess,
Her minute is an hour, one day becomes the next
Like a mobile fire hazard, except she does not move
And what's so wrong with that if you've got nothing left to lose

Her suspicious eyes are watchful beneath her glassy stare
A necessary reflex considering the people that are there.
A party full of sorrow with faces of broken dreams.
Trying to hold it together, but bursting at the seams

Yet they all are drawn here, their reasons are the same,
Knowing that the consequences are only theirs for blame.
The mask of normality have snapped their fragile strings
As they bask in the oblivion that escapism never really brings.

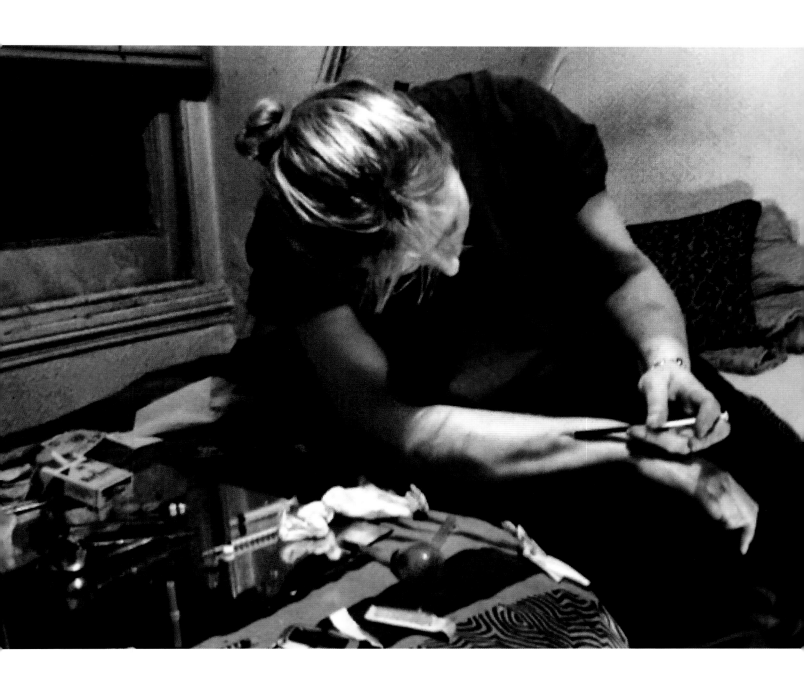

I awake with the morning sun. I wait 15 minutes in bed resisting. I succumb, I succumb, I smoke my first poison of the day. As a result I cough. Then I get up. I have a coffee, a stale croissant. More shit for my body. I smoke another cigarette, and so my day begins. SLOTH

THE EMPERORS PALACE

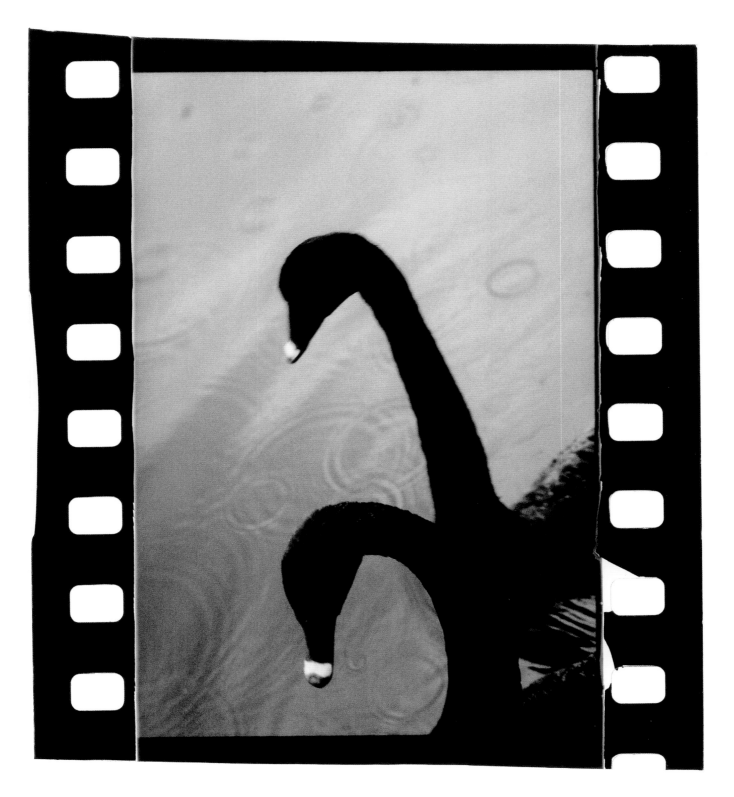

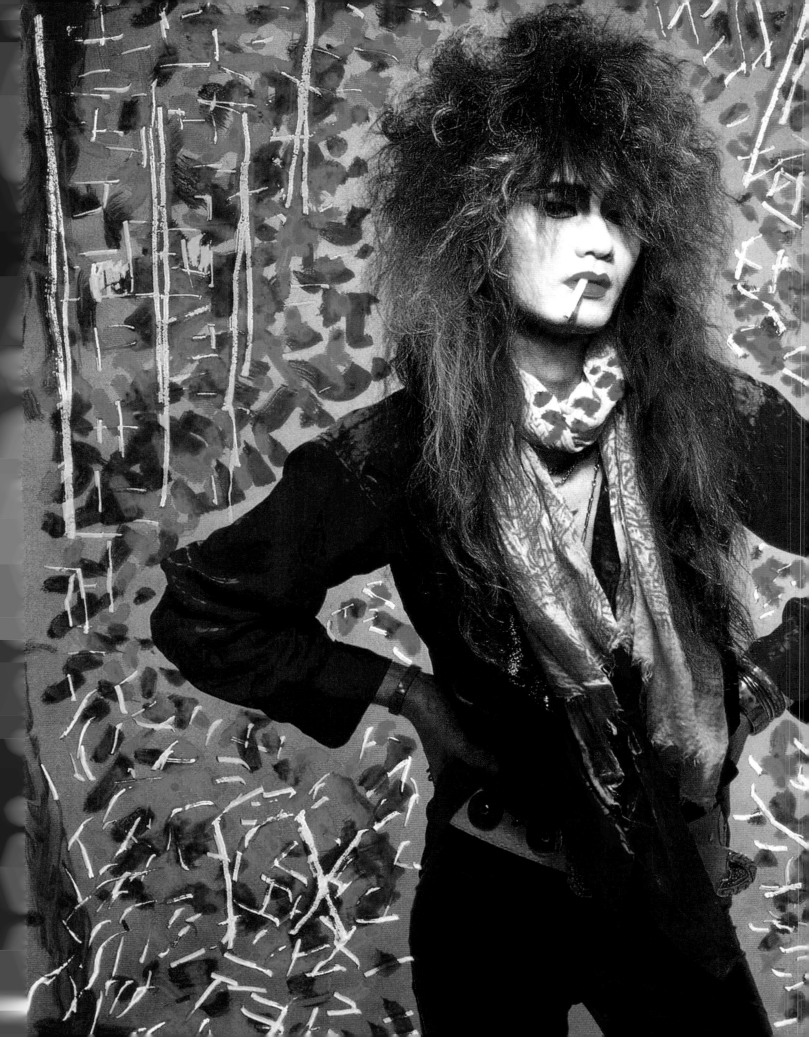

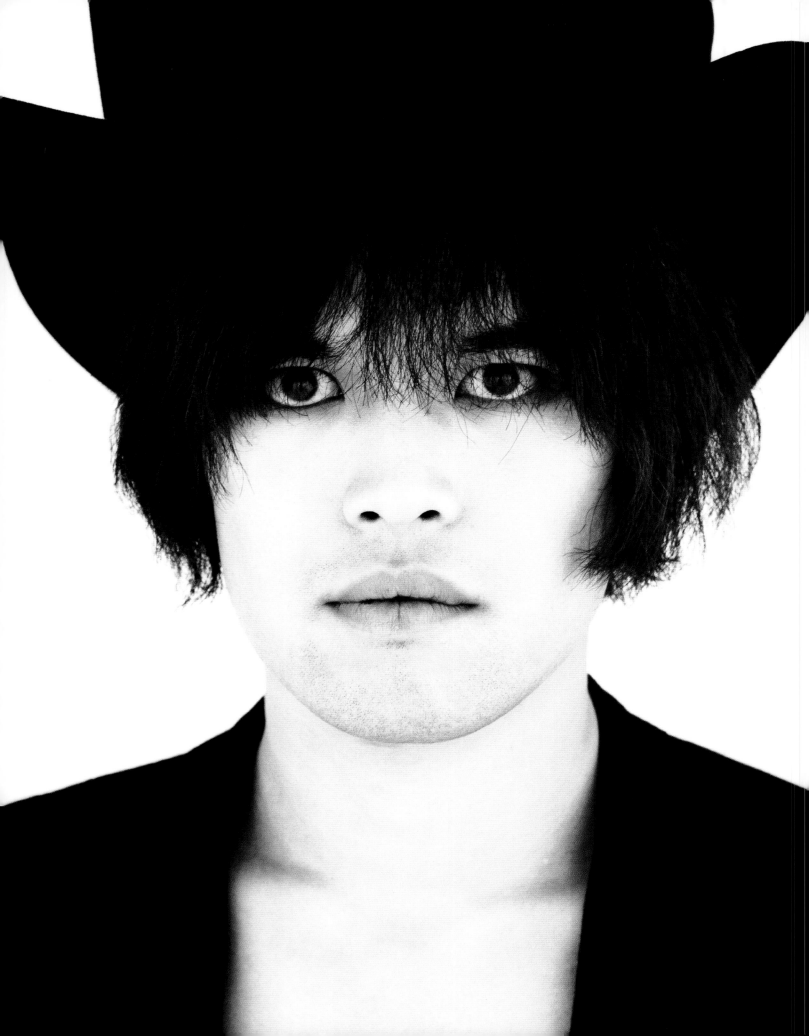

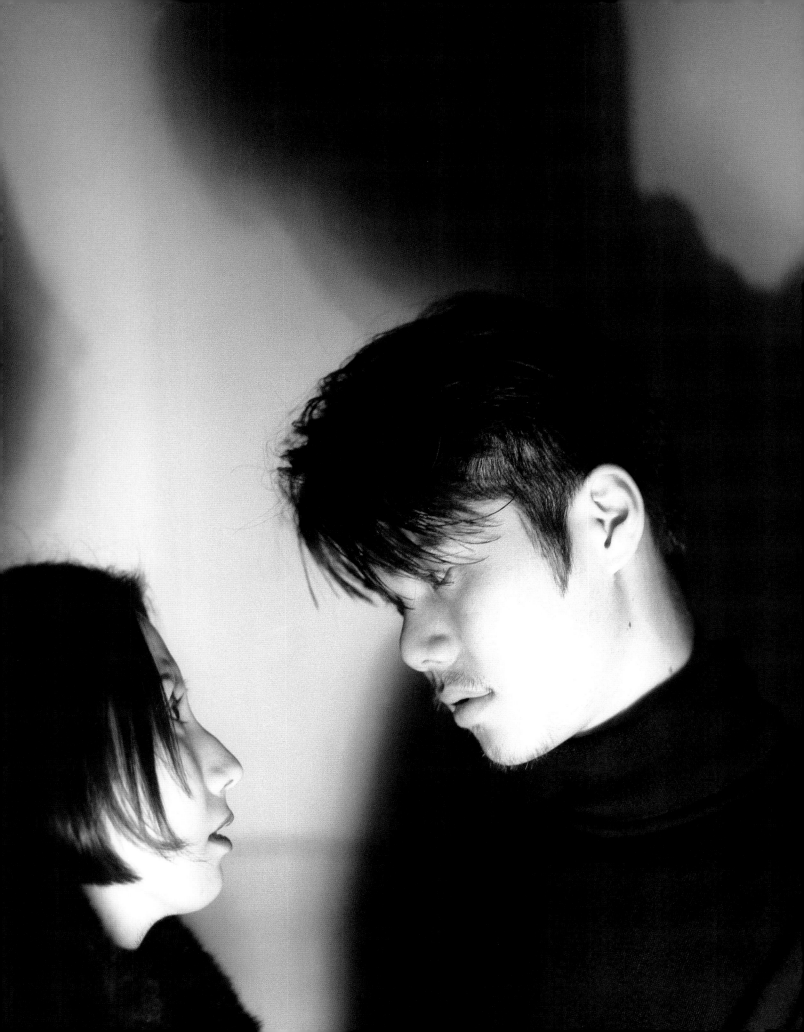

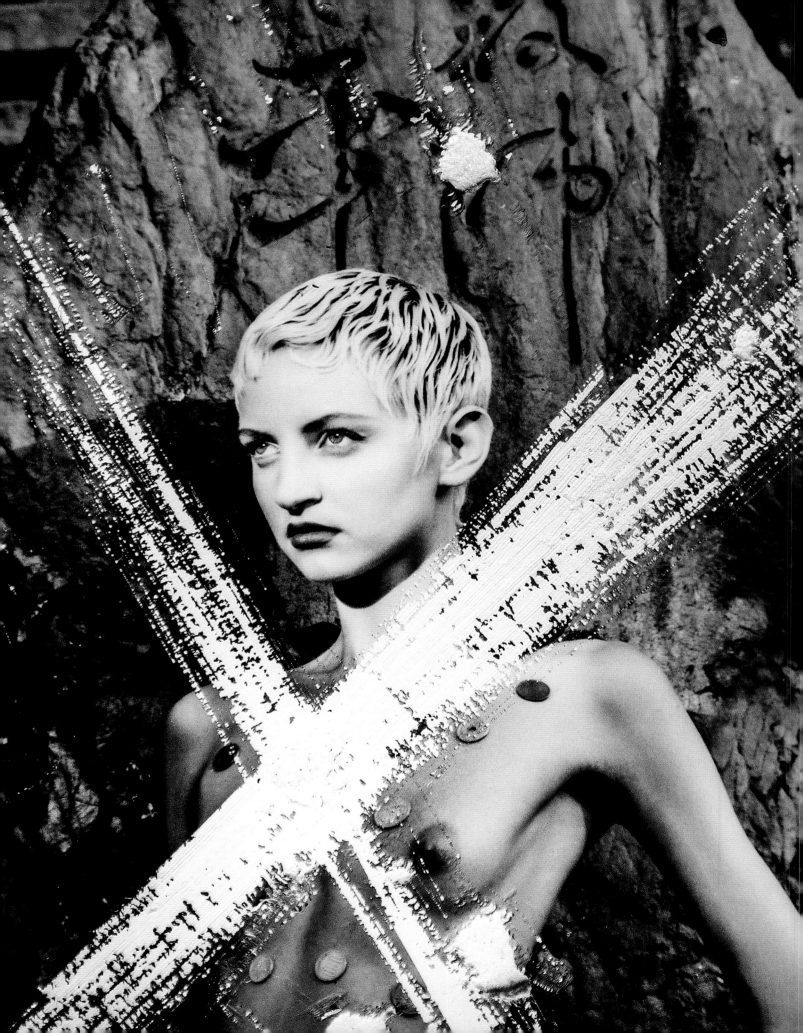

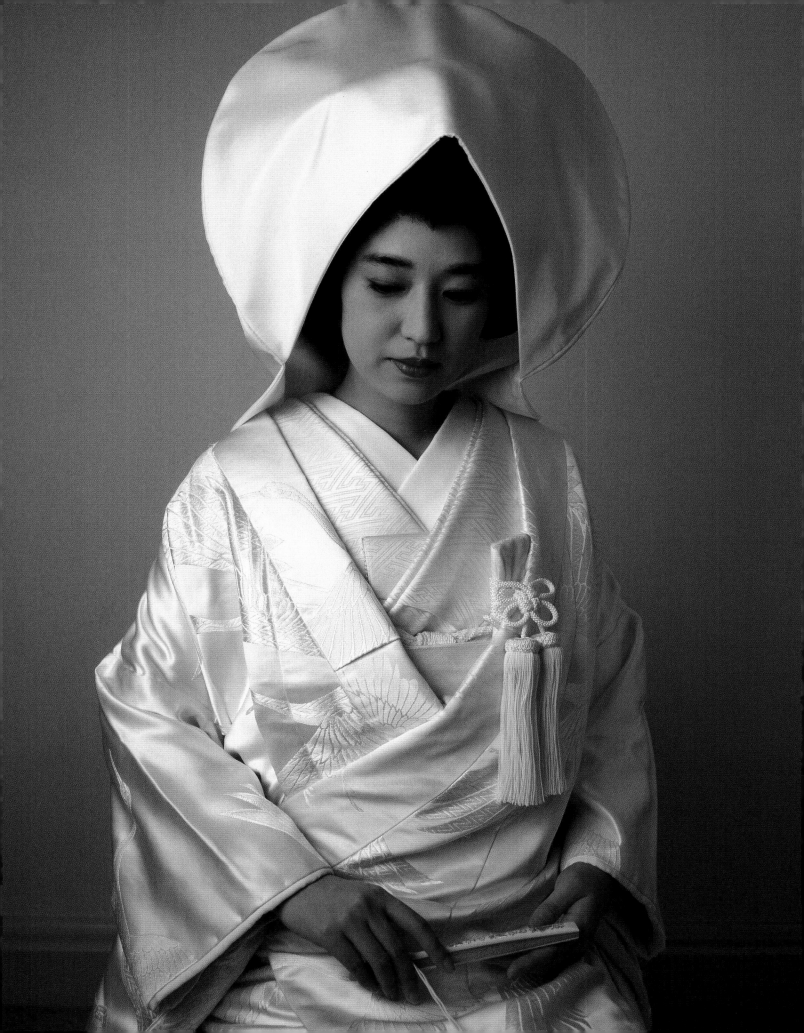

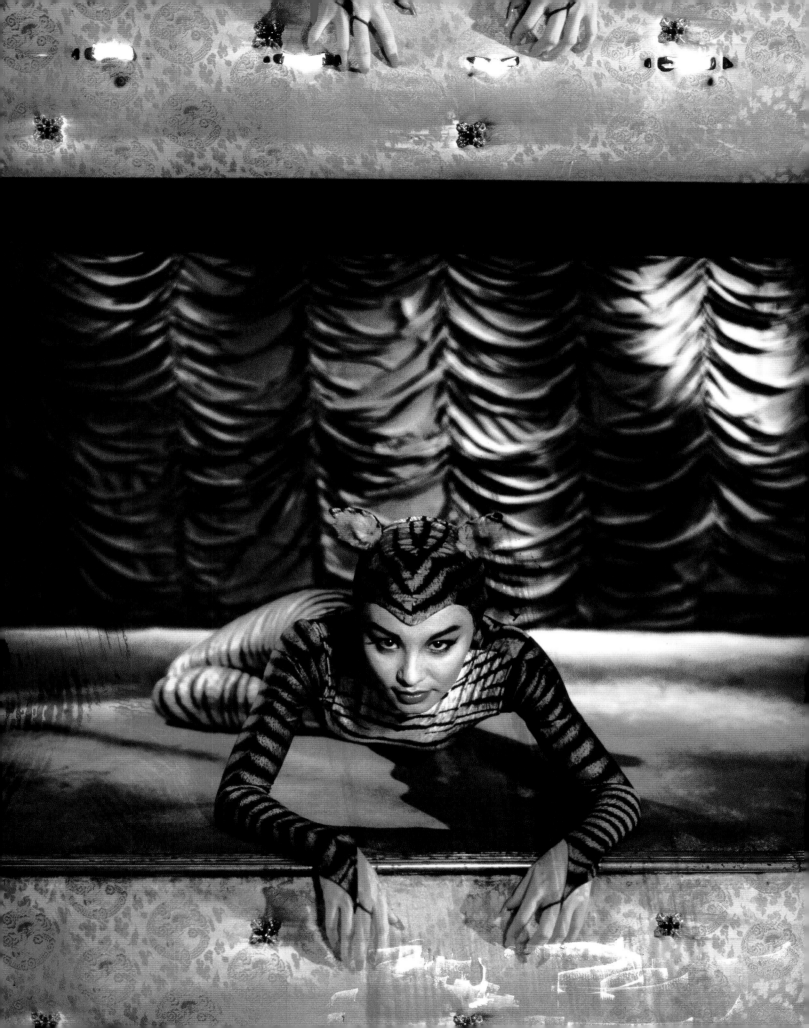

ANGIE

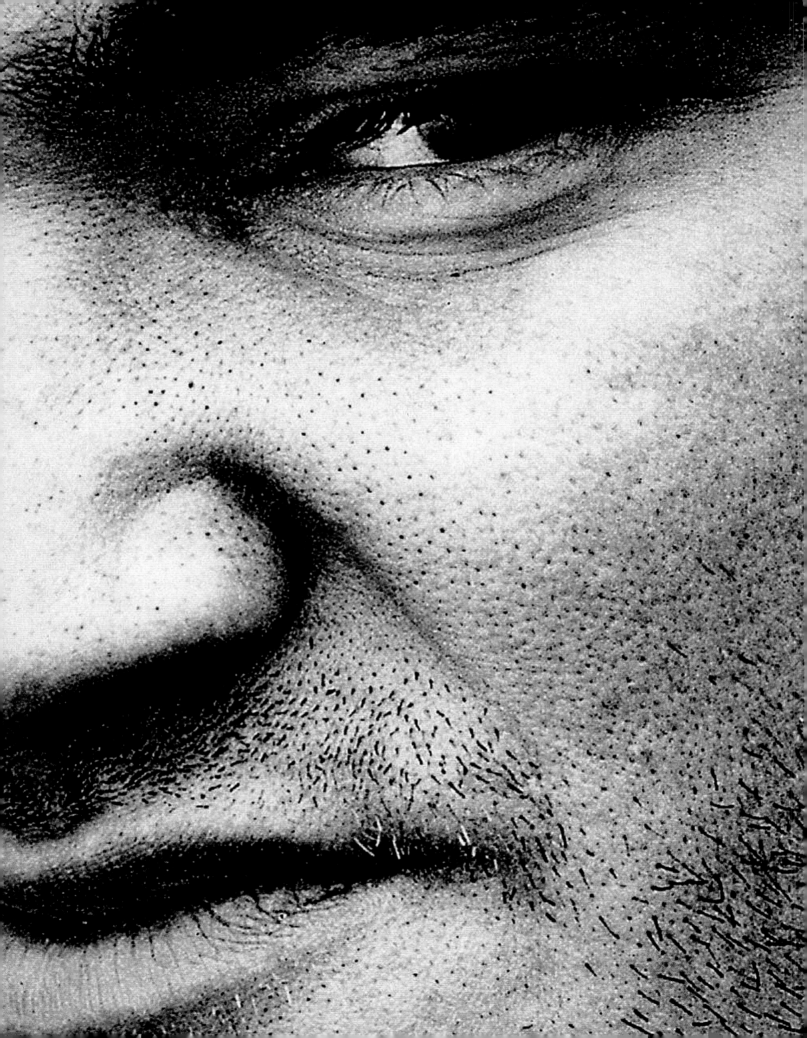

Don't
Fuck
With my
Shit.

JL

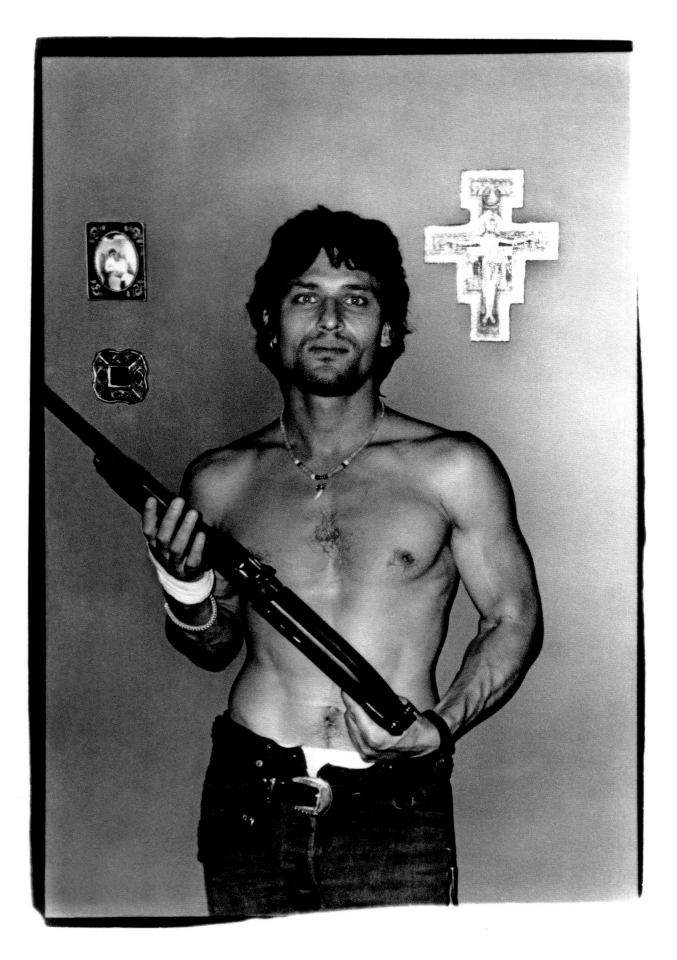

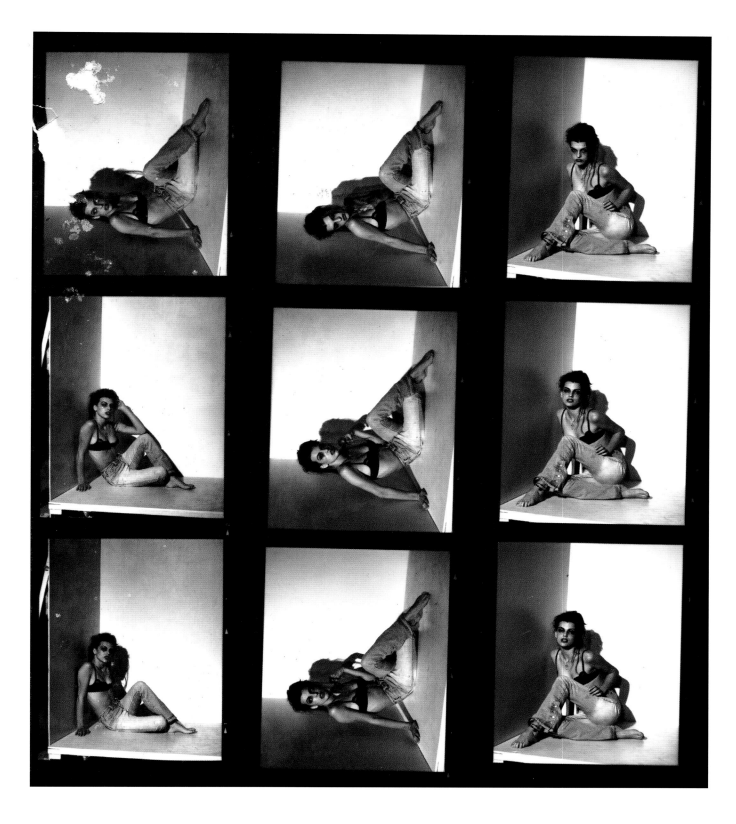

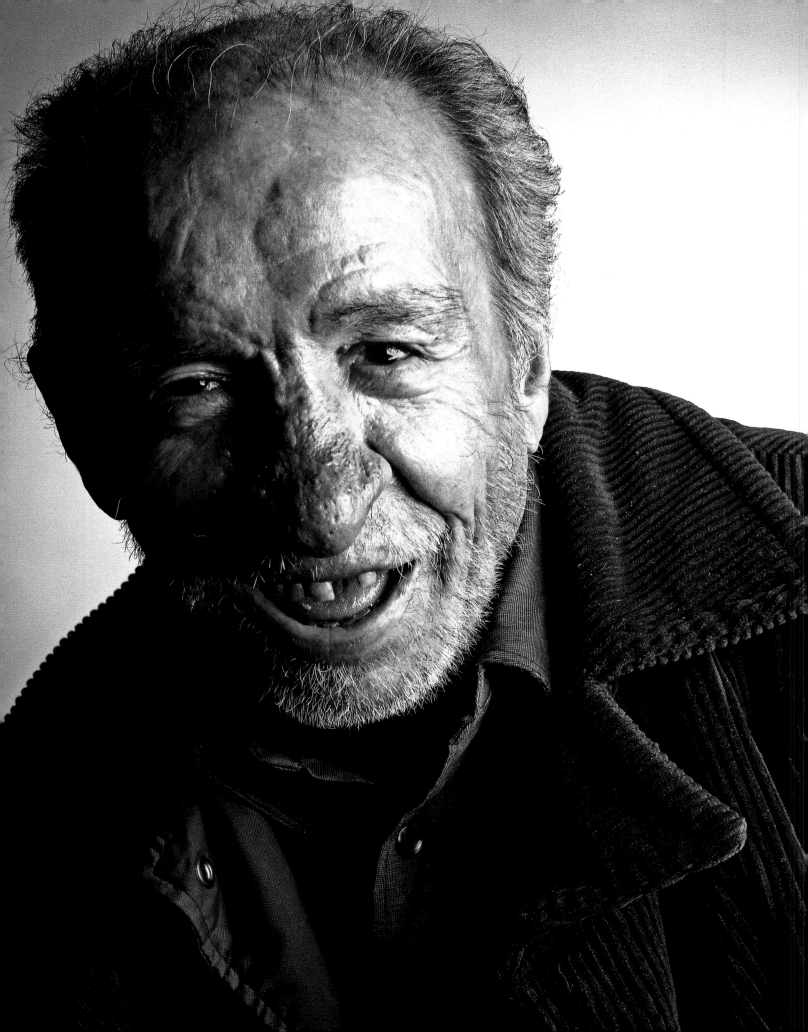

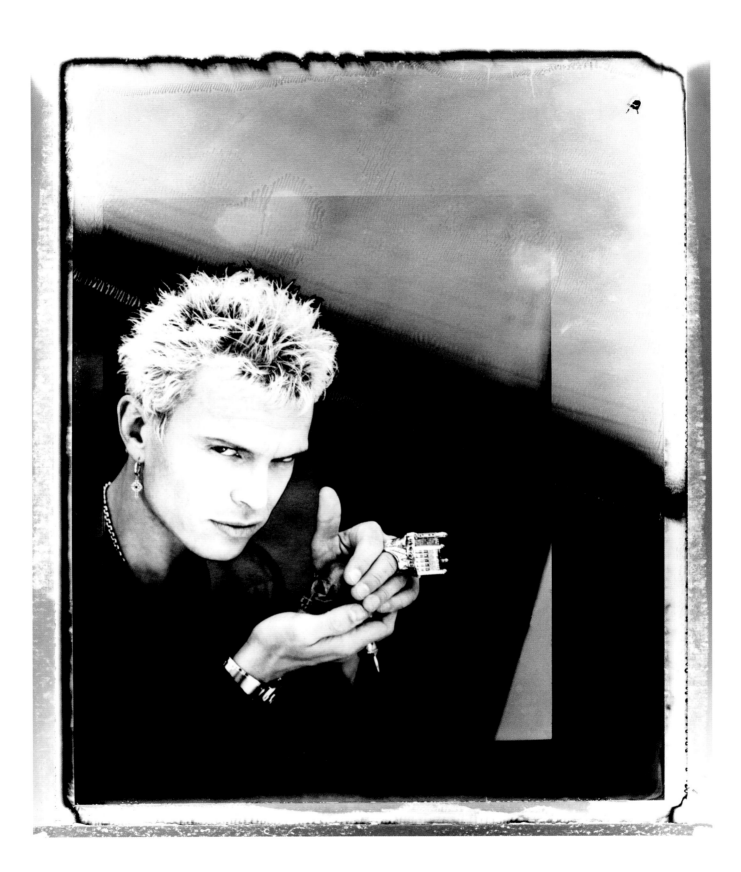

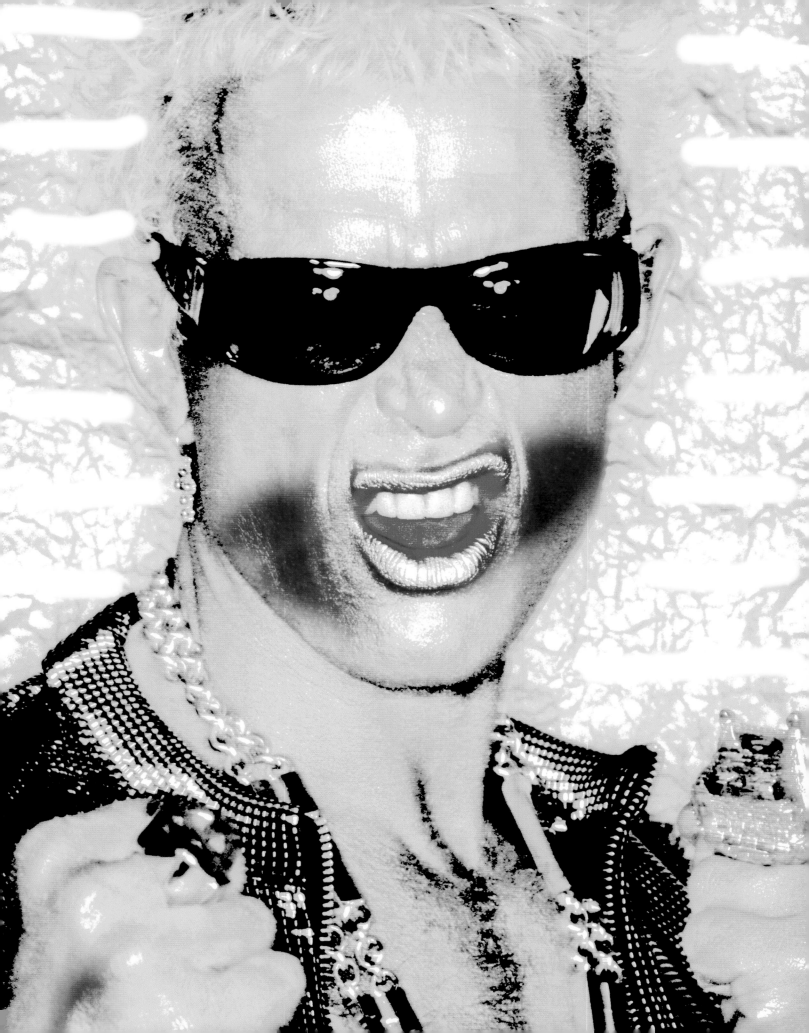

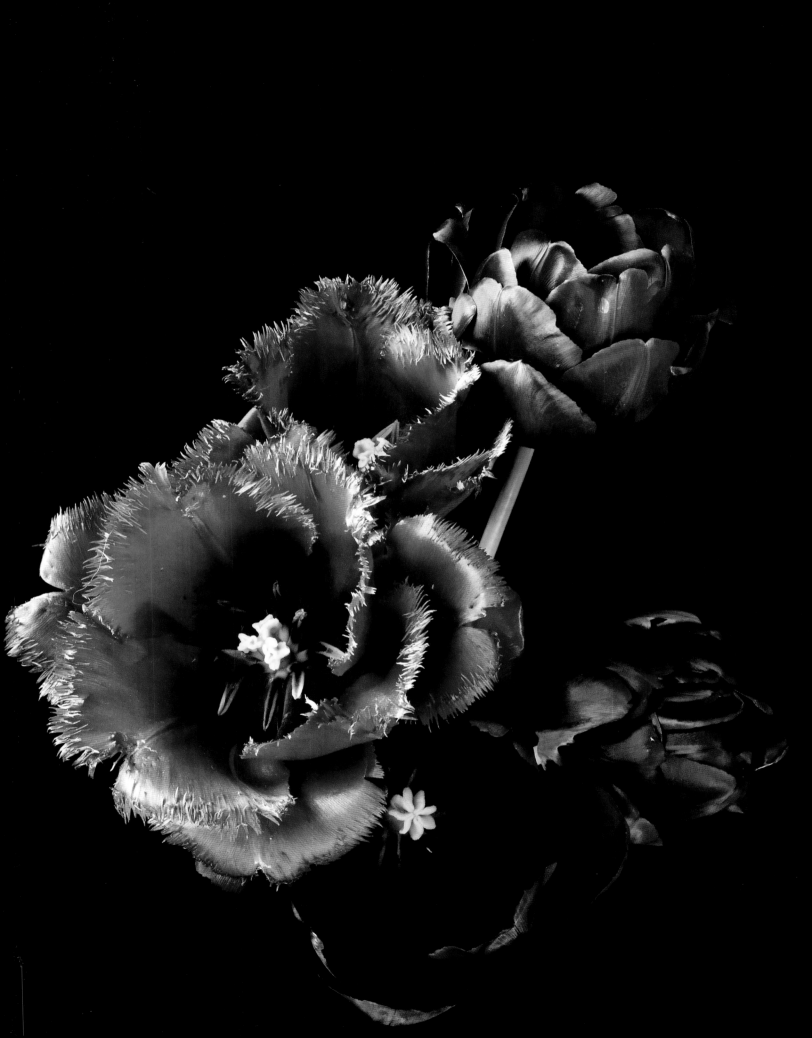

A Vicious After Thought

Well, it's been nearly forty years since those dark days in New York City and I have to ask myself how I feel about things and what really might have really happened if only for my own peace of mind.

First, let's deal with Nancy. Despite wishing it was otherwise, I do feel there is strong evidence to conclude that yes, Sid did kill Nancy. Regardless of the arguments put out in films — some of which I colluded with — that tried to put the blame on a third party. All quite likely, but not really.

In real life Sid was more the victim of Nancy. Despite being billed as a classic love affair, Sid's relationship with Nancy was really a one-way street. Nancy's street. The last couple of times I saw the two of them together at the Chelsea Hotel, I felt Sid was embarrassed by Nancy. He always was somehow. Who wouldn't be? Nancy was, as her nickname proclaimed, nauseating, to the extreme. Everyone knew this. She would go on about Sid this, Sid that and everyone would sort of shrug their shoulders and look away, as Sid did.

Sid was sexually and relationship naive when the two of them met and she latched onto him. Once drawn into the spider's web it is near enough impossible to get out. The knife that inflicted the damage was bought by him only days before. Joking or not, you do not say you did it 'cause I'm a dirty dog' to the police. Yes, the police were a bit lax with regards to the case, but mostly because it seemed like a pretty straightforward case. Guilty. I also can't quite understand how Sid, waking in the morning, would leave Nancy — who may not have been not be dead at that point — bleeding on the floor and goes to the Methadone Clinic without even telling reception to get an ambulance. No love lost there.

Despite all the so-called seedy characters in and around the Chelsea and Sid's room it was gonna take some pretty brave person to go up there and rob them while stabbing Nancy in the process. Possible, of course, but unlikely. I would have been more afraid of Nancy actually.

I was back in London on the night of Nancy's murder. The next time I saw Sid was at Max's Kansas City's bar two days after he had been released from jail on bail. That night we travelled up to Hurrah's nightclub and the Todd Smith incident occurred and he was arrested again the next morning. Strange behaviour for an innocent person. I didn't have the time to ask him what had happened that night. I did a couple of months later though, on the night after he was released again on bail, only for him to tell me he couldn't remember. You can't remember whether you murdered someone? After that the conversation centred on how he was gonna get off and what he needed to do to do so. Not a good line of conversation for an innocent man in retrospect.

So, how did Sid die and why? It has always bothered me that a hit of heroin taken five or six hours prior could have killed a now healthy ex-junkie. In my humble experience I have always found that someone who recovers from an OD does not die after. When I left Sid maybe four or five hours after him having a fix that did turn him blue-ish for a while, he was fine. We had spent the last few hours up talking. He was drinking tea, smoking cigarettes, even eating a bit of his mother's dinner from hours ago. His mother was up still, although in another room, and Michelle Robinson was awake, in body if not in mind. He even wanted more heroin. I lied and told him there was none left. Here is where I made my mistake though. As Sid had paid for the heroin, I gave what was left to his mother under strict orders that she did not give Sid any until the morning.

Now I really knew nothing about Sid's mother and her addiction problems. When we were together a few times and he saw her he would quickly hide or go another way in order not to be confronted by her. Sure, he had told me stories of what she did to him as a kid, hide chocolate bars of hash down his pants as they went back and forth from Morocco to Spain and so on. Things that made me not want to know the woman at all. How on earth was she going to look after Sid? She seemed hardly capable of looking after herself. Also, much ado has been made of the purity of the heroin that night. Well, it was pretty good but no way was it as pure as they have made out. Anyway, it's virtually impossible to gauge purity in a dead man's bloodstream.

Prior to the release of Alan Parker's movie, 'Who Killed Nancy', which I featured in, I saw an interview with Parker in which he said Sid's mother had told him before she died that she had gone in and injected Sid with drugs as a mercy killing because she couldn't stand to see her son suffer any more. I was horrified and immediately called up Alan and asked him "What the fuck?" He played it down, saying it was never supposed to be on camera. Was this just bad taste or an attempt at publicity? So I thought, until I did my own investigations.

Sid was found flat on his back, blanket up to his chin with one arm outside the covers, his left arm. On that arm were a few needle marks, most done by Sid himself. However there were a couple of other marks that showed entry marks or points administered by someone else. Sid was a junkie who liked to fix himself. It's the junkie equivalent of fucking yourself. You seldom let someone else do it.

Life had fucked Sid like it does so many. He probably didn't have the greatest of starts in life and throughout, trouble came through every door. Before he knew it, his time was up. It's a shame because I met a funny, mischievous, shy boy, hiding inside a persona of someone else.

I'm sorry that everything conspired against you. How dare your mother. There was no way out.

THERE WAS NO WAY OUT

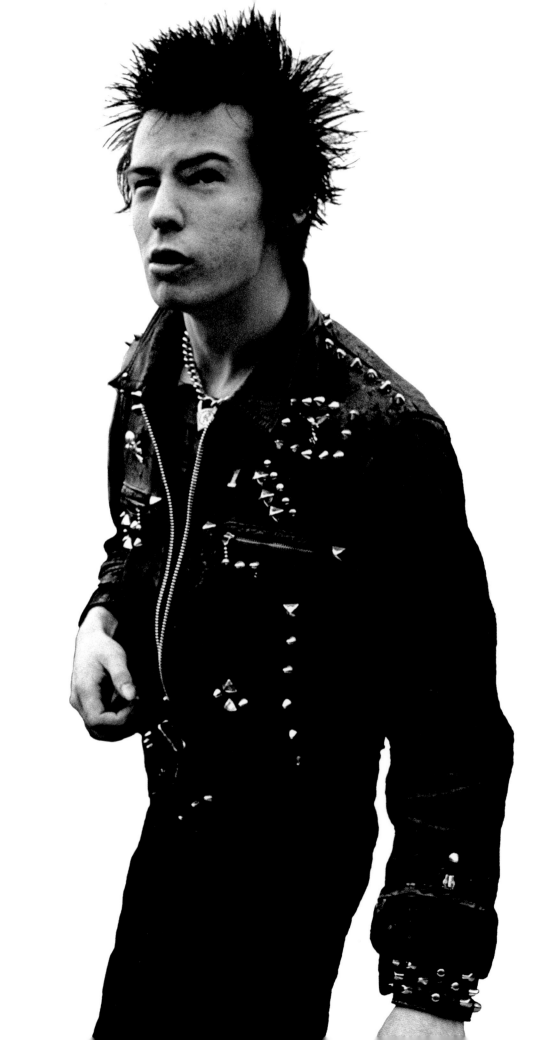

THE DEATH OF PHOTOGRAPHY

'We do not see things as they are. We see things as we are.'
Anais Nin

Ok, photography as we know it, or to be more precise, have known it, is dead. The baby has been put to bed, its adolescence has begun and it's digital. If you love photography you should not bemoan this change but embrace it for the simple reason digital has made photography more democratic.

Not to embrace it could lead you down a road where you might be regarded as elitist or worse still, having fascist tendencies. This is a change into a digital world that is far greater than Kodak's introduction of the box camera. Another democratic moment by default or by design. The rise of digital smart phones, photo apps and social media have changed the face of photography and in so doing made us re-evaluate the work of past photography or at least, look at it from a different perspective. Know the past but always move forward I say.

I stopped telling people I was a photographer in the mid 80's. It had become an embarrassment. Everybody I seemed to meet was a photographer. 'No, you are not a photographer. You're a camera owner', my riposte when affronted by mostly male models that were trying to launch themselves into what they hoped would be careers move. Well, I was working in the fashion business back then. They had probably worked for a few good photographers and thought, 'this looks easy'. Well, anyone who does his or her job well makes it look easy. I would wish them luck and tell them it was a long road. The beauty and the problem with photography is that one can become adept and produce good images fairly quickly. However this doesn't mean that you're a photographer yet.

By the mid-80's I started to travel to Japan for work. Here they seemed to have definitions a bit more ordered. There you would have cameramen and once you had achieved a certain level of expertise, you might be called a photographer. Maybe only 5% reached this level. It was an honour badge of sorts. In order to achieve this I believe the photographer must be in charge although one must keep in mind that usually great work comes from great teamwork especially in commercial fields and here I must say I don't regard commercial as a dirty word.

The idea of taking pictures for oneself is a difficult subject. For years when I started, I took very few pictures for myself. I could not afford to. Taking pictures cost money. Not only in equipment or film costs but transport of people to different areas to be photographed for a silly example. Maybe people you wanted to photograph who had no money for travel or a cup of coffee during the shoot. Someone had to be footing the bill no matter how small a price that might be. Some of these problems remain of course but the big cost was always film and development of. Unless you were rich or on a grant this could put a damper on photo taking for sheer pleasure.

Then along came digital imaging and in a few short years one could produce images as good, or differently good, as analogue or film. The quality achievable was amazing. A new reality in itself. I embraced this change.

No more trips to and from the lab. Sniffing chemicals in a darkroom was replaced by staring at monitors, both of which are probably detrimental to one's health. My mother constantly telling us kids to not sit so close to the TV as it would destroy our eyesight always comes to mind.

Mentioning eyesight, I believe photography for me became a way of seeing. In that it taught me to observe from other perspectives making me look closer at details and subsequently to look

objectively at my work. It became a way of life for me to photograph, and in so I have learnt so much from that.

I don't believe everything I see or hear. Through photography I have always learnt, adjusted, edited or reflected on what I saw or was seeing.

Edward Weston wrote in his diary in 1926, 'the camera sees more than the eye so why not make use of it.' Thanks to smart phones and small inexpensive digital cameras, taking pictures is something virtually everyone can partake in these days. How slick or contrived it becomes is up to us. Photo apps let us use tricks used for years by professionals at the touch of a button. Social media asks us for written and visual content. We comply in our own way if we partake. We become aware of fake or false imagery as we analyse it in our human bio-computer.

However, long before digital imaging arrived on the scene we always manipulated images. The very process of taking pictures is a form of manipulation. Mankind was created once man wanted to make something better I believe and any object bears the handprint of its maker as so it should.

Image manipulation is not really a technique but an argument. I would say from the very beginning images were tweaked or changed to achieve desired effects. Take the work of Frank Harvey, who photographed Antarctica, then in the trenches during the first W.W., some of which were even shot in colour. Later he collaged segments of different pictures together in the darkroom and throughout the war, these images were used as war posters in Britain. Later his composites were declared fake by historians and the work derided although they certainly served their purpose at the time. Later John Heartfield used photo collage to great effect during the second W.W. Although these were not supposed to be correct visual recordings as Harvey's work was thought to be.

Now with digital everything is possibly faked but as one becomes more educated in the techniques whereby this is possible one is usually able to decipher the tricks. Virtually everyone has some idea of the retouching done on magazine covers or adverts although there are various degrees of subtlety. Also any imagemaker when looking at an image will adjust in their mind the situation, apparatus and technique used to make this image possible although we might not always be correct.

Photographic death occurred in the changeover from analogue to digital and was secured by the arrival of the internet-enabled smart-phone. However one should be aware that in digital-imaging at present, only one-third of the available photons are used in digital conversion. This means that two-thirds of the digital image is interpolated by the processor in conversion from raw file to jpeg or tiff. It is a reality but not one as we really know it to be.

The camera has moved on from being a picture-making device to a data-making device. Maybe the camera of the future will be an app. Incorporate LIDAR data with emerging virtual reality, semantic reality and artificial intelligence to imagine where computational imagery could be taking us. The development of curved sensors will allow us to interpret light differently and we'll have a whole new visual culture emerge far beyond mere documentation. Photographs or images of what we know rather than just what we see. Worlds de-constructed then re-assembled in multi-perspectives for deeper understanding. Images will be responsive to change. Today, the same way we interpret what is written we interpret the visual image. In the future, we will find ways to incorporate the two.

I believe in a good picture image the viewer should not be concerned with lighting techniques or post productive techniques. The image should rise above this. Technique is only important to the imagemaker to achieve the desired effect they are after. A good mantra is to be aware of all the techniques, tricks etcetera then try to forget them all. A good question to ask yourself is what are you focusing on? What is your P.O.V. or point of view?

As a cameraman one is no different from a dentist really in some respects. You are a technician. It can be painful experience. Indeed a sitter once compared having their photo taken by Avedon as similar to a dental procedure.

Yes, photography infancy is dead. The change into adolescence is so great that not to realise this is to lead one to a historical backwater using a quaint visual language removed from the cultural mainstream. Not much respect for the history of photography then.

Since the days of Camera Obscura, opticals and later photography have been used in the creation of fine art. The history of Photography has been described as a history of scientific discoveries and technological advancements mirroring the growth of humanity's collective progress over the course of our industrial revolution. From salt printing to gelatin silver prints which were solarised by accident, to platinum printing and on to dye-transfer and dye destruction. Warhol started with photographic images then employed Polaroids for the majority of his work albeit silk-screened after. A sort of processing and printing really. Gentlemen do prefer Polaroid though.

So, what is the photographic experience? It is Karsh having two minutes to take his famous Churchill portrait. It is Capra shooting four rolls of film on the D-day landing only having them destroyed in processing leaving only eleven frames printable. It is George Roger, famous for his photos of London during the Blitz, photographing Belsen in 1945 and later talking about how he had walked around the camps moving bodies to create better compositions he thought, at the time. He vowed never to take war pictures after that. It is Henrich Hoffman taking nearly a million pictures of Adolph Hitler over the years. Images Hitler studied to perfect his poses and gestures. It was also through Henrich that Hitler was to meet his Eva Braun. It is Rosenthal re-shooting the Ipagima image again with a larger flag and being able to get only one frame taken. Later when he was accused of staging the picture he replied, 'too perfect to be posed.'

It is probably by the 1930s that the photograph stopped accompanying the news and became the news. Thus Dorothea Lange's Oklahoma pics along with Humphrey Spender's photos of northern England poverty come to mind.

The Photography experience is also Alexandro Rodchenko. It is Blumenfeld. It is Wegee. It's Gustave Eiffel's work on the elements in preparation for his Eiffel Tower, the rather beautiful woman's leg with garter. Man Ray's experiments look very similar. It's August Sander's unprejudiced attempt at observation over his native Germany. It is Cartier-Bresson looking for his Buddhist inspired fraction of a moment. Paul Strand encouraging the moment to arise in order that a story might be told. It's the economist Salgado turning to photography to document the face of globalization in the hope it would reveal more than his statistics. It is the C.I.A. superimposing Lee Harvey Oswald's mug shot, after his arrest for murdering Kennedy, onto a photo of an F.B.I. agent holding a rifle with a Pravda newspaper, only admitting to the fraud in the late 80's. It's Peter, you can do anything you want with these eight pages as long as it's in colour against a white or grey background and we haven't seen the model and the hair and make-up people are new to us as well and the clothes aren't up to much either. Yes, the photographic experience is all of these things and more depending on the individual but I will leave it to Corda, famous for his Che Guevara pics, who said, 'It must create an emotion inside of you.'

Photography is an illusion we accept because it looks so much like the reality around us. However, reality is not high contrast black & whites or re-touched faces. The very first photographic image was an illusion only possible by a very long exposure and some chemical trickery. It just looked more real than anything that had gone before. So when people say regarding digital and the future there will never be such a thing as a straight photograph I say maybe there never was despite photography's reputation for always telling the truth.

Two present day photographers whose work interests me are Jeff Wall and William Eggelston. Wall, whose painstaking and laborious photographs of the same subject over months maybe put to rest the question of photography's inability to change elements in the final image as a painter could do. I had thought Eggelston was using a similar technique or approach to capture his images but oh how wrong I was.

Orson Welles once said, 'the camera is much more than a recording apparatus. It is a medium via which messages are sent to us from another world.' Was Edward Steichen correct when he said, 'no photographer is as good as the simplest of cameras', or had he had one too many sherries, maybe with Orson over lunch? I would like to agree with both somewhat. I have had photo sessions that border on religious experiences or epiphanies.

That moment when you and your camera become one.

Your camera might even tell you what to do, suggest alternatives and you must respond. It is for that moment when you become one with your equipment, and your subject. When you are asked questions (sometimes of everything you know), you must respond that you still love to take pictures. Is this the democratic moment? I do hope so.

People are always comparing photography to painting but I feel it should also be compared to music, another of the great arts. The rhythm, the dance, the feel. Prints replacing notes. I believe photography can now be the mainstream and not just a radical backwater of contemporary art. It can become the finest art of the moment.

We should relish the death of photography's infancy. Adolescence moving into adulthood offers this bright new future. I regard photography as a learning tool, one that never stops. Virtually everyone uses imagery today, doctors in surgery, parking attendants whilst dealing out tickets and on and on. Photography could and should be used in therapy with I'm sure interesting results. Later, the results of what you shot and why could be discussed and even analysed.

I love cameras and may there continue to be more of them. Maybe later we could go back and edit our life, for a life un-examined is a life not worth living I believe. I hope you have enjoyed the book and some of the images. It is just part of my story, un-similar and similar to many. Maybe I should regret in life only the things I did not do. Now I need to educate myself a little more, make some sense of what is around me, so where is that camera or should I say, image-making device of mine? Do you have the eye?

Peter

The Man behind the Lens.

I had no idea who Peter Gravelle was. He had contacted me through social media early 2012. We had a mutual friend from our days in NY in 1980 Roger de Cabrol who introduced us both. As it so happened we had lived parallel lives in London and NYC but had never actually met each other. Both living lives to the full but the cup was always half empty on reflection. Fast forward 30 years and after a year of contact on fb we eventually arranged to meet for a coffee. That coffee meeting never materialised. I received a phone call saying he had to go away. I thought a nice holiday in the sunshine. I was disappointed. I was longing to meet him. Little did I know that Peter was living in turmoil and hell. He was an ex substance abuser and was trying to come off prescription drugs and had gone into yet another rehab to detox. A brave thing to do. Surely it is easier to live by the sword and die buy the sword at that point. Through all that turmoil from his past he had a life force that was desperate to survive and flourish. He is like a bolt of high voltage electric energy all creativity, humour, anger and charm. He's also a great poet which is a heady combination. All the tools you need to see life, whatever it is, through his lens. I salute you, and your work over 40 years speaks for itself. You are one of the great photographer's of your generation. Rock stars, fashion, fetish, flowers, landscapes, still life, people, graffiti. There is nothing you cant take pictures of. The death of photography is as truly iconic as you are. I love you always. Thank you for letting me be by your side in the metamorphosis of your historical pictures into this amazing story of your life.

Angela: January 2016

A LIFE
UN-EXAMINED
is A LIFE
NOT WORTH LIVING

Credits

With; The Sex Pistols, Elvis, Feet of Christ, The Damned, The Roxy Club, Siouxsie Sioux, Generation X, Ari-Up, Chelsea, Snatch, The Only Ones, Johnny Thunders, Patti Palladin, Debbie, Elvis Costello, Iggy Pop, Glenn Matlock, Midge Ure, Les Chappell, The Police, Malcolm McLaren, Lene Lovitch, Wilko, Marrianne Faithfull, John Cooper-Clarke, Nancy Spungeon, Johnny Rotten, Radiostars, Eva, Judy Gilette, Dondi Caviness, House of Harlot, Rachael McLean, Lisa Doyle, Teresa De Priest, Jean-Paul Gaultier, Michelle, Meredith, Jesse Sewell, Hil Jennings, Troll, Nadja, Angela Barry, Quentin Tarantino, Steve Dior, Milla Jovovich, Ray, Billy Idol, Titus, Raymond, Sid Vicious and more.

Thanks: Vogue, Harper's Bazaar, Rolling Stone, Donna, Klik, N.M.E., Kodak, Fuji, Polaroid, Sinar, Hasselblad, Nikon, Pentax, Canon, Samsung, Apple, Epson, Jenny Christopolou, Lloyd Simmonds of Y.S.L., Desmond Van Staden, Vassilis Zoulias, Pina Gandolfi, Jacek Zaluski, Norman Hathaway, Richard Weedon, Daniel Phelps, Andrew Cottrell, Ashley Walker, Chris Brooks, Fabrizio Ruffo, Marco Franchina, Larry Trippi, Giorgio Repossi, Peter Ryan, Sebastiano Cortes, Alex Mahairas, Curtis Benjamin, Malcolm Perry, Les Wiseman, Lucca Stoppini, Michele Lupi, Dr. Doug Foster, Susan Dallas, Yan Basely, Marilyn Alexander, Trudi Partridge, Isabelle Bondi, John Berger, James Malin, Barry Jones, Marc Zermati, Zenon, Whiskey a Go-Go, The Mudd Club, The Viel, Akihiro Hiraga, Lexington Queen, Cleo's, Hollywood, Billion Dollar Babes, Dudley, Rose Carr, Sir Raymond Albert Maillard Carr, Dr. John Cunningham Lilly, Alejandro Jodorowsky, Carlton for teaching me photography, school for making me a rebel, drugs for widening my vision, Japan for the sushi experience, Colin, Gary and the crew at Carpet Bombing Culture and to all those who made a good job possible over the years. It was a delight.